PAPER. PEN. PANDEMIC.

Viral Cartoons from around the Globe.

Imprint

1st Printing
© 2020 Benevento Verlag by Benevento Publishing Salzburg — München, a brand of Red Bull Media House GmbH, Wals near Salzburg

Distributed by gestalten.
E-mail: sales@gestalten.com, www.gestalten.com

Publisher and editor:
Benevento Publishing - A brand of Red Bull Media House GmbH
Oberst-Lepperdinger-Straße 11—15
5071 Wals near Salzburg, Austria

Concept, composition and design:
Team Rottensteiner Red Bull

Art direction:
Marion Bruckmeier

Project management:
Anne-Sophie Stocker

Assistance composition:
Maximilian Rottensteiner
Walter Grill

Final artwork:
Michael Höller

Cover design:
Team Rottensteiner Red Bull

Cover:
Bruce MacKinnon

Picture editors:
Eva Bauer, Markus Kucera

Translation:
Anne Fries

Printed in Slovakia by Neografia

ISBN 978-3-7109-0130-0

FSC
www.fsc.org
MIX
Papier aus verantwortungsvollen Quellen
FSC® C020353

BEN
EVE
NTO

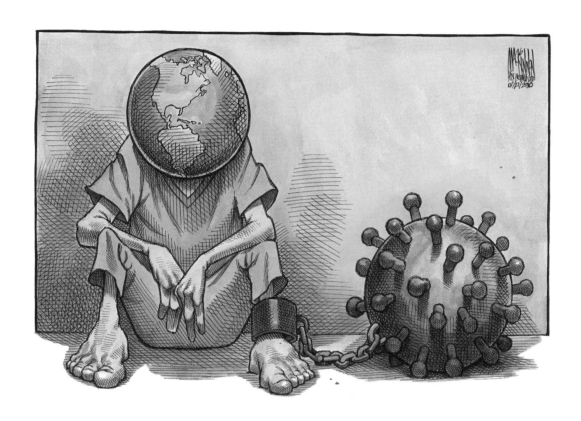

PAPER. PEN. PANDEMIC.

Viral Cartoons from around the Globe.

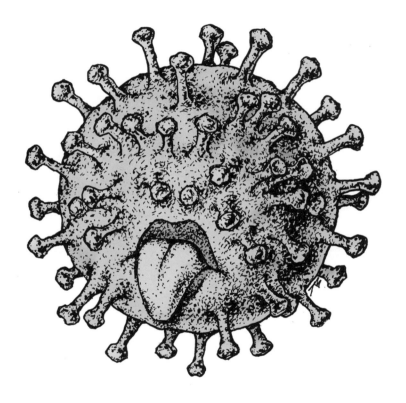

PROLOGUE.

A virus, with a diameter far smaller than one ten-thousandth of a millimeter. And yet thanks to its extremely infectious, initially unpredictable and sometimes lethal nature, it has grabbed center stage the world over.

Amidst all the sick madness are the observers, with their knack of spotting the essence of things, and their gift for reproducing it in pictures. They do not report, do not explain, and do not moralize.

Cartoonists scratch away at the surface of events with their pens to expose the underlying issues. Their perspectives bring other, unexpected facets of a subject to light, giving the beholder greater insight, and encouraging him to "think outside the box".

As well as examining the peculiarities of the SARS-CoV-2 virus and the "new normality" in times of crisis, the artists have taken a critical look at the astonishing ways in which people have dealt both with this insidious disease itself, and with various absurd proposals on how to combat it.

What these free thinkers among the commentators on world affairs have produced is every bit as diverse as their visual languages and the senses of humor of their respective cultural groups.

Over 400 works by more than 100 cartoonists in over 50 countries on all continents are collated in this book, which surely also offers a glimmer of hope in these surreal times — because as long as we can still laugh about a threat, it certainly can't have killed us.

8

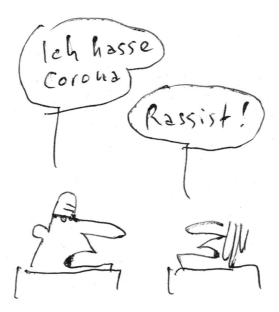

I hate
corona
— Racist!

Tex Rubinowitz
Austria

IS THE KILLER VIRUS HERE?

Daily Mail, January 24, 2020

KILLER VIRUS NOW SPREADING FAST

Evening Standard, January 30, 2020

THE OUTBREAK

Focus, February 3, 2020

CORONA ALARM!

Bild, February 24, 2020

VIRUS PANIC

Daily Mirror, February 28, 2020

CORONA IS HERE

Dee Telegraf, February 28, 2020

CORONAVIRUS CLOSES IN

Daily Guide, March 12, 2020

GLOBAL PANDEMIC

El Periódico de Catalunya, March 12, 2020

MANY LOVED ONES WILL DIE

Daily Mail, March 13, 2020

WAR ON CORONA

Sunday Mail, March 15, 2020

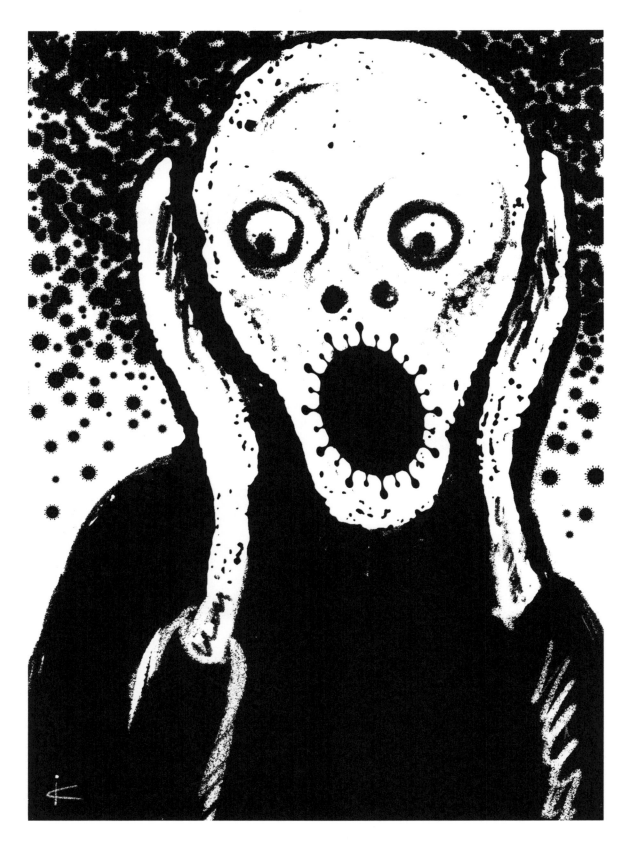

Ilya Katz
Israel

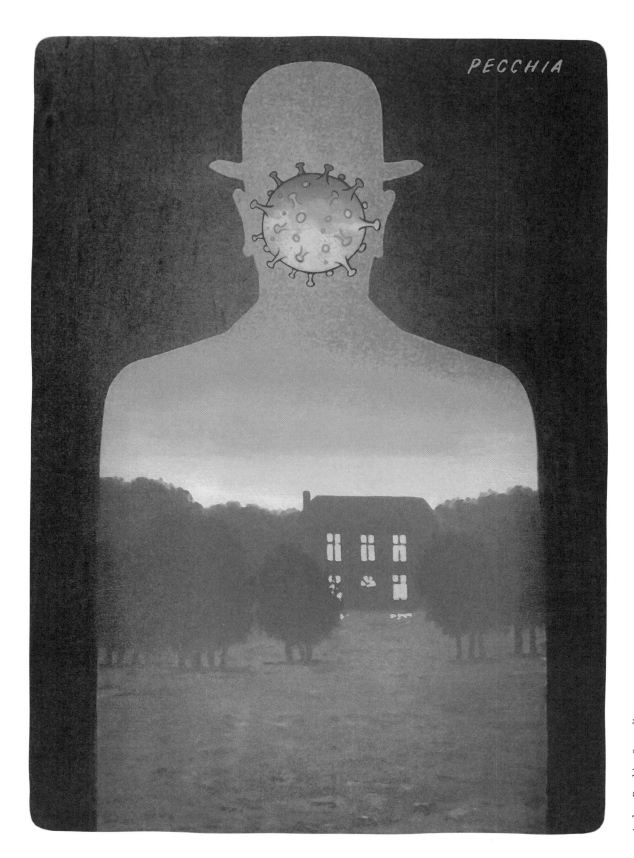

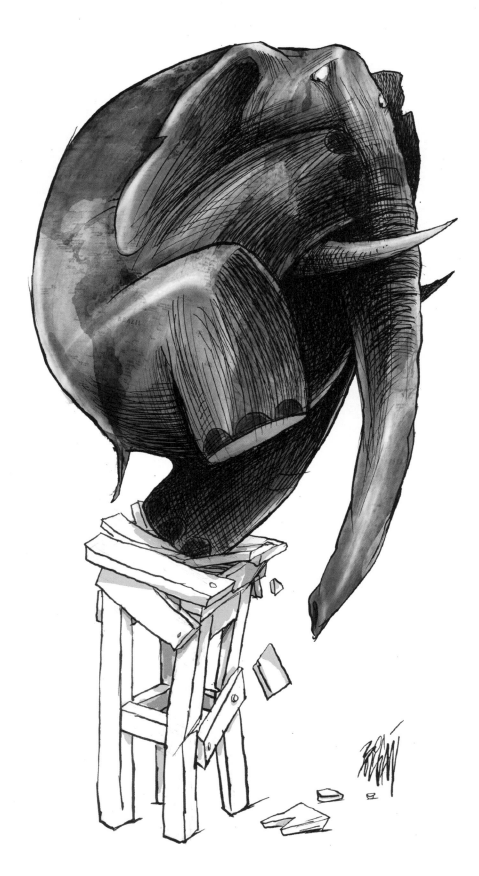

Angel Boligán . Virus y Miedos
Mexico

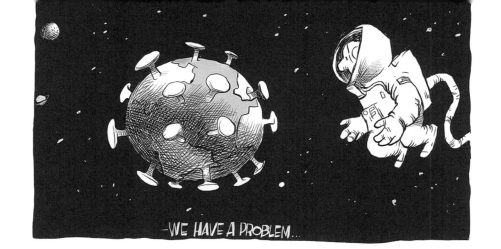

Kleber . o problema Corona
Brazil

13

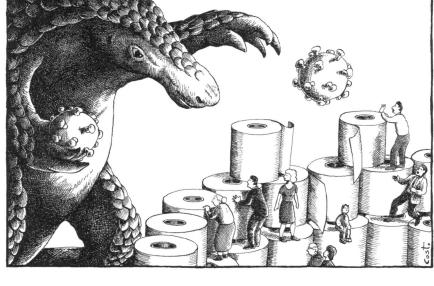

Cost . . pangolin
Belgium

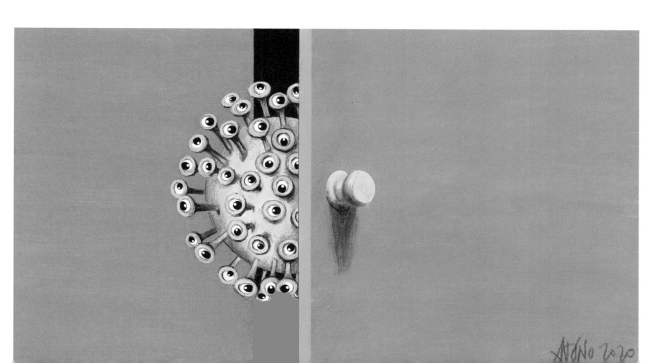

António Antunes . Lurking
Portugal

14

Dlog . Pandemic Headache
Tunisia

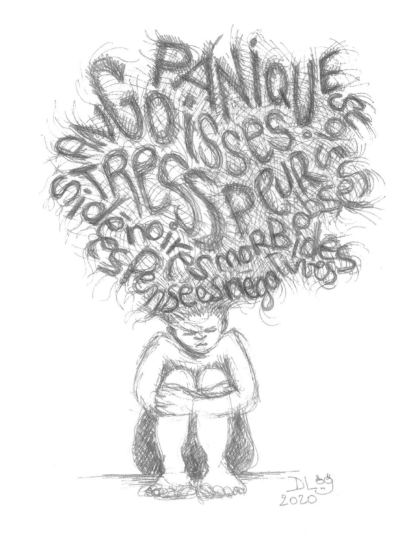

PANIC
ANXIETY
STRESS
FEAR
DARK THOUGHTS
NEGATIVE THOUGHTS
MORBID OBSESSIONS

Christof Stückelberger . He just wants to play
Switzerland

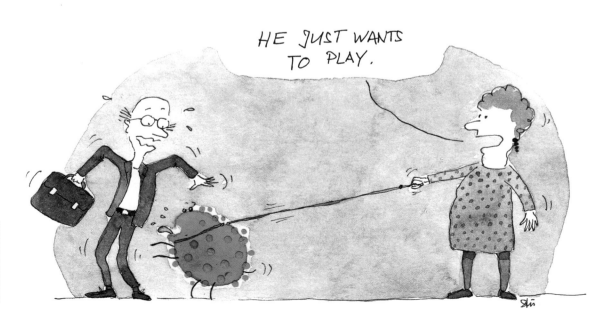

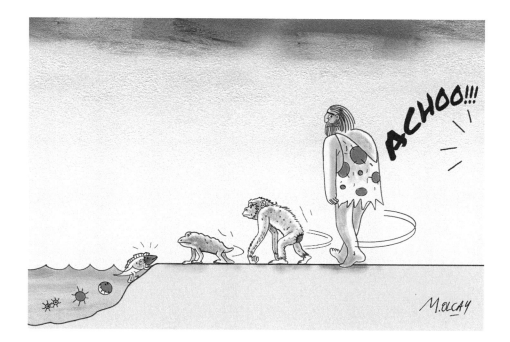

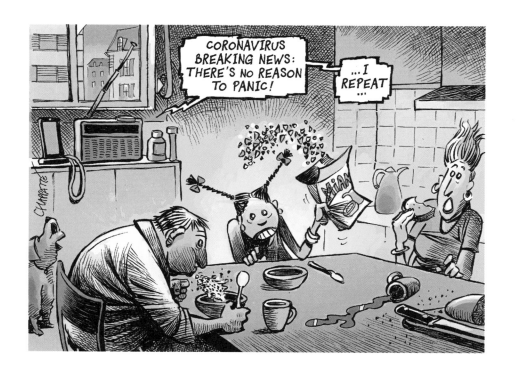

Muammer Olcay . Stay At Home!
Turkey

Chappatte . Facing the epidemic (first published by Le Temps, Switzerland)
Switzerland

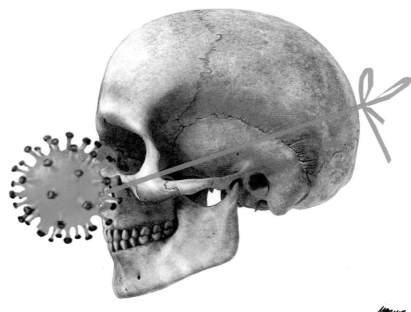

Marina Bondarenko . skull-clown
Russia

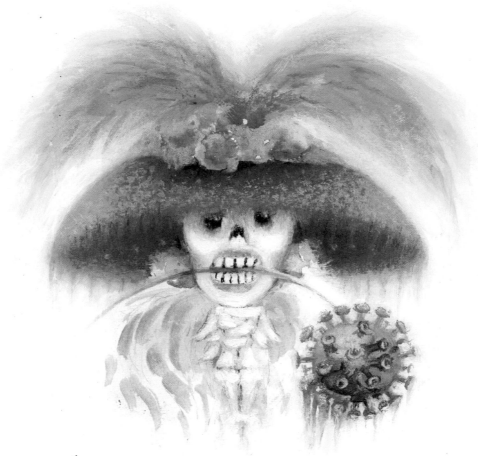

María Verónica Ramírez . Catrina 2020
Argentina

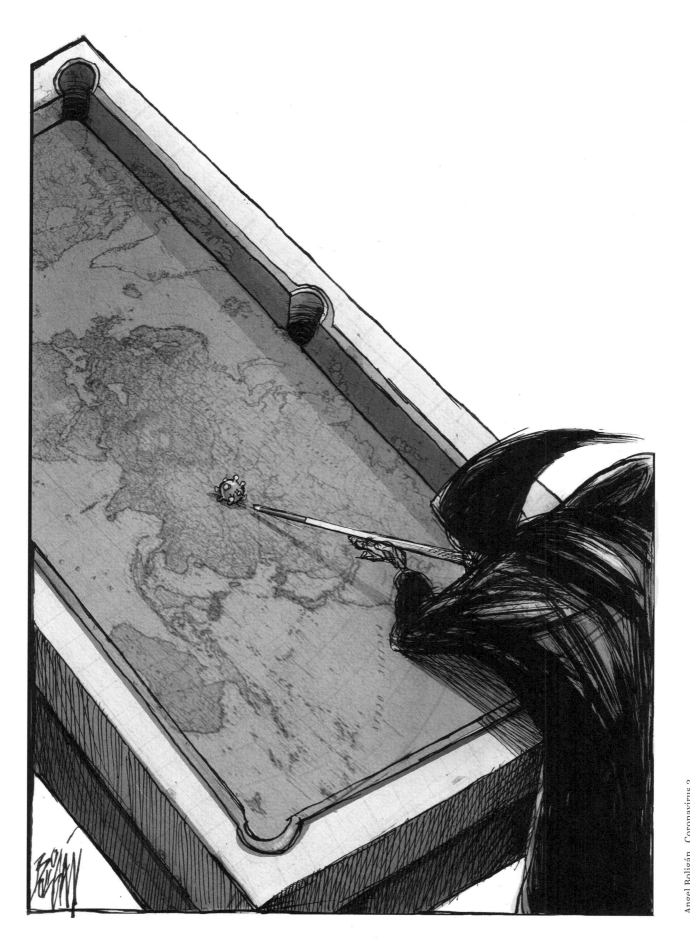

Angel Boligán . Coronavirus 2
Mexico

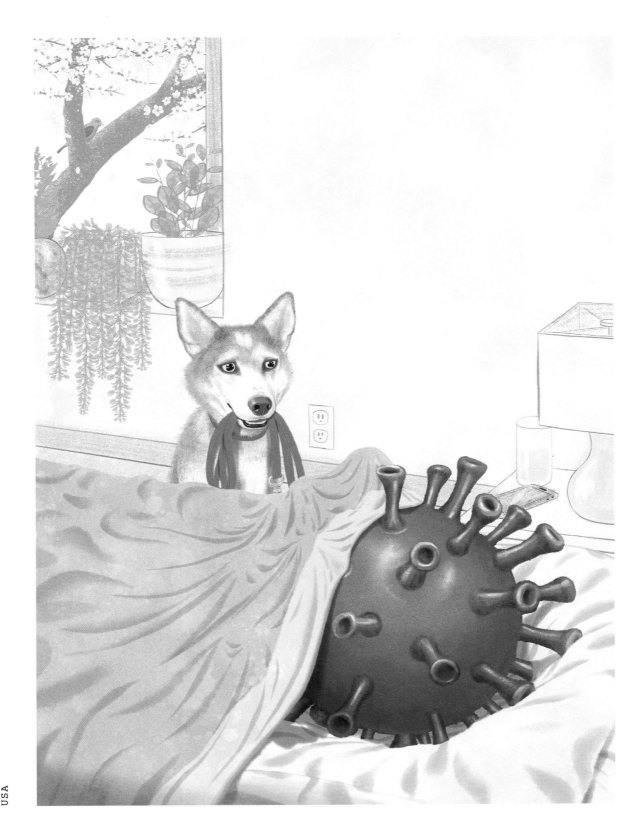

Jason Raish . Who('ll) Let The Dogs Out?
USA

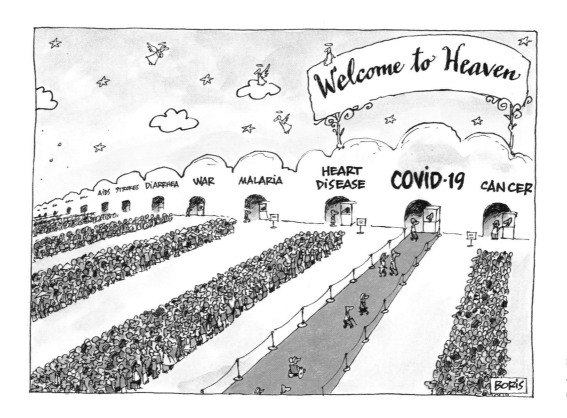

Marina Bondarenko . covid death
Russia

Boris . Heaven
Canada

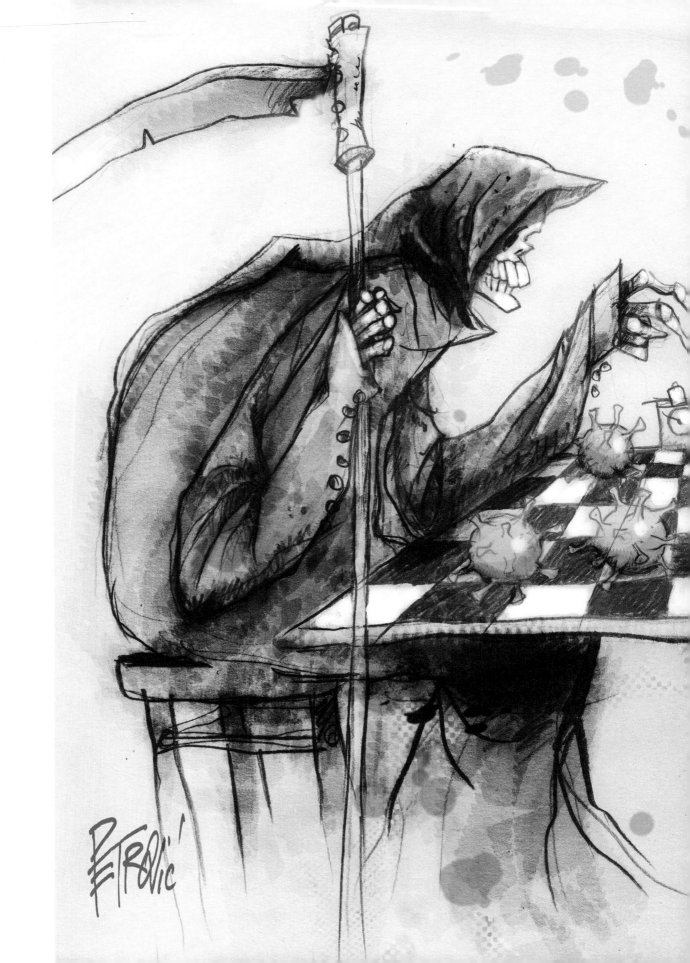

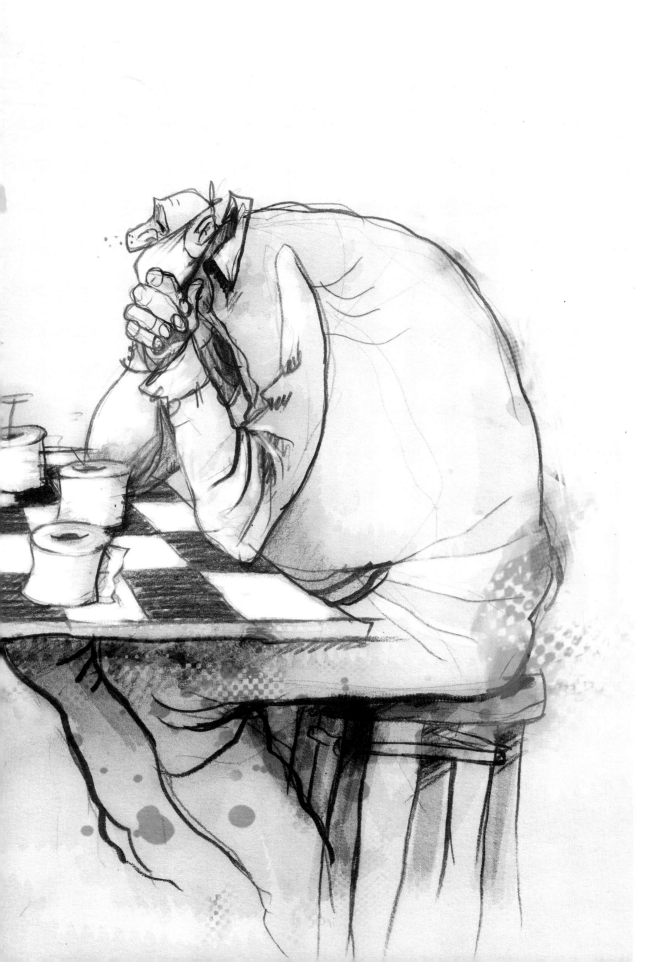

Zoran Petrovic
Germany

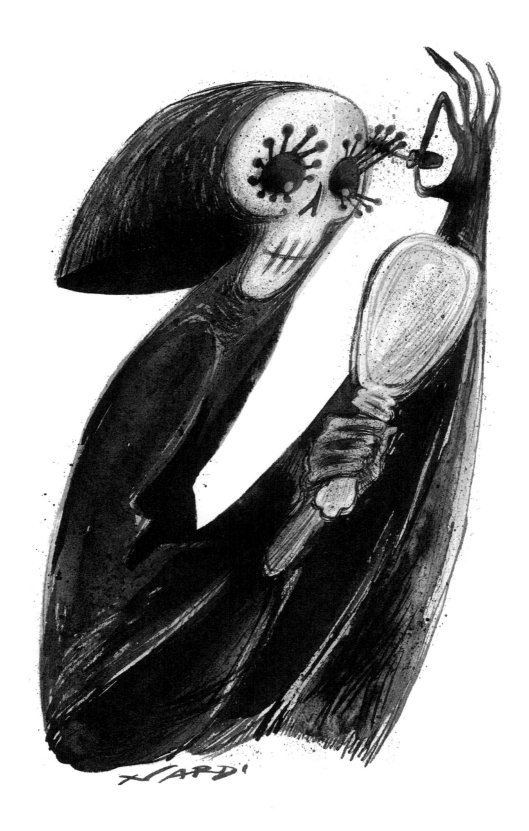

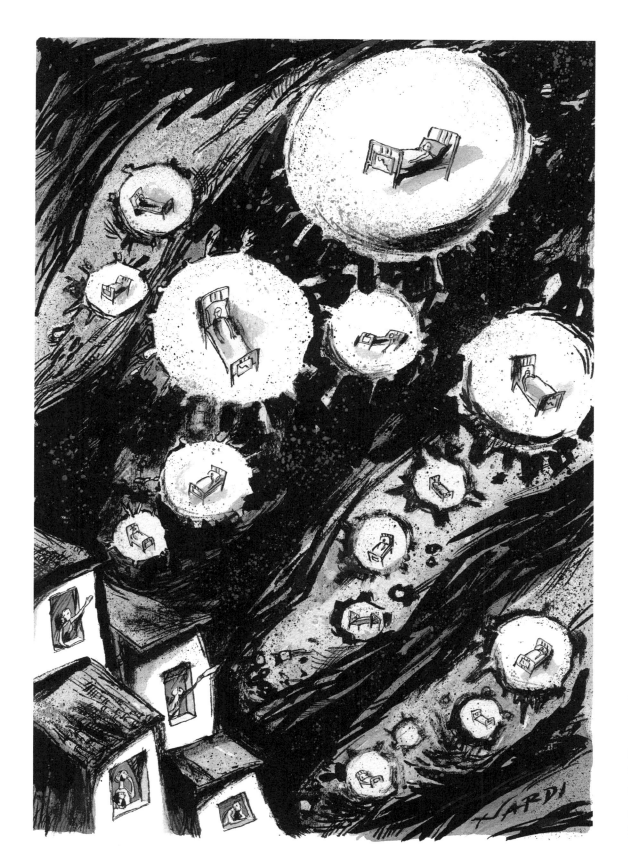

Marilena Nardi . The vanguard
I t a l y

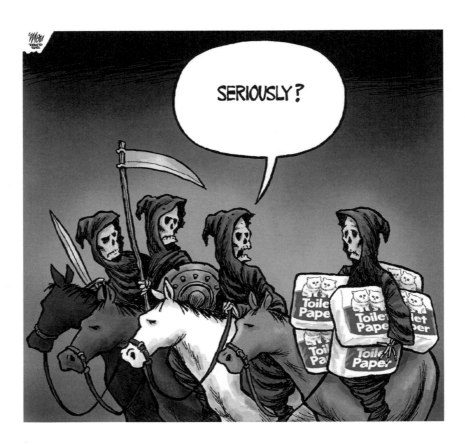

Theo Moudakis . Four Horsemen
Canada

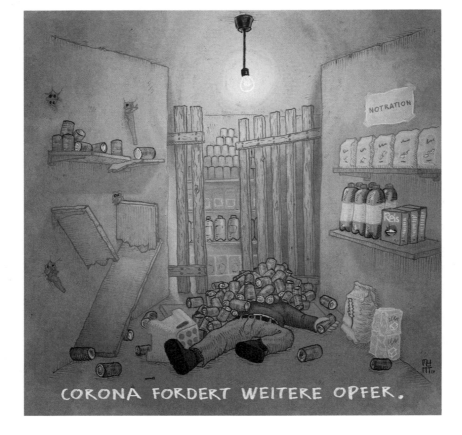

Mynt . Keller
Switzerland

Emergency
ration

Corona
claims
more
victims.

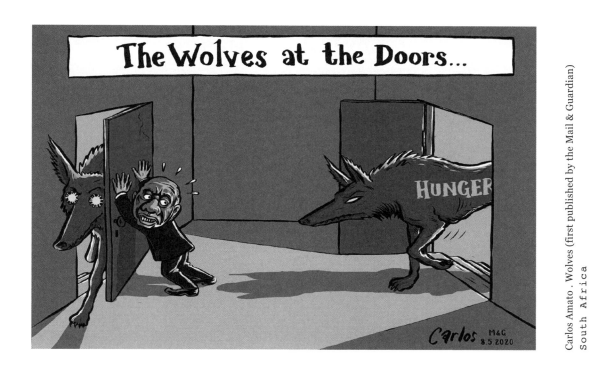

Carlos Amato . Wolves (first published by the Mail & Guardian)
South Africa

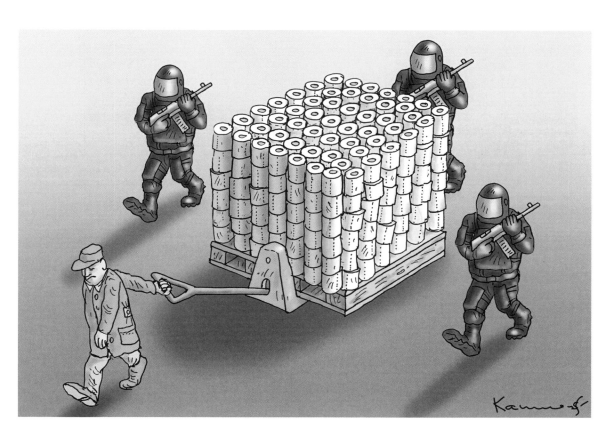

Marian Kamensky . Ende der Hamsterkäufe
Austria

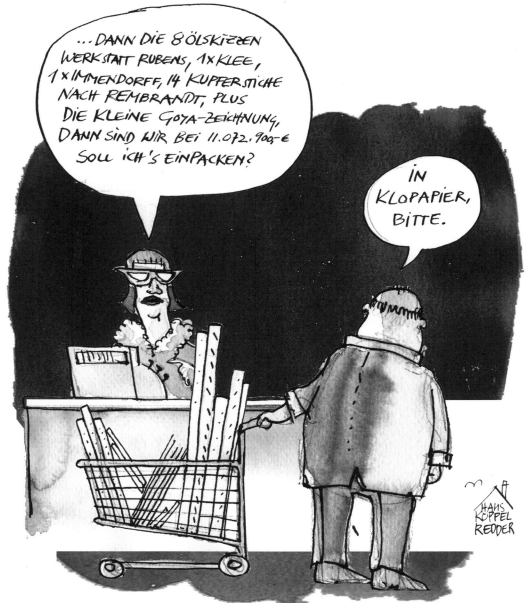

Just a matter of time until coronavirus panic-buying reaches the art market

… So we have 8 oil sketches by the Rubens studio, one Klee, one Immendorff, 14 etchings after Rembrandt, plus the small Goya drawing — that all comes to €11,072,900. Shall I wrap it up?

Yes, in toilet paper, please.

You wiped
WHAT with our
toilet paper?

Hans Koppelredder . Klopapier
Germany

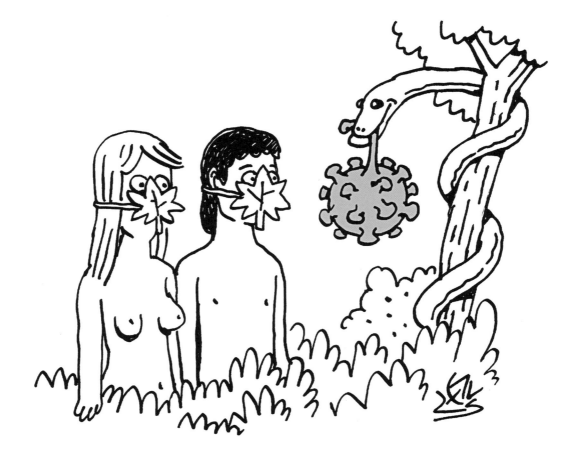

Alen Lauzán . Pandemic Gardens
Chile

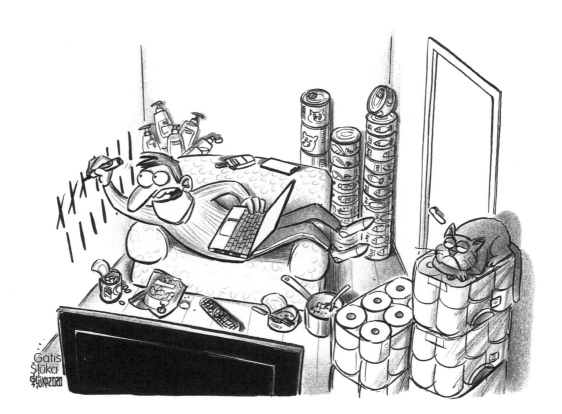

Gatis Šļūka . Self-isolation
Latvia

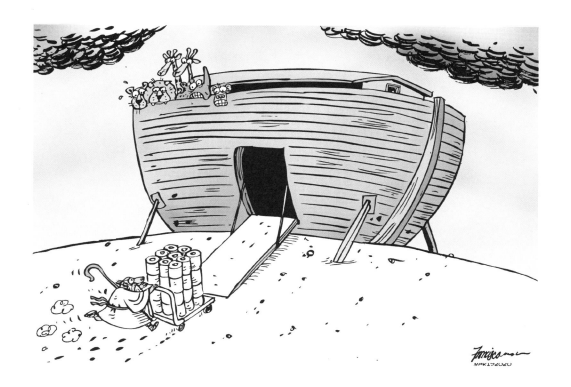

Manny Francisco . The first panic buyer
Philippines

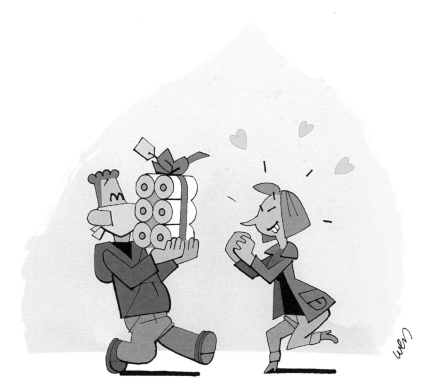

DIE LIEBE IN DEN ZEITEN VON CORONA.

Love in
the Time of
Coronavirus

Karsten Weyershausen . Die Liebe in den Zeiten von Corona
Germany

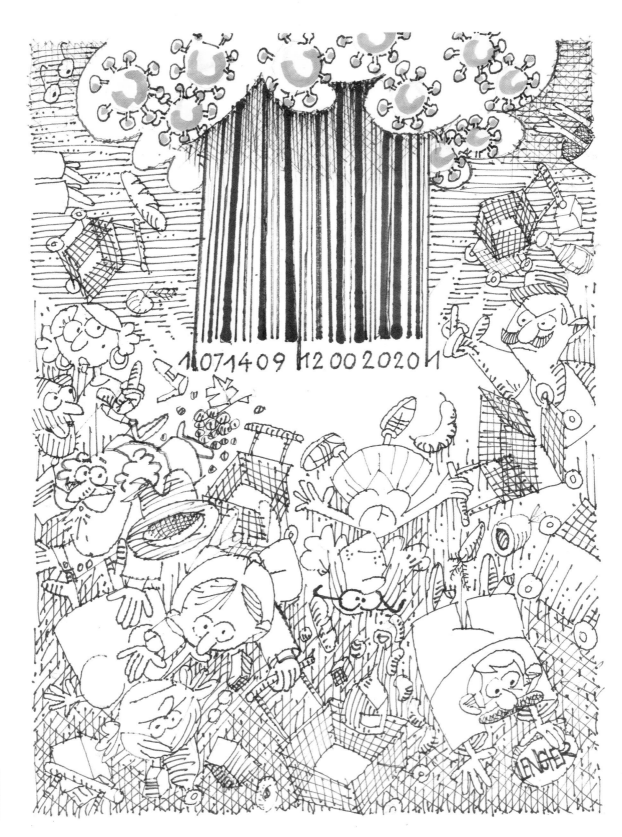

Nicolae Lengher . Crisis Explosion
Romania

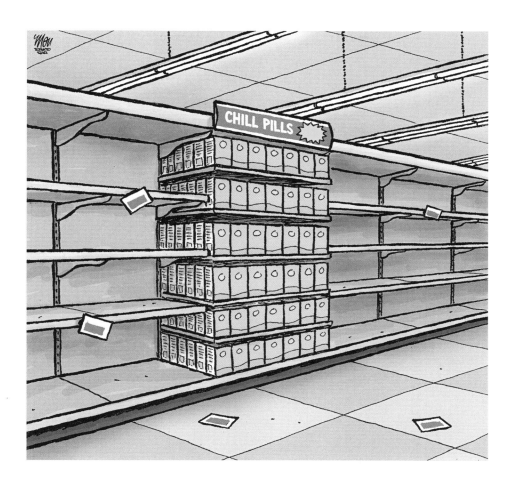

Theo Moudakis . Chill Pills
Canada

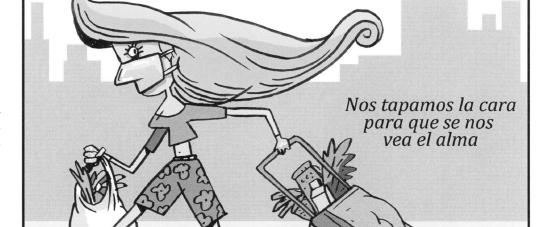

We cover our faces to re-veal our soul

Nos tapamos la cara para que se nos vea el alma

Turcios
Spain

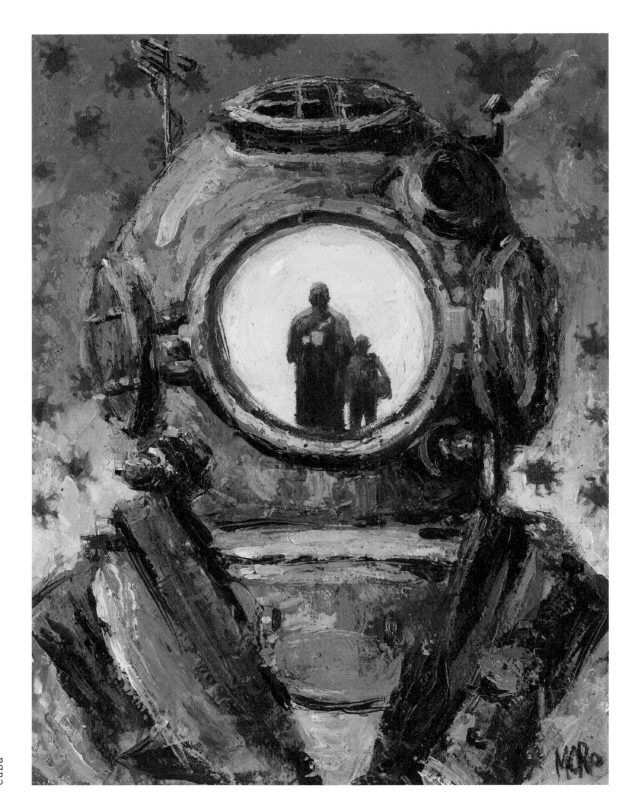

Michel Moro Gómez . The diving suit-house
Cuba

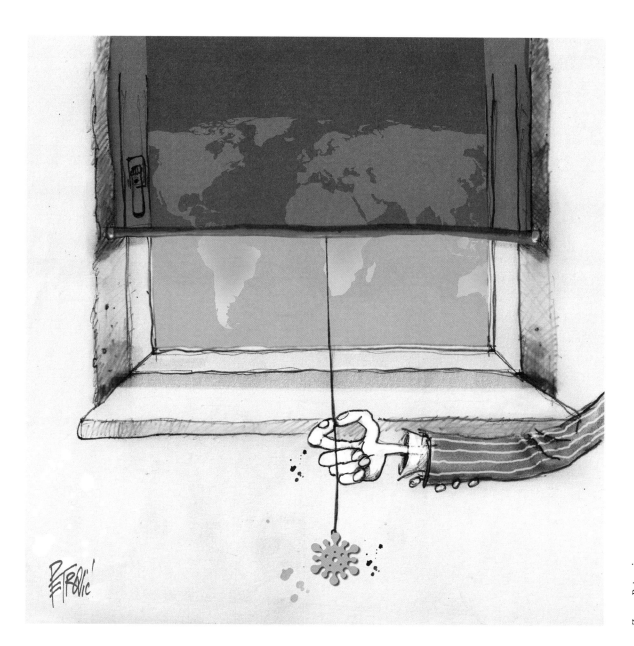

Zoran Petrovic
Germany

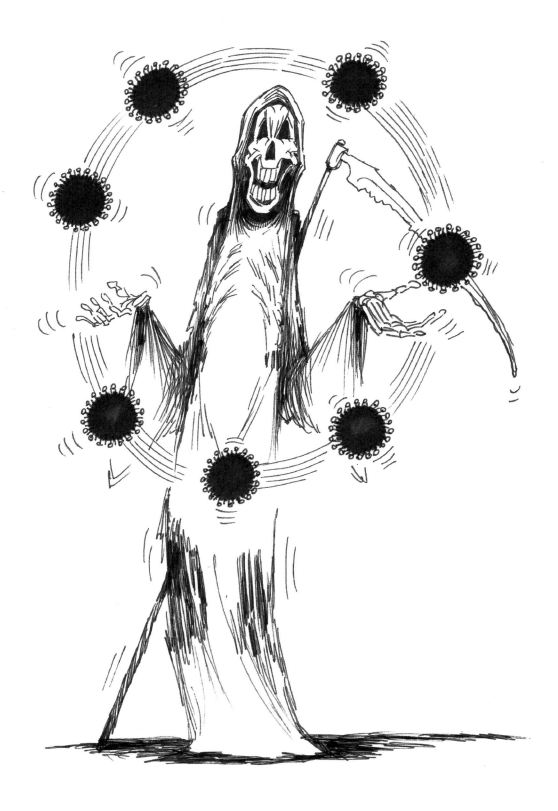

34

Goran Celicanin
Serbia

EVERYBODY AT HOME
La Repubblica, March 10, 2020

CORONVIRUS: THE WORLD IN LOCKDOWN
Le Monde, March 12, 2020

WAR ON COVID 19
Daily News, March 12, 2020

STAY AT HOME
San Francisco Chronicles, March 17, 2020

TIME TO GET ANTI-SOCIAL
Metro, March 17, 2020

SCHOOLS OUT 'TIL SUMMER
Daily Record, March 19, 2020

HOUSE ARREST
The Sun, March 24, 2020

WHEN THE WORLD STOPS
Time, March 30, 2020

SALUTE OUR HEROES
Herald Sun, April 1, 2020

WORK FROM HOME NATION
Newsweek, April 10, 2020

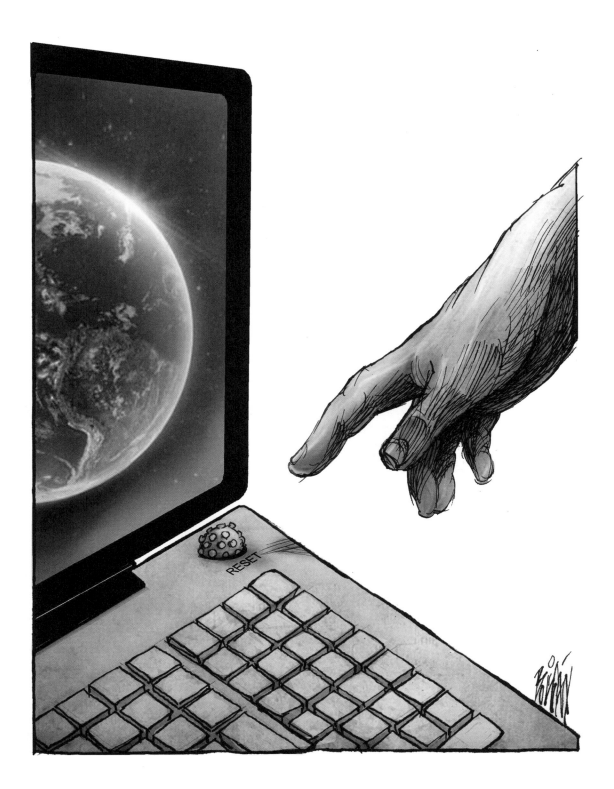

Angel Boligán . Reiniciar
Mexico

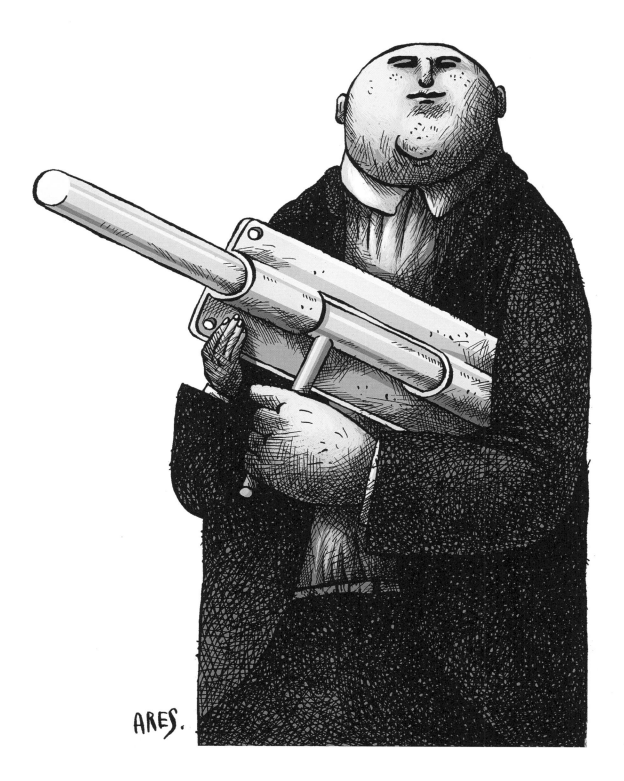

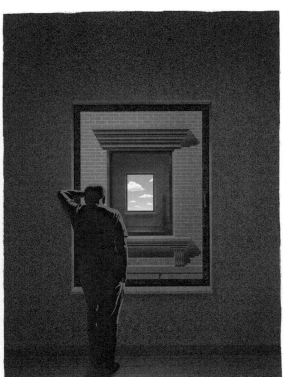

Mirko Ilic · B.C. 4 (2020)
USA

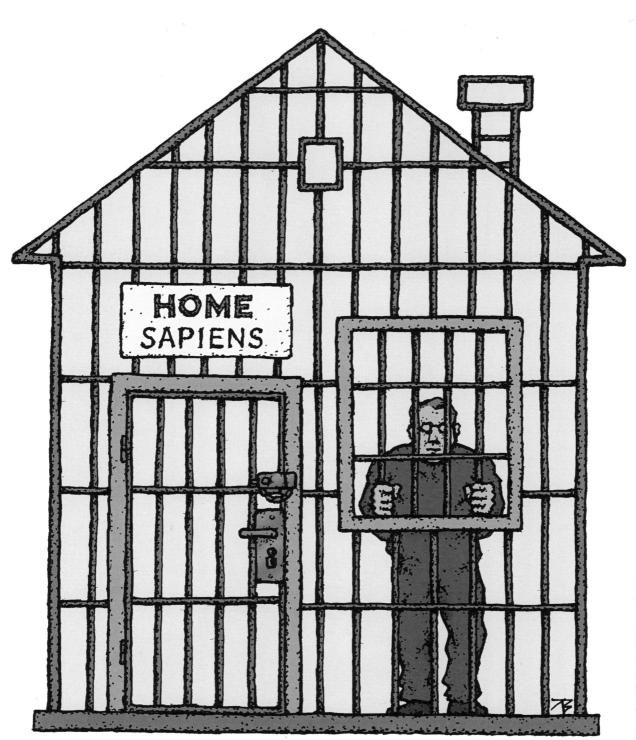

Jugoslav Vlahovic . Without Words
Serbia

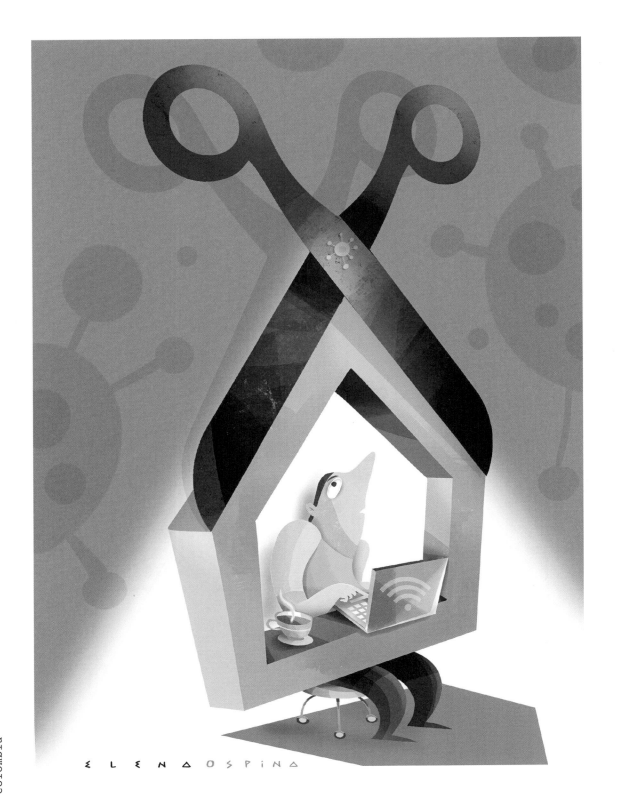

Elena Ospina . Freedom of expression in times of pandemic
Colombia

Honey?! The
world there
... is it
still good?

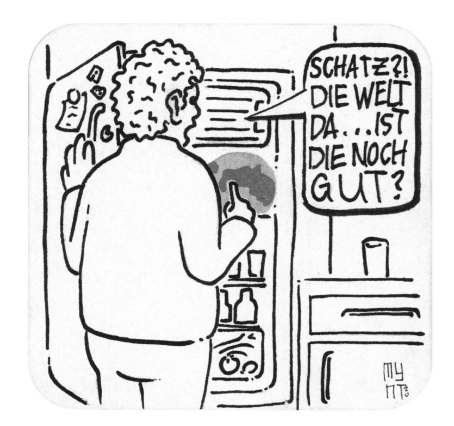

Mynt . Ist die Welt noch gut?
Switzerland

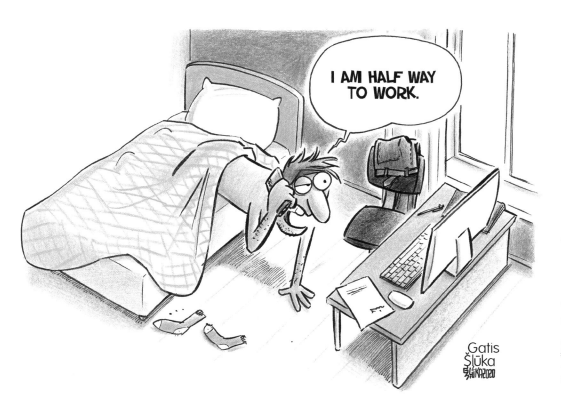

Gatis Šļūka . On the way to work
Latvia

42

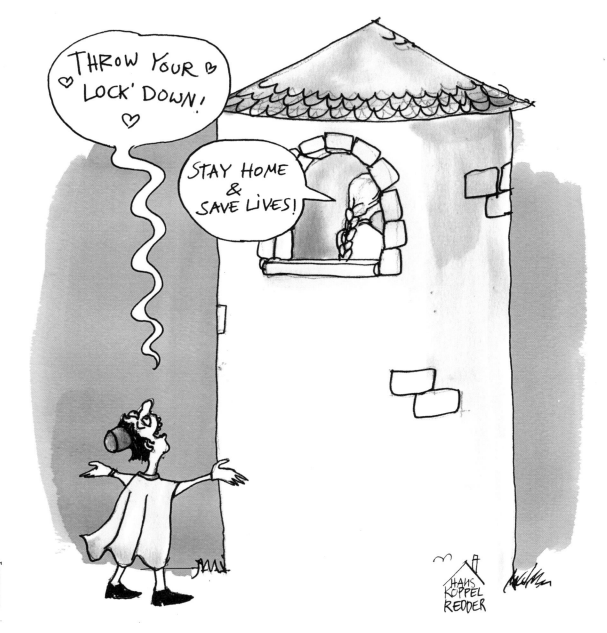

Hans Koppelredder . Rapunzel
Germany

If you leave me on my own in this crisis, don't bother ever showing your face here again!!

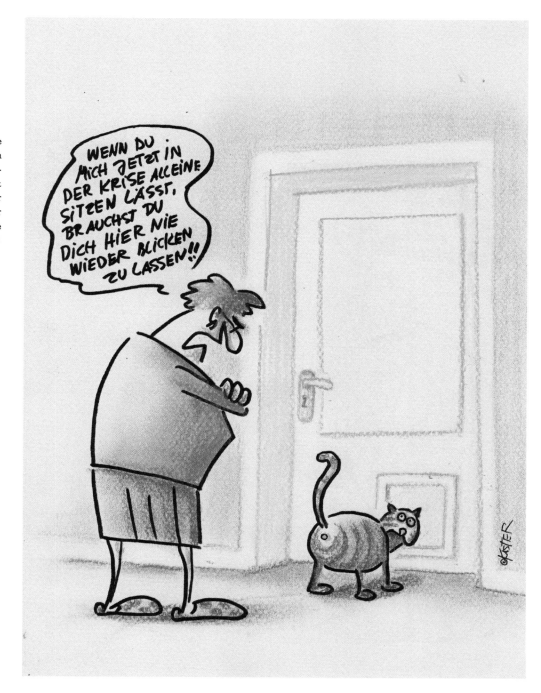

43

Petra Kaster . Ultimatum
Germany

44

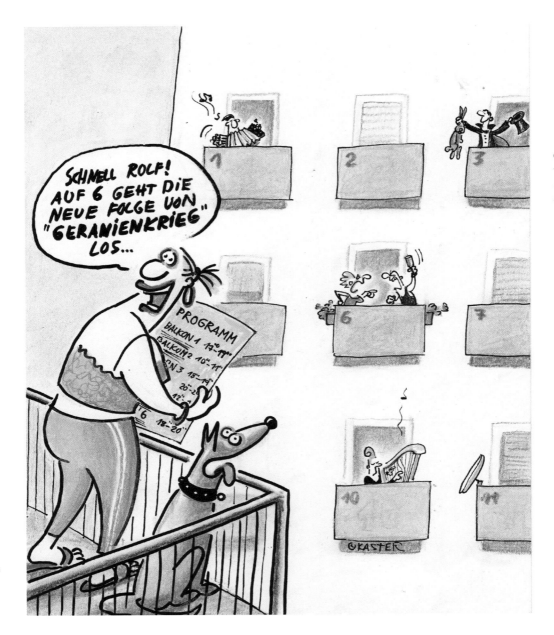

Petra Kaster . Corona Kulturprogramm
Germany

Quick, Rolf, the new episode of "Geranium Wars" is about to start on 6 …

I take it
you're still
wearing
it because
you've simply
got nothing
to say

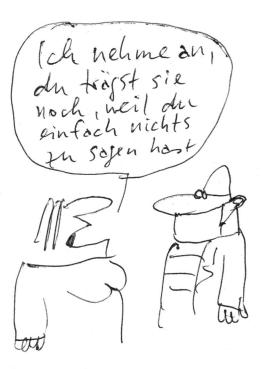

Tex Rubinowitz
Austria

Come quickly
— they're
not talking
about the
coronavirus!

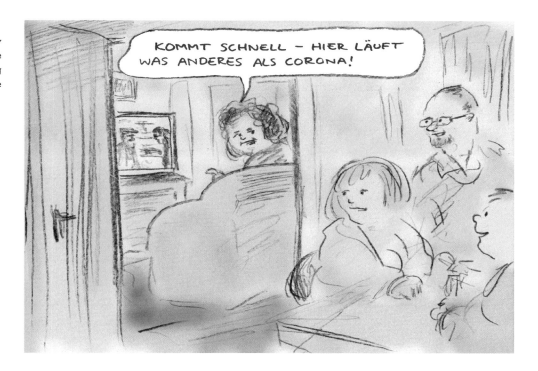

Bernd Zeller . Sondersendung
Germany

#MÉMORIAL DE CAEN

HÉROS JUIN 1944

MEMORIAL
OF CAEN

Heroes
June 1944

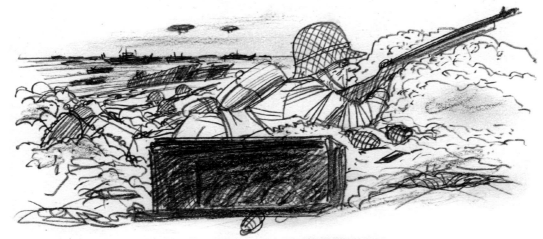

HÉROS AVRIL 2020

Heroes
April 2020

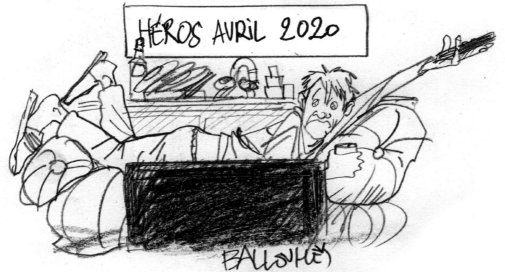

Pierre Ballouhey
France

What? Am I scared? Who the hell is this Corinna anyway?

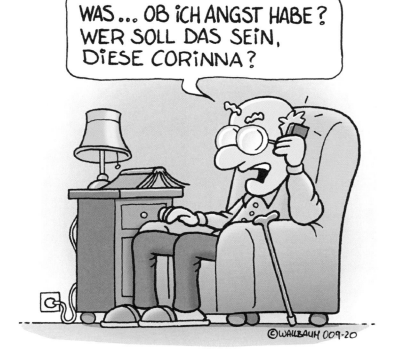

WAS... OB ICH ANGST HABE? WER SOLL DAS SEIN, DIESE CORINNA?

©WALLBAUM 009-20

WILMAAA!!!

Fred! Anyone who goes out does not come back in! Respect the quarantine rules!

¡¡¡VILMAAA!!!

PEDRO, EL QUE SALE YA NO ENTRA, ¡RESPETA LA CUARENTENA!

47

Oliver Wallbaum . Coronoa-Risiko-Senior
Germany

Karry Carrión . Picapiedras Cuarentena (Karrycaturas Covid)
Peru

It's quite a political paradigm shift: You used to be able to recognise stupid people because they were the ones who were scared.

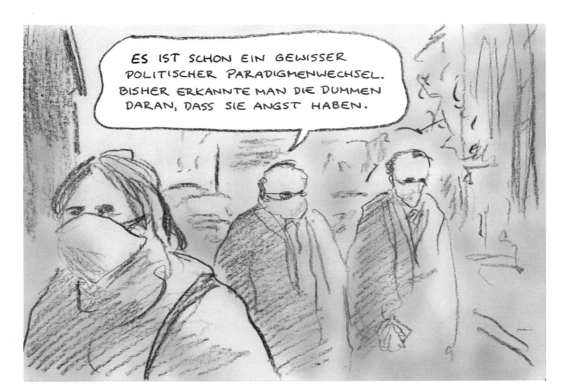

Bernd Zeller . Angstverbreitung
Germany

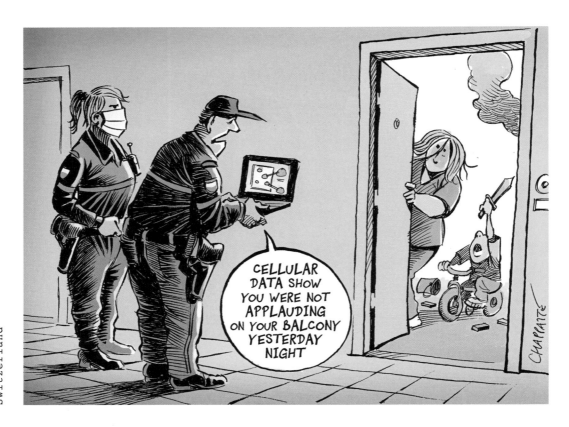

Chappatte . Social control in the time of coronavirus
(first published in NZZ am Sonntag, Zürich)
Switzerland

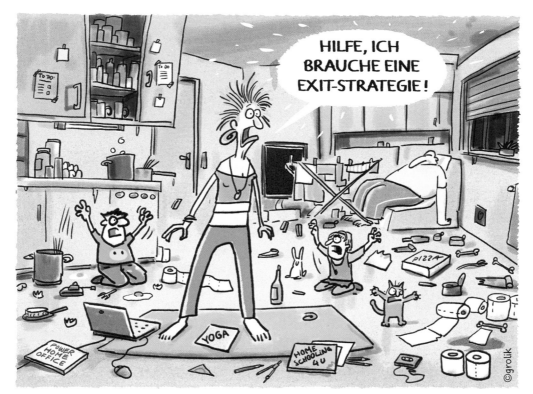

Zé Dassilva . Resolutions for 2020
Brazil

Help, I need an exit strategy!

Escape room Germany

Markus Grolik . Escaperoom
Germany

Peter C. Vey . Eric's calling from camp again
USA

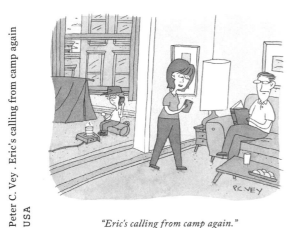

"Eric's calling from camp again."

Victoria Roberts . Trust me, Margherite – I'm an architect.
USA

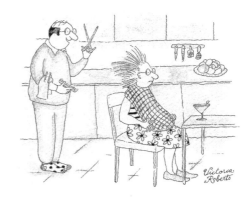

"Trust me, Margherite—I'm an architect."

Debuhme . Vers un déconfinement progressif
Switzerland

VERS UN DÉCONFINEMENT PROGRESSIF ?

Move towards
progressive
relaxation of
confinement?

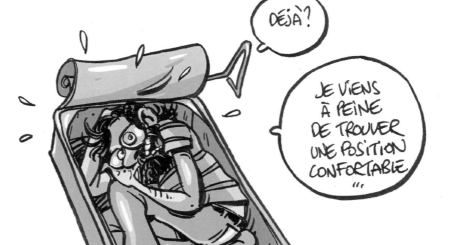

Already?

I've only
just got
comfortable …

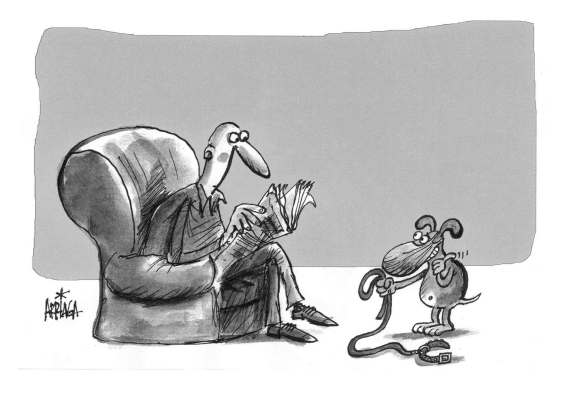

51

Manuel Arriaga . Go
Spain

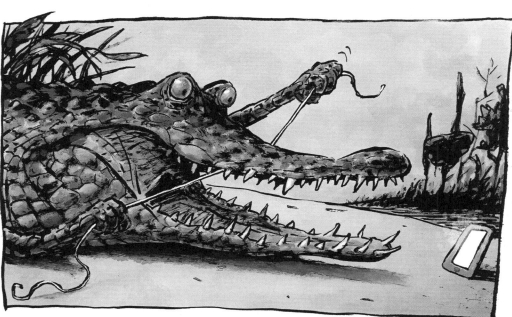

HOME
OFFICE

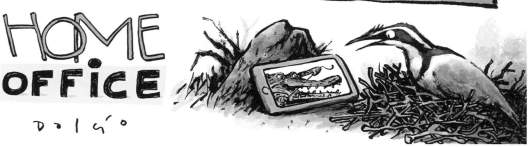

Dalcio Machado . Home office
Brazil

52

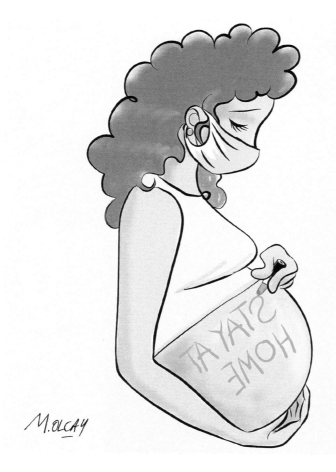

Muammer Olcay . Stay At Home!
Turkey

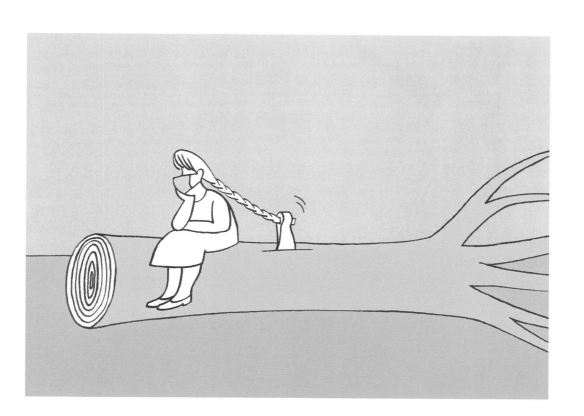

Marie Ploténá . Are you free ?
Czech Republic

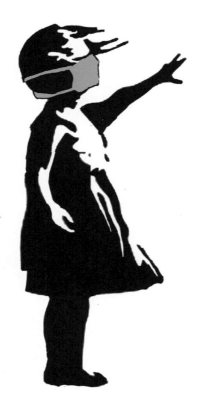

Luc Descheemaeker . Banksy Girl
Belgium

O·SEKOER

Christian Stellner . Quarantäne auf Schloss Windsor
Austria

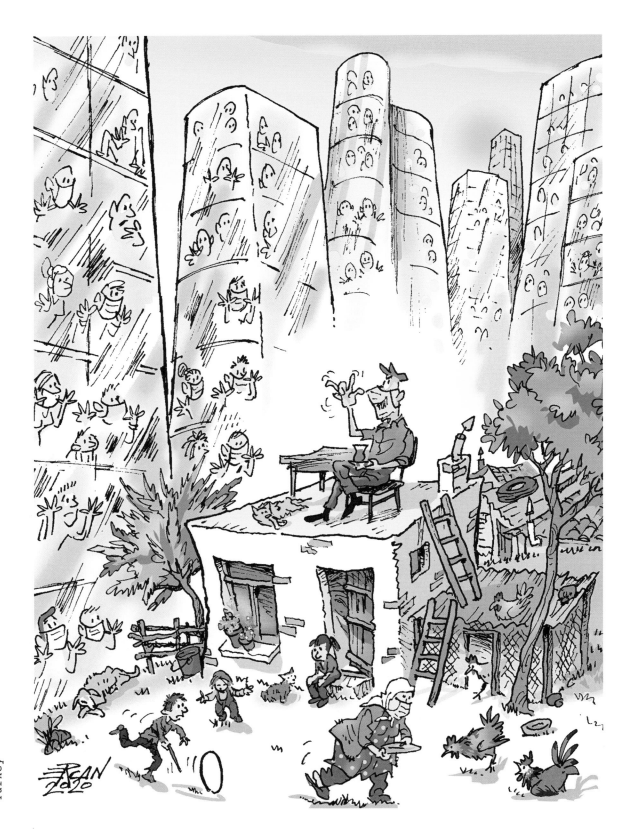

Ercan Akyol
Turkey

Is it really so hard to understand? You're supposed to keep your distance!

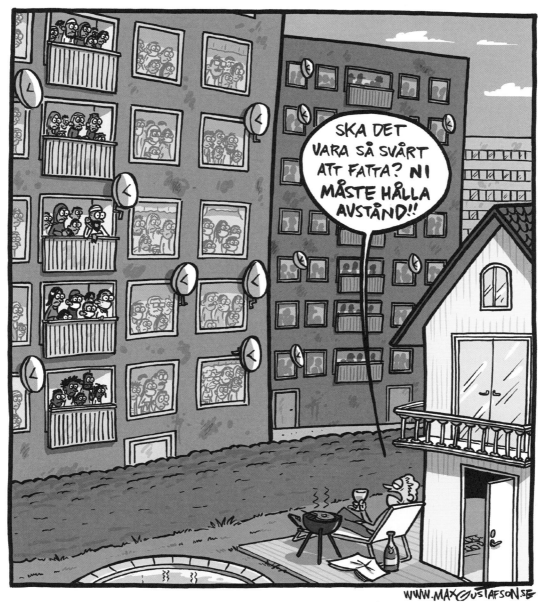

Max Gustafson . Smittsam ojämlikhet (Contagious inequality)
Sweden

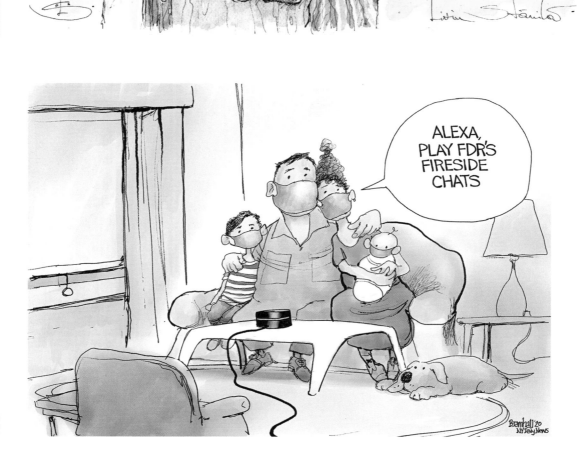

Liviu Stanil . Working from Home
Romania

Bill Bramhall . Cartoon - Covid-19 FDR's Fireside Chats
USA

CURRENT SELFIE

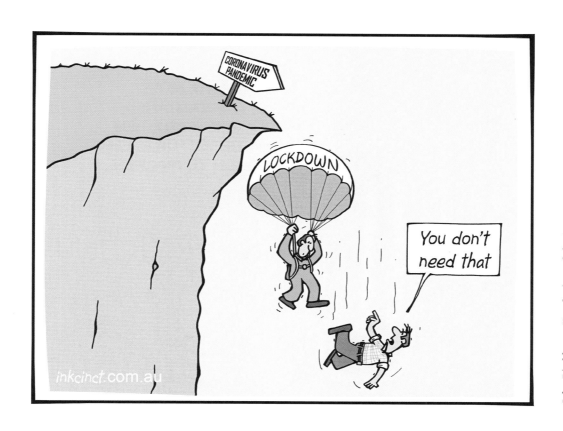

59

Bonil. Current Selfie
Ecuador

John Ditchburn. You don't need that!
Australia

Carlos Amato. Pandemic Pub (first published by NewFrame.com)
South Africa

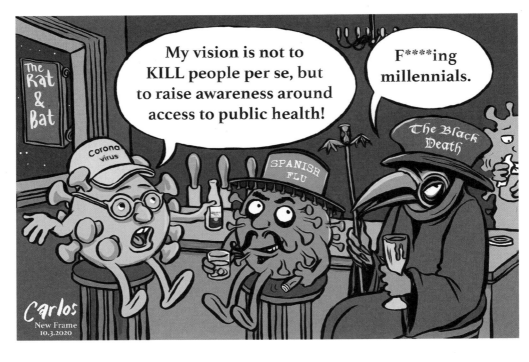

Markus Grolik. Fleischindustrie
Germany

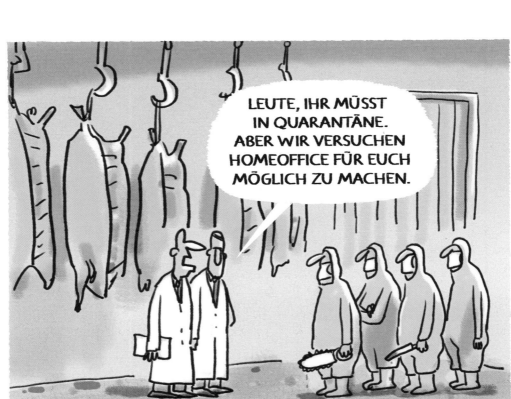

FLEISCHINDUSTRIE

Guys, you have to be quarantined. But we'll try to figure out working from home for you.

Meat industry

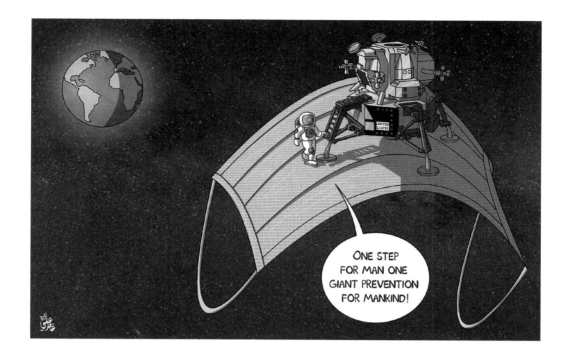

Ghamir Ali . One step for mankind
Morocco

61

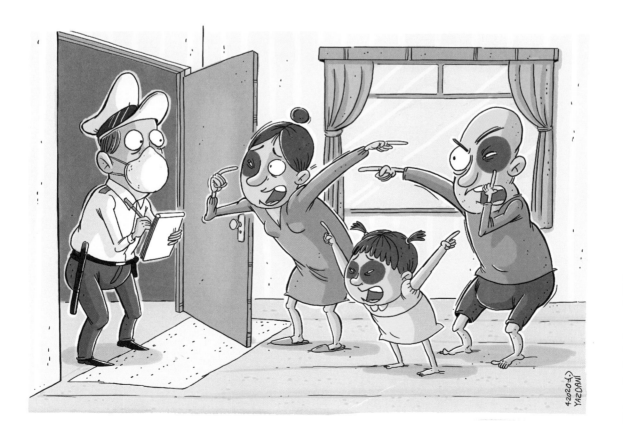

Mahnaz Yazdani . Domestic Violence
Iran

Hicabi Demirci . Corona and Freedom
Turkey

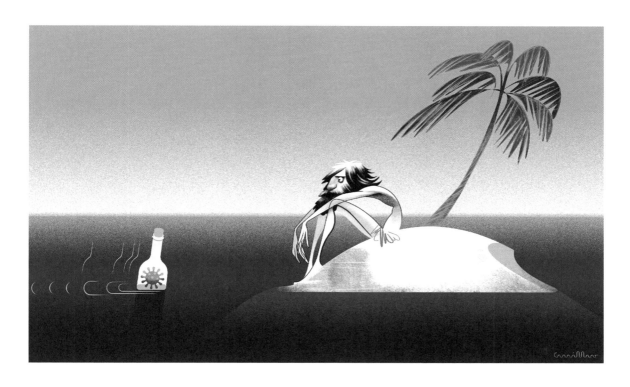

André Carrilho . Message in a bottle
Portugal

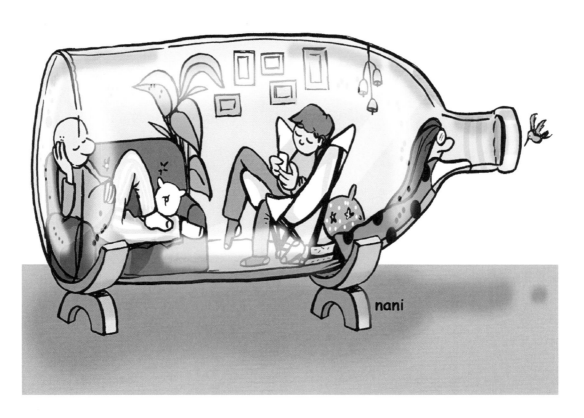

Nani Mosquera . Stay at home
Colombia

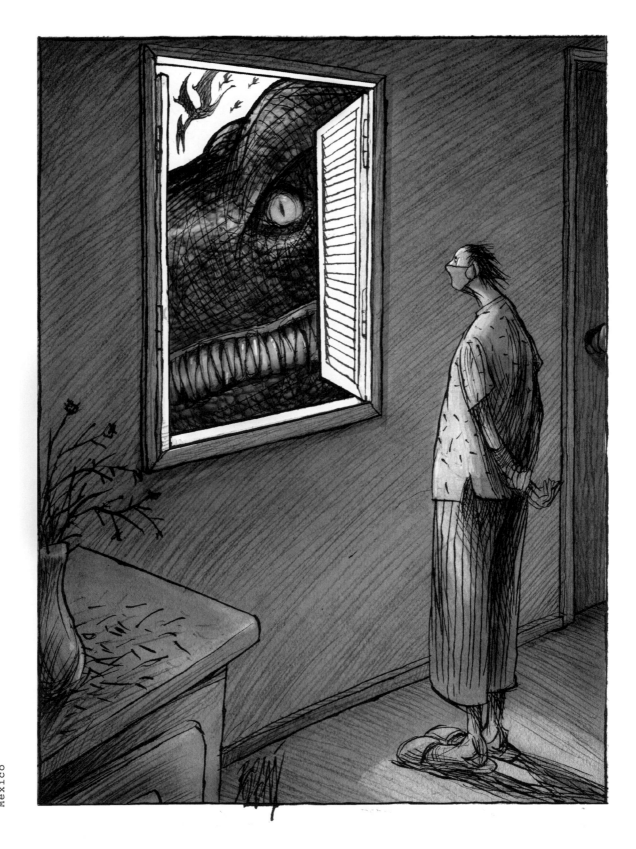

Angel Boligán . The Return of the Fauna
Mexico

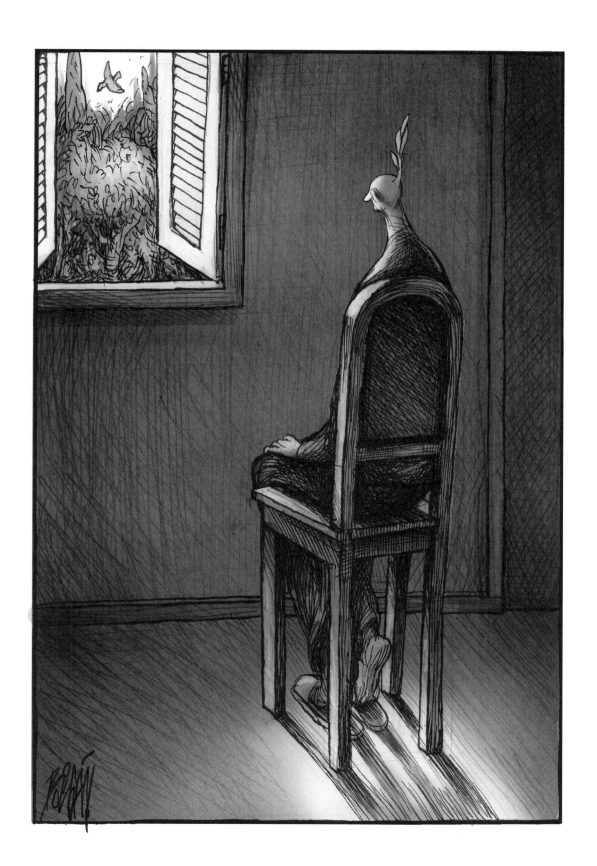

Angel Boligán . Reflexion de Temporadacopia
Mexico

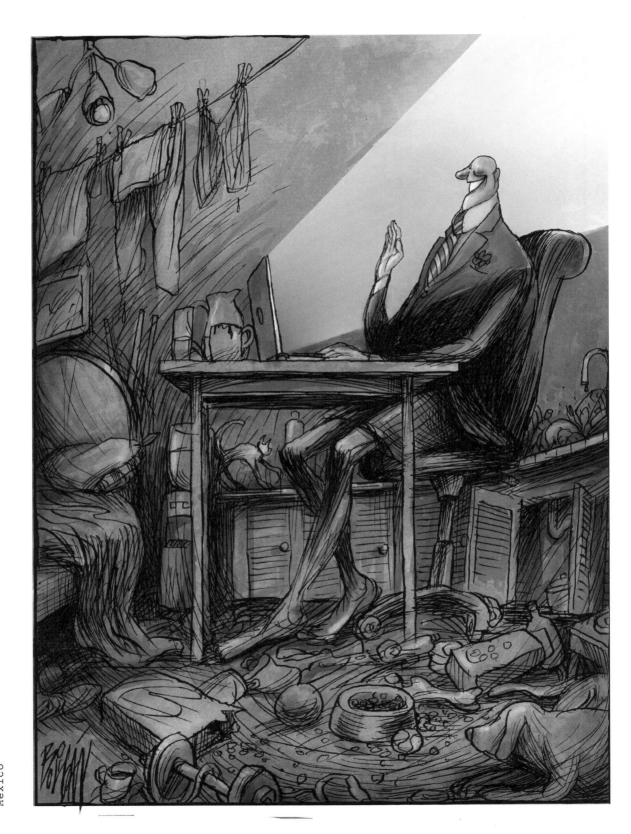

Angel Boligán . Home Office 2020
Mexico

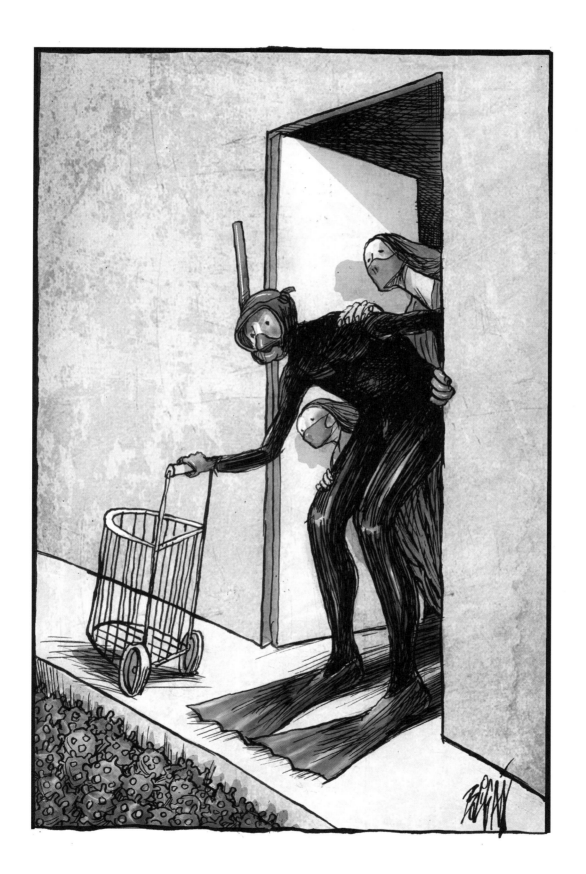

Angel Boligán . Al Mandado
Mexico

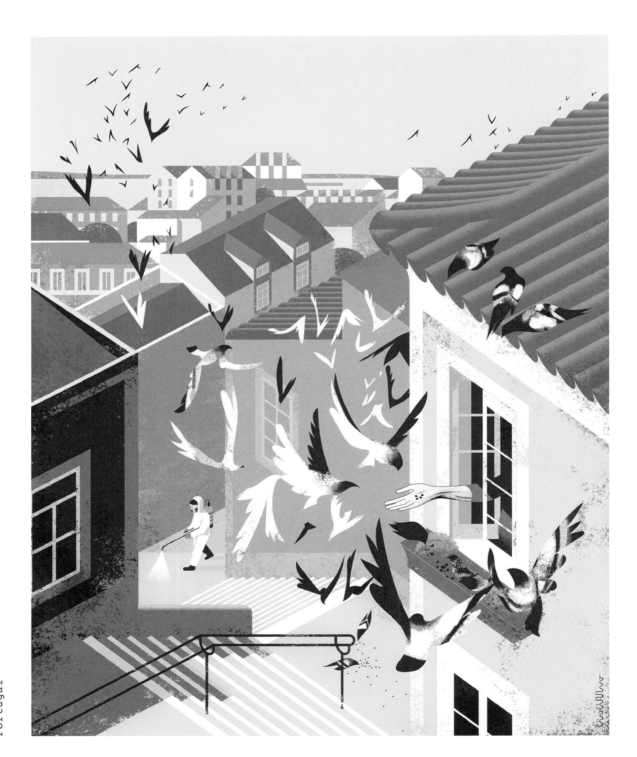

André Carrilho . Confinement
Portugal

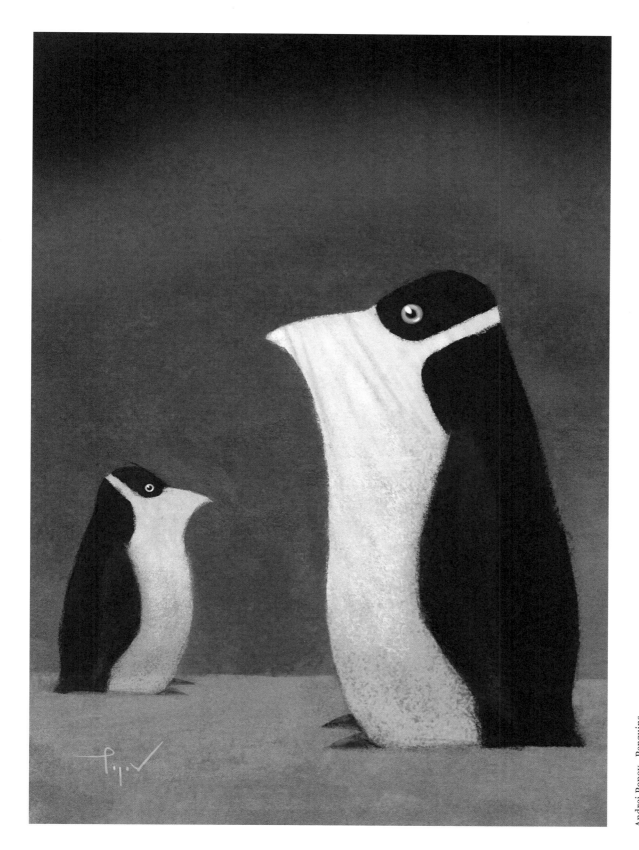

Andrei Popov . Penguins
Russia

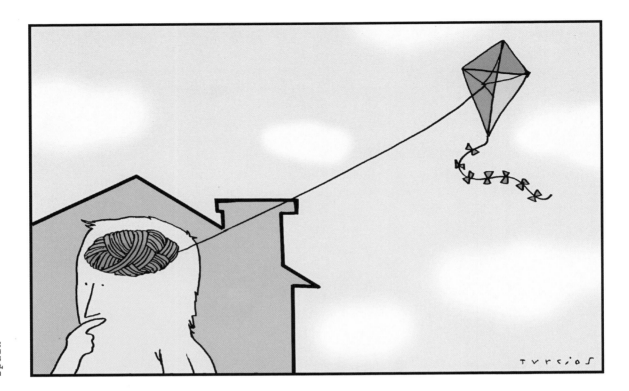

Turcios
Spain

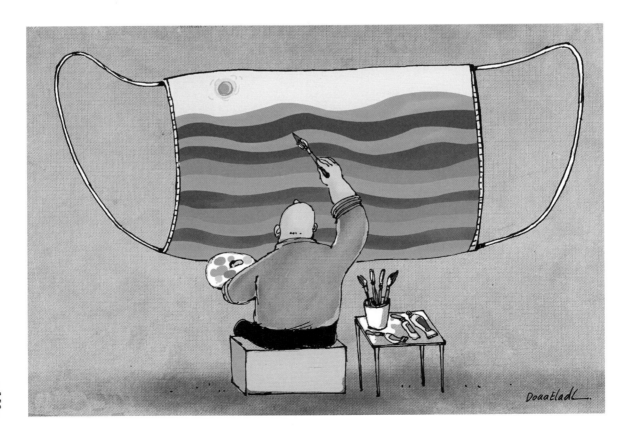

Doaa Eladl . Hope
Egypt

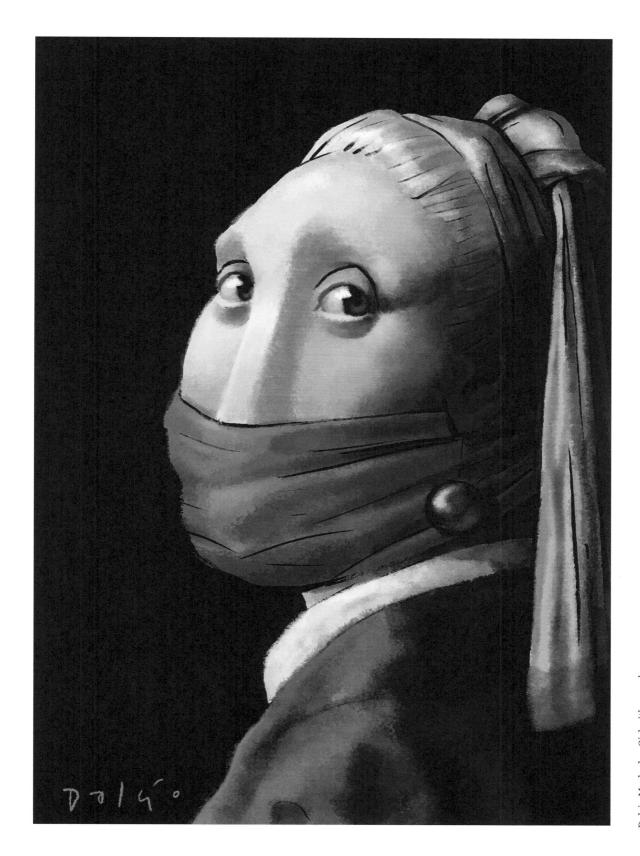

Dalcio Machado . Girl with a mask
Brazil

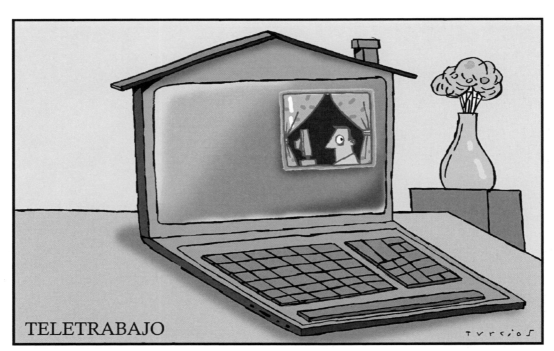

TELETRABAJO

Teleworking

Turcios
Spain

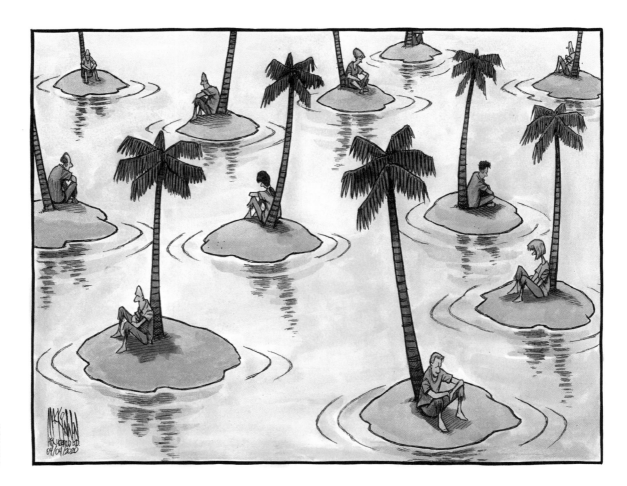

Bruce MacKinnon
Canada

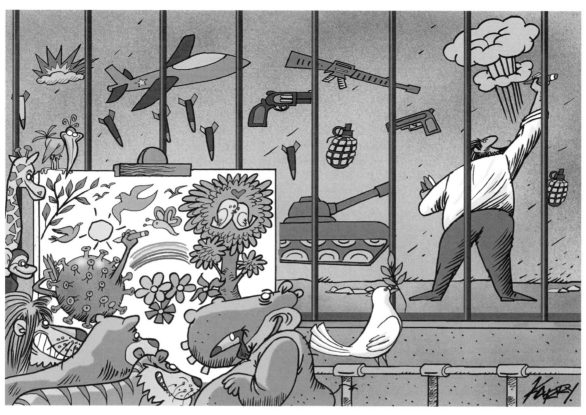

Karry Carrión . Humano Enjaulado (Karrycaturas Covid)
Peru

Karry Carrión . Limpieza Planeta (Karrycaturas Covid)
Peru

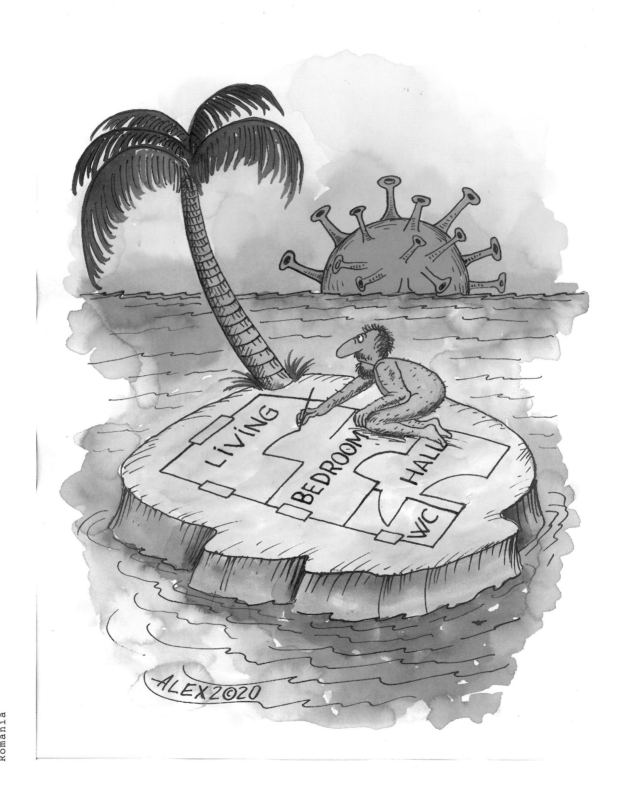

Aurel Stefan Alexandrescu . Island
Romania

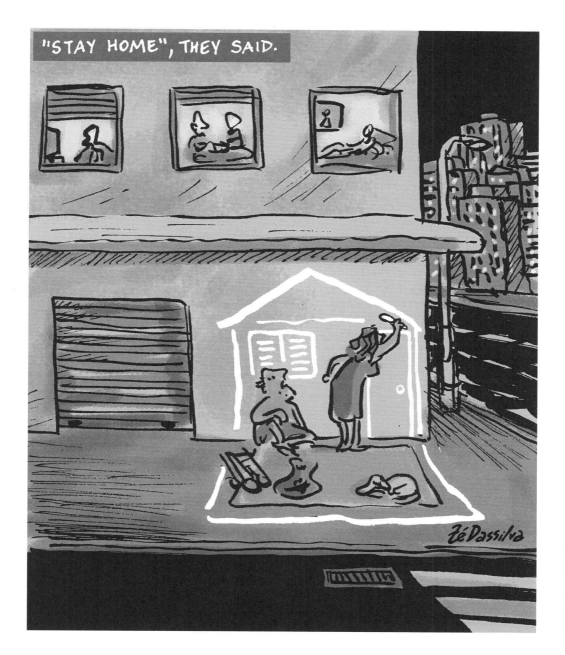

Zé Dassilva . Stay home
Brazil

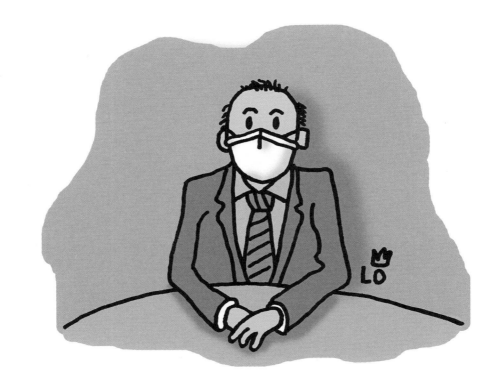

Tentin Quarantino

Lo Graf von Blickensdorf . In Quarantäne
Germany

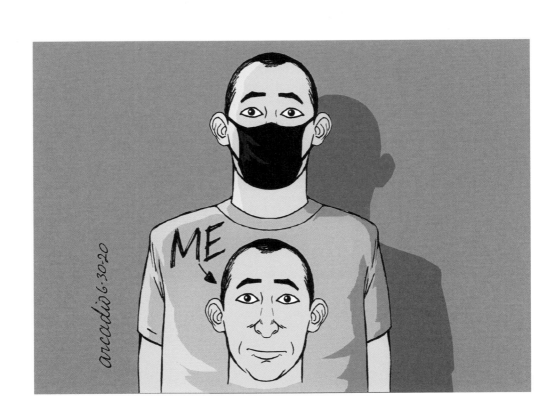

Arcadio Esquivel . That is me
Costa Rica

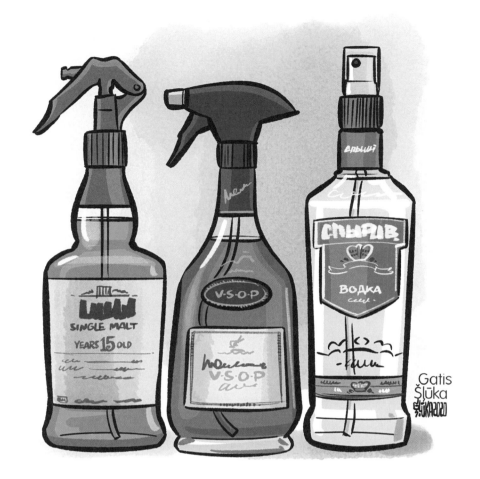

Gatis Šļūka · Hand sanitizers
Latvia

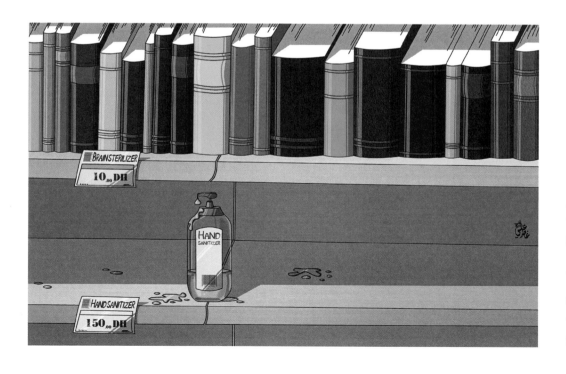

Ghamir Ali · Brain sterilizer before the hand sterilizer
Morocco

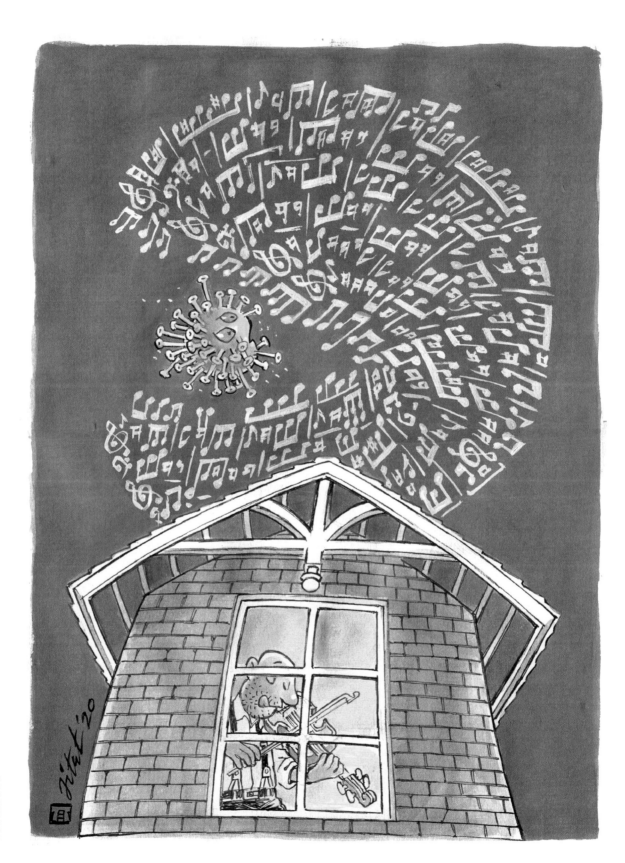

Jitet Kustana . Corona Music
Indonesia

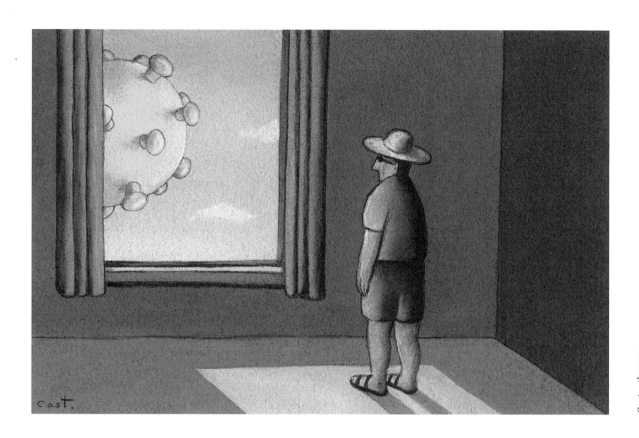

Cost . . the sun
Belgium

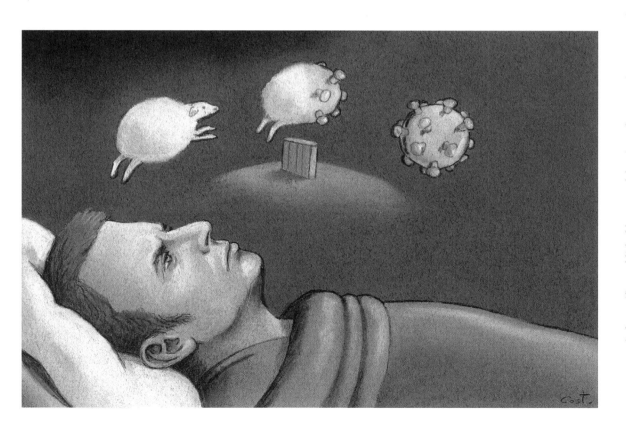

Cost . . Macron's dream (first published by Journal du Dimanche, France)
Belgium

Berat Pekmezci . Missing Summer
United Kingdom

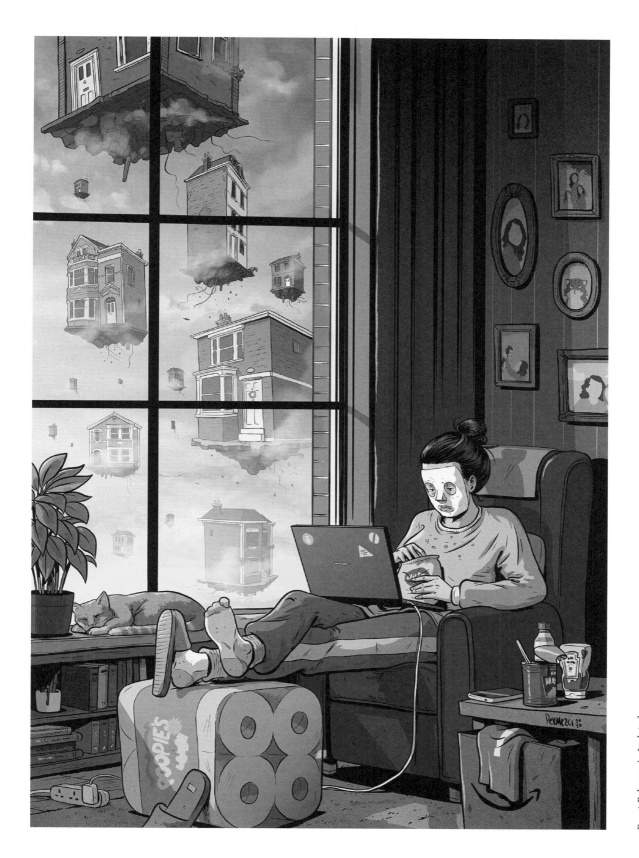

Berat Pekmezci . Isolated
United Kingdom

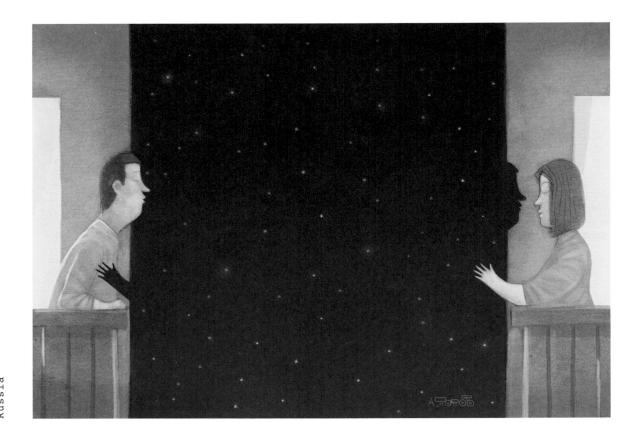

Andrei Popov . Love at a distance
Russia

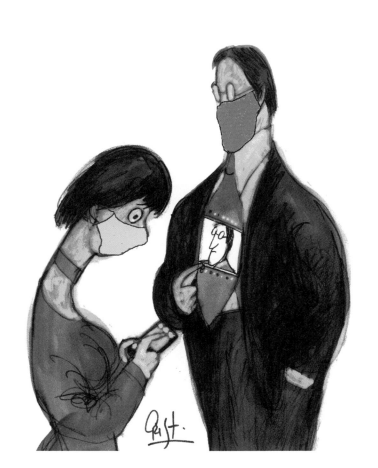

Cristobal Reinoso . This is me
Argentina

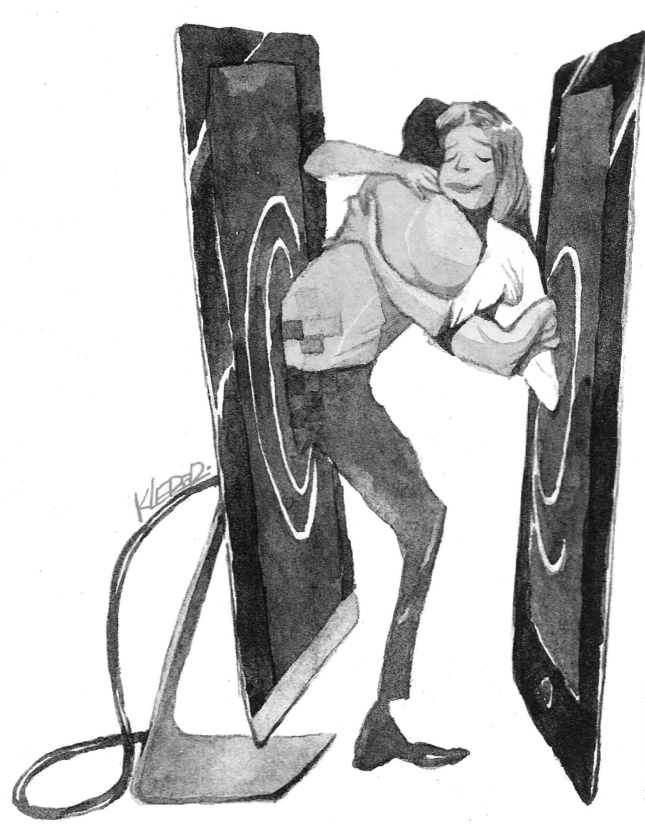

Kleber . o Amor na pandemia
Brazil

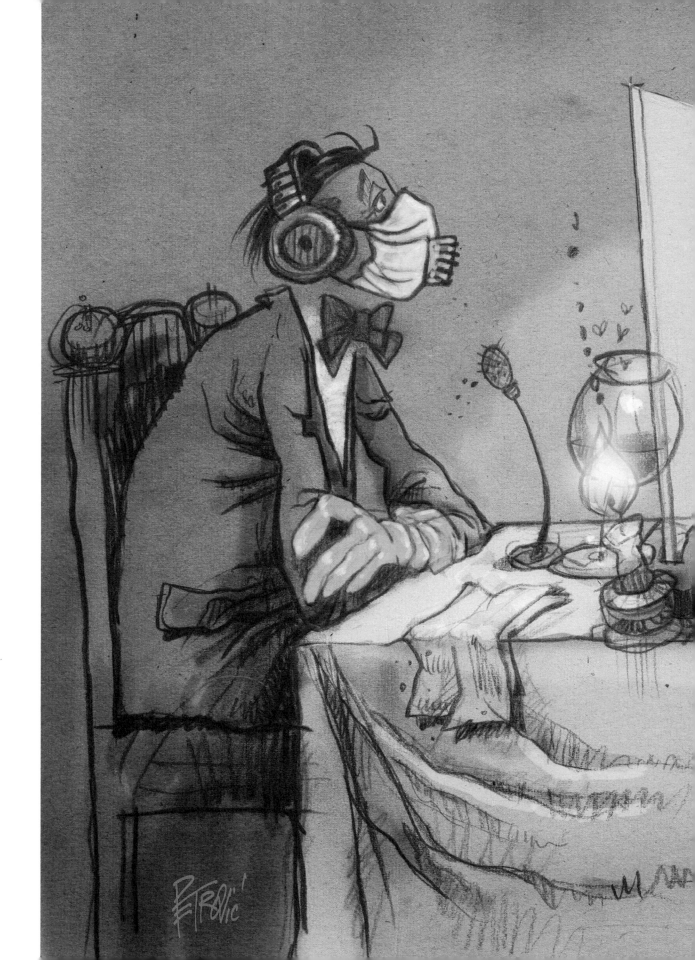

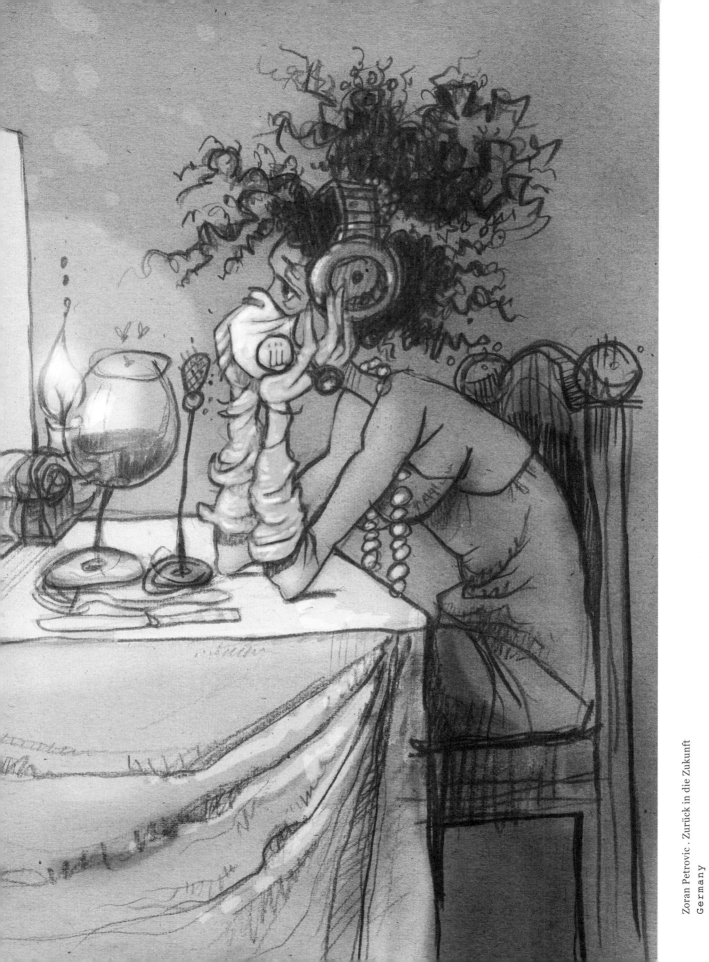

Zoran Petrovic . Zurück in die Zukunft
Germany

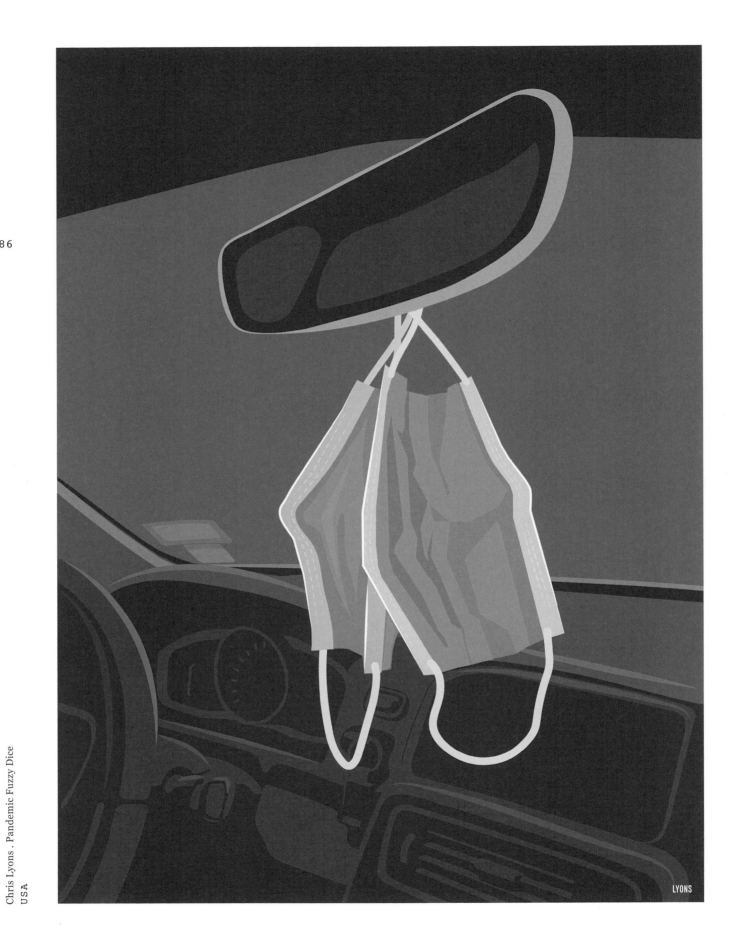

Chris Lyons . Pandemic Fuzzy Dice
USA

LYONS

THE MASK DRAMA
Metro, March 17, 2020

BLEAK NEW WORLD
Der Tagesspiegel, April 17, 2020

EVERYTHING'S GONNA BE ALRIGHT
F*CK OFF COVID 19
GQ Portugal, April Special Edition, 2020

HURRAH! LOCKDOWN FREEDOM BECKONS
Daily Mail, May 7, 2020

RETURN TO ABNORMALITY
Liberation, May 11, 2020

DON'T GO TO THE SEA, THE VIRUS MUTATES!
Informer, May 16, 2020

SECOND WAVE LOOMS
The Sidney Morning Herald, July 8, 2020

WE'LL SHOP IN MASKS TILL NEXT YEAR
Daily Mirror, July 15, 2020

CORONA THE SECOND WAVE
Profil, August 2, 2020

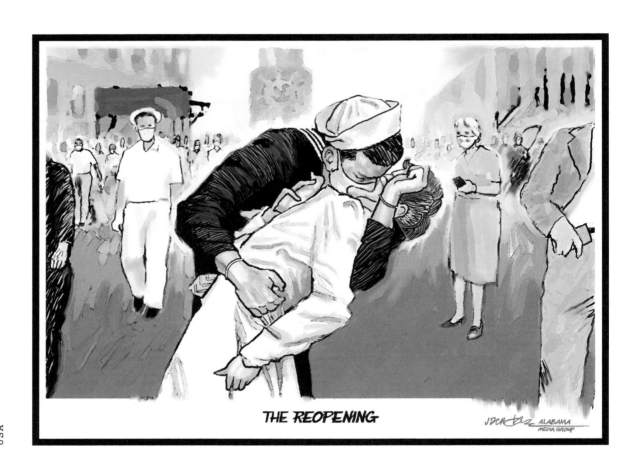

THE REOPENING

J.D. Crowe . The Reopening
USA

KAMA SUTRA

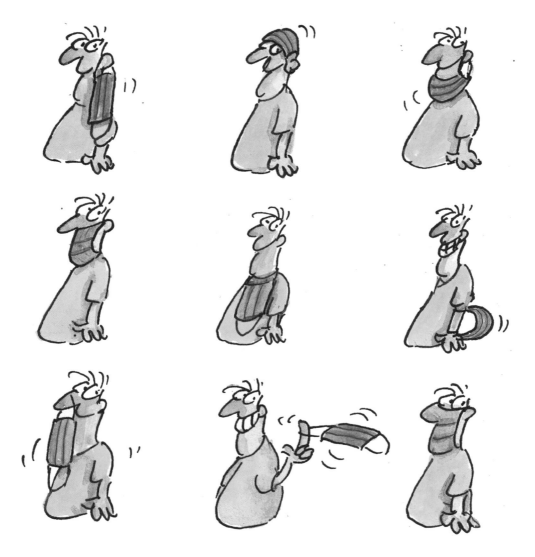

C. PATRASCAN

CORONA LÄSST MÄRCHENHOCHZEIT PLATZEN!!

Fairy-tale wedding off due to coronavirus!!

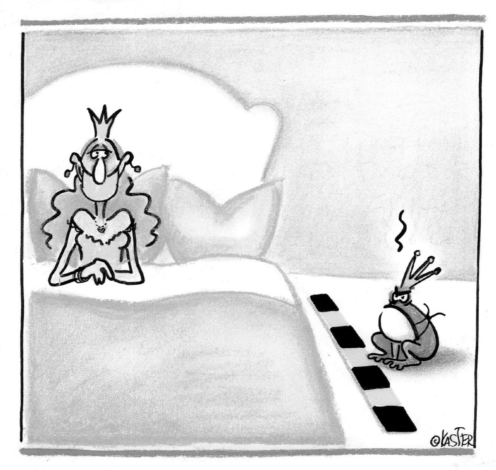

Petra Kaster . Coronahochzeit
Germany

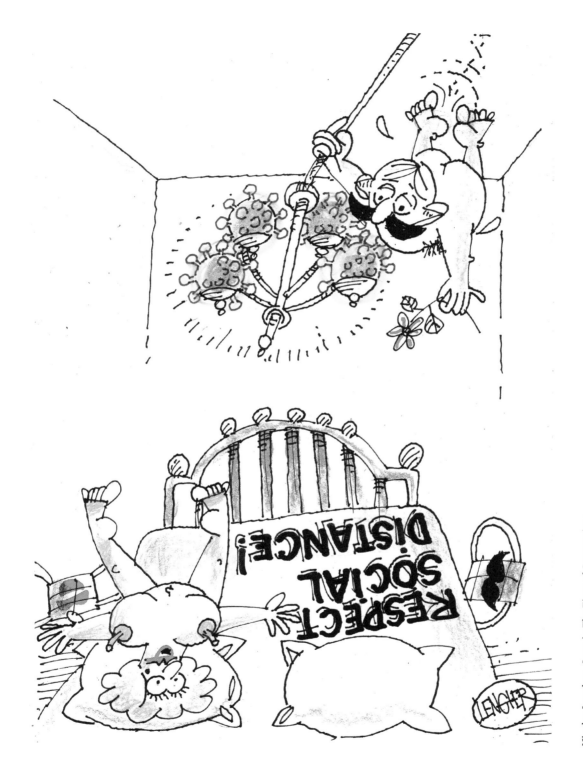

Nicolae Lengher . Love in The Time of Coronavirus
Romania

Tchavdar Nikolov . Boris and Charles
Bulgaria

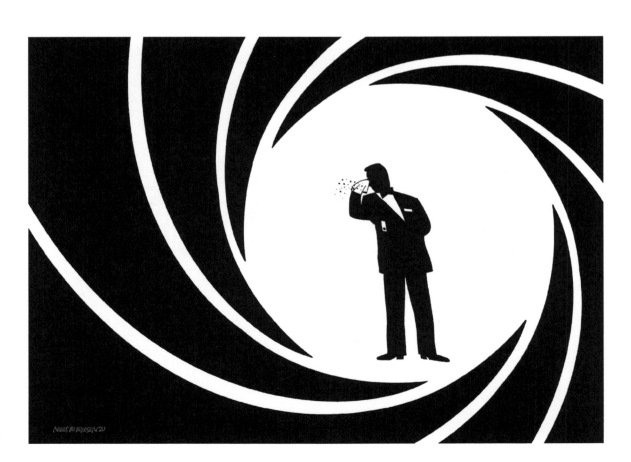

Niels Bo Bojesen . No Time To Die.
Denmark

No! You
haven't
changed!

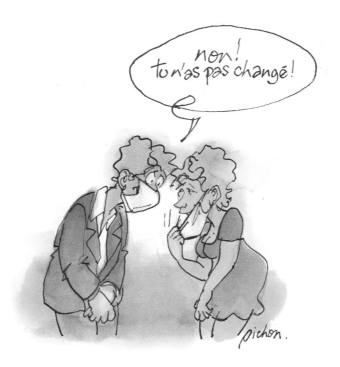

Pichon . . non! tu n'as pas changé!
France

93

I protect
myself, but
I also want
to look
pretty …
There's no
reason to
let your-
self go!

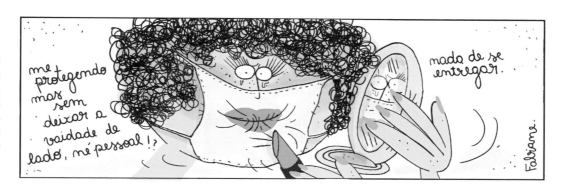

Fabiane Langona . Anti-viral Vanity
Brazil

PATRIARCHAL PANDEMIC

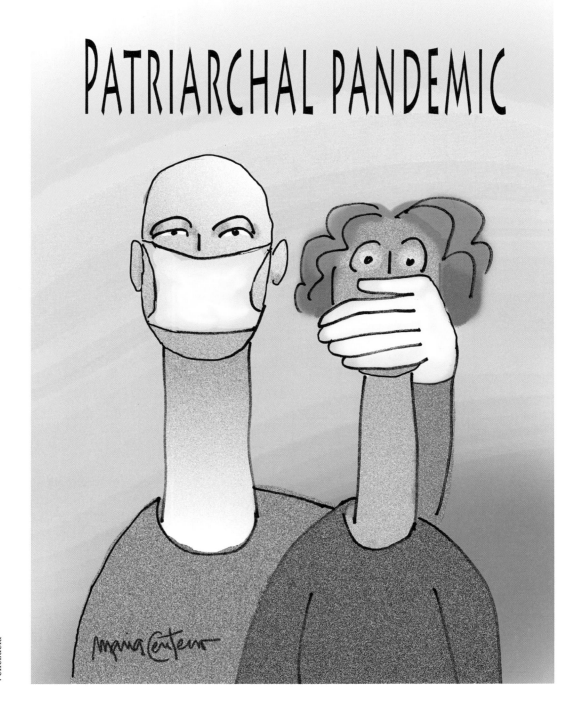

Maria Centeno . Patriarchal Pandemic
Venezuela

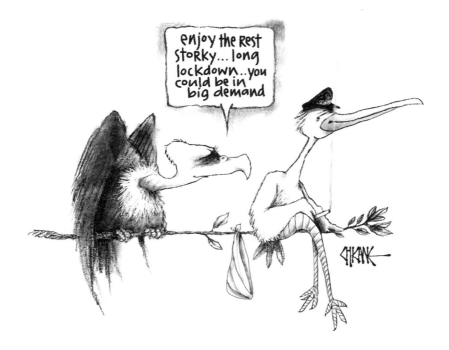

Chicane . Covid conception
United Kingdom

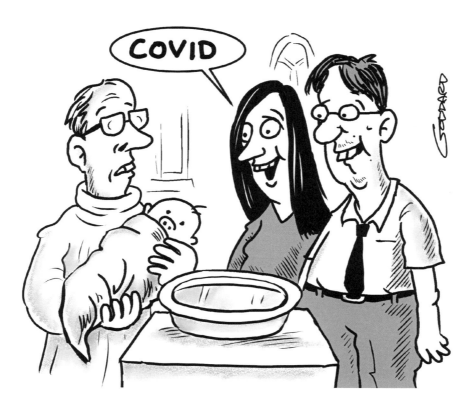

Clive Goddard . Covid Christening
United Kingdom

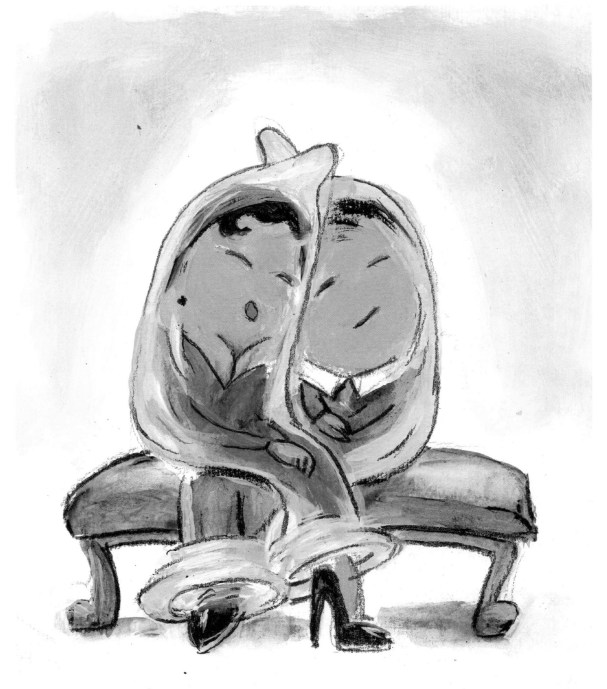

María Verónica Ramírez . Happy End

Argentina

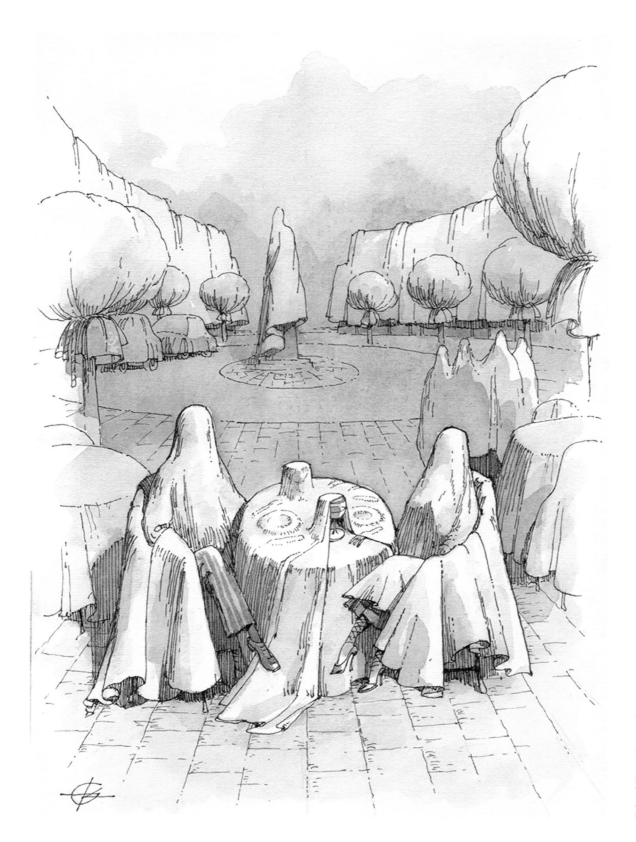

Grigori Katz. Coronavirus
Israel

98

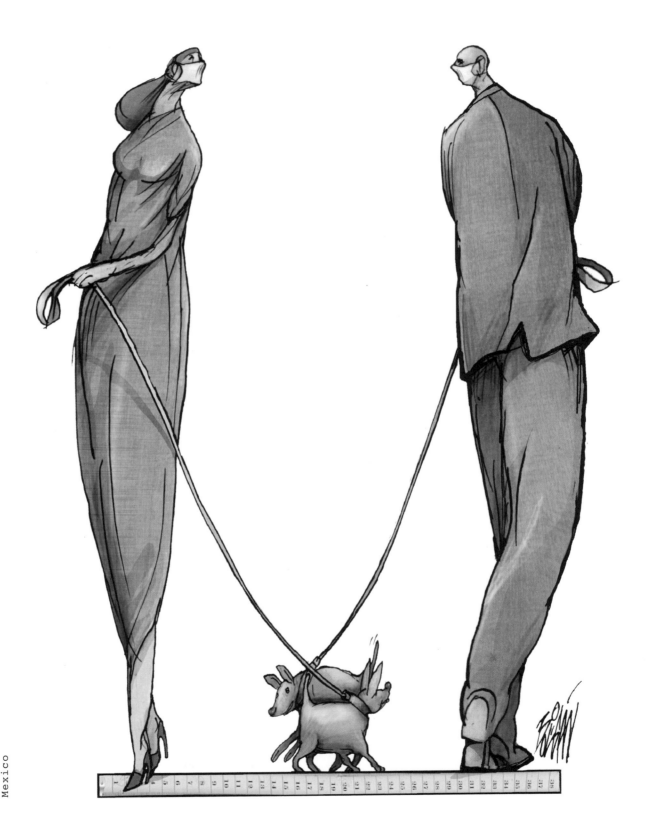

Angel Boligán . Sena Distancia
Mexico

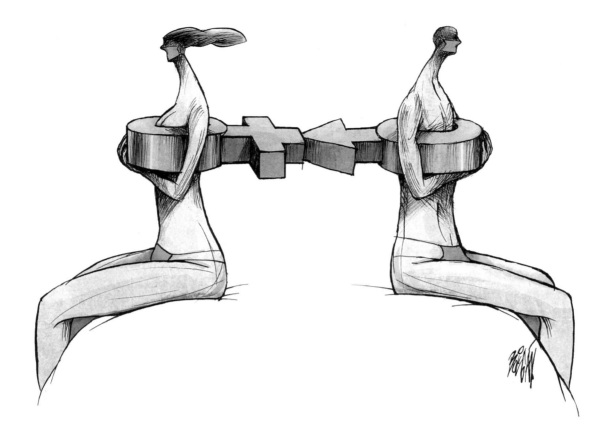

Angel Boligán . Sexo en Confinamiento
Mexico

And who
are you?

Your
distance
chaperone.

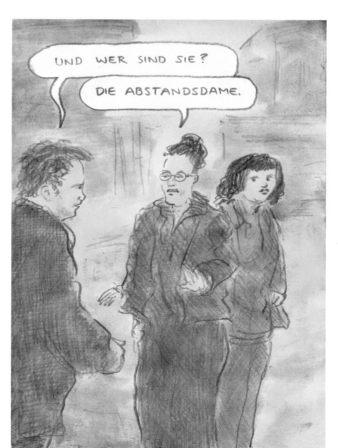

Bernd Zeller . Sittenwacht
Germany

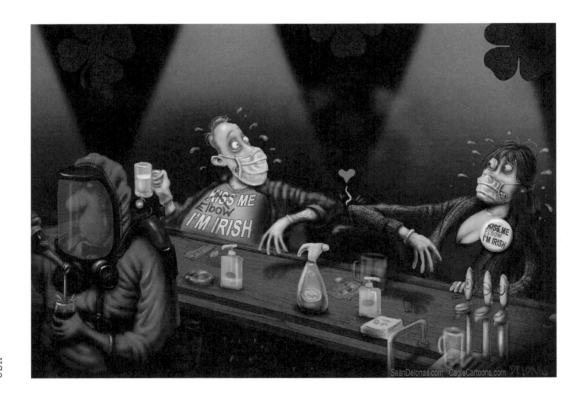

Sean Delonas . Coronavirus Elbow Bump
USA

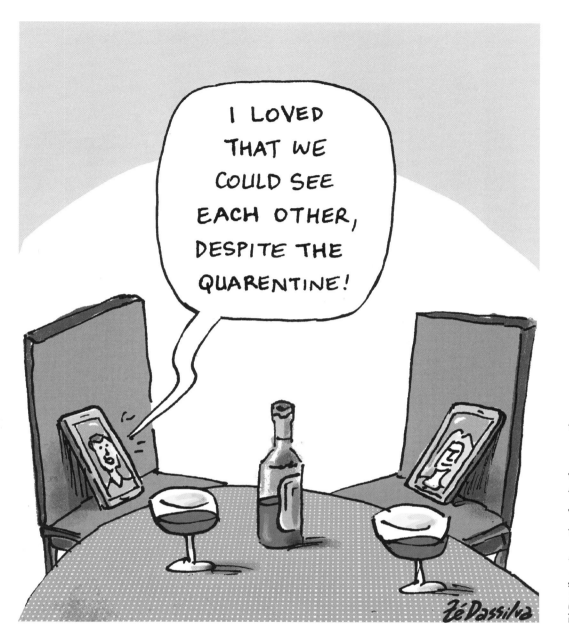

Zé Dassilva . A meeting despite the quarantine
Brazil

André Dahmer
Brazil

102

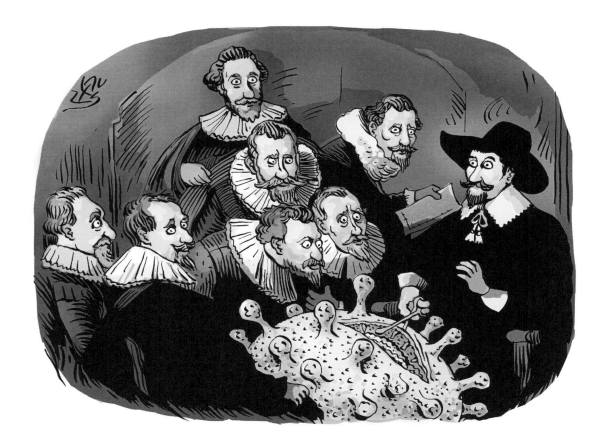

Alen Lauzán . Covid Anatomy Lesson
Chile

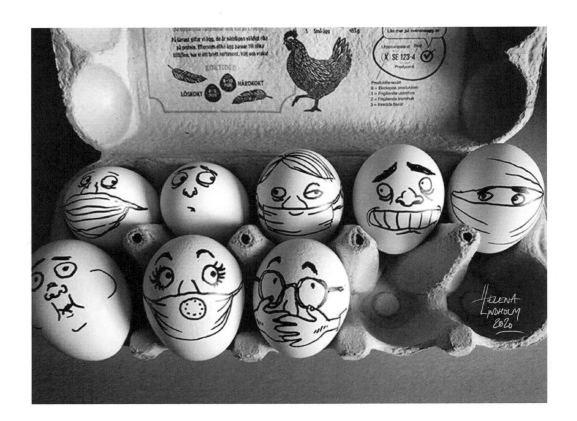

Helena Lindholm . Try Not To Hatch
Sweden

Yayo . Colors of Hope
Canada

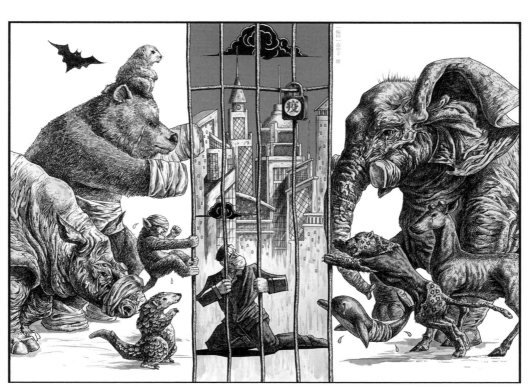

《Reincarnation》 Gaozhongli China 2020

Gao Zhongli . Reincarnation
China

104

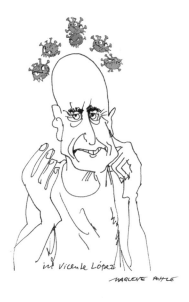

in Vicente López

MARLENE POHLE

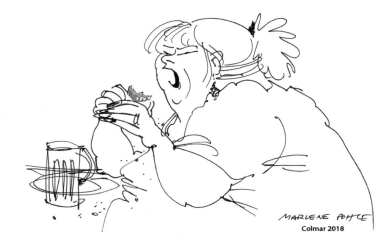

MARLENE POHLE
Colmar 2018

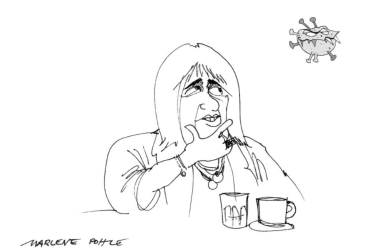

MARLENE POHLE

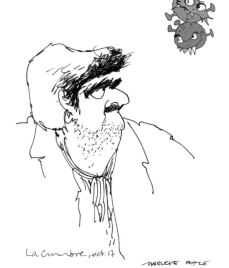

La Cumbre, oct. 17

MARLENE POHLE

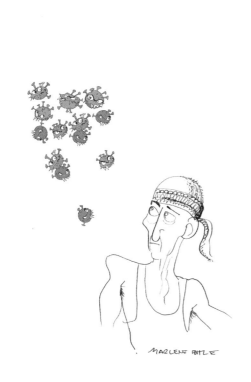

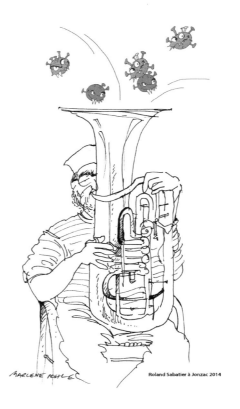

Roland Sabatier à Jonzac 2014

MARLENE POHLE

MARLENE POHLE

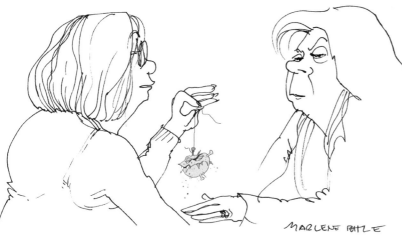

MARLENE POHLE

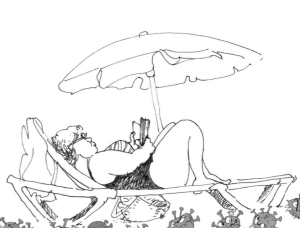

Portinatx, Ibiza

MARLENE POHLE

Marlene Pohle . Vicente López . Colmar . Rosario . La Cumbre . Bar Anita. Ibiza . Jonzac . Rosario . Ibiza
Argentina

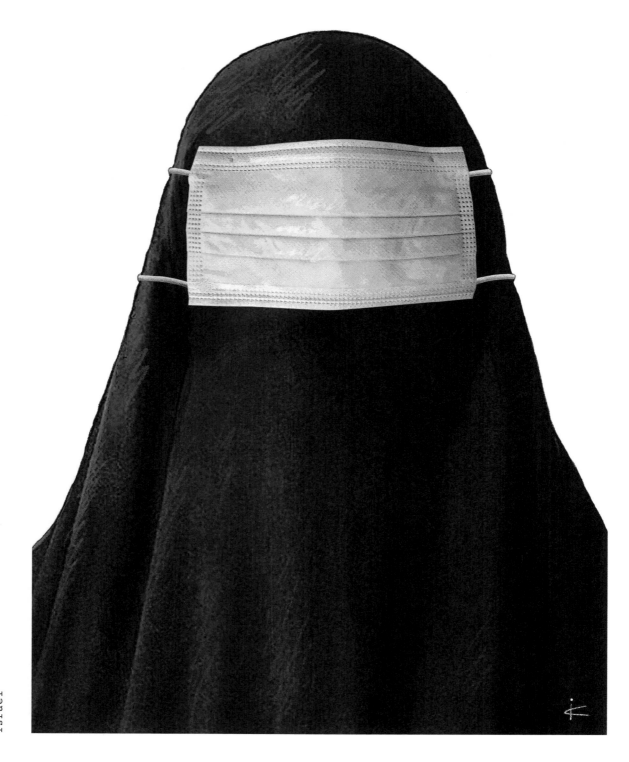

Ilya Katz. Coronavirus Pandemic
Israel

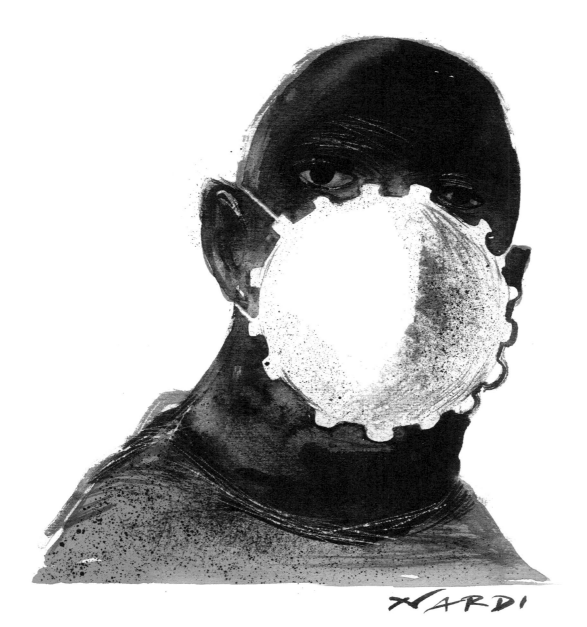

NARDI

Marilena Nardi . May Day
Italy

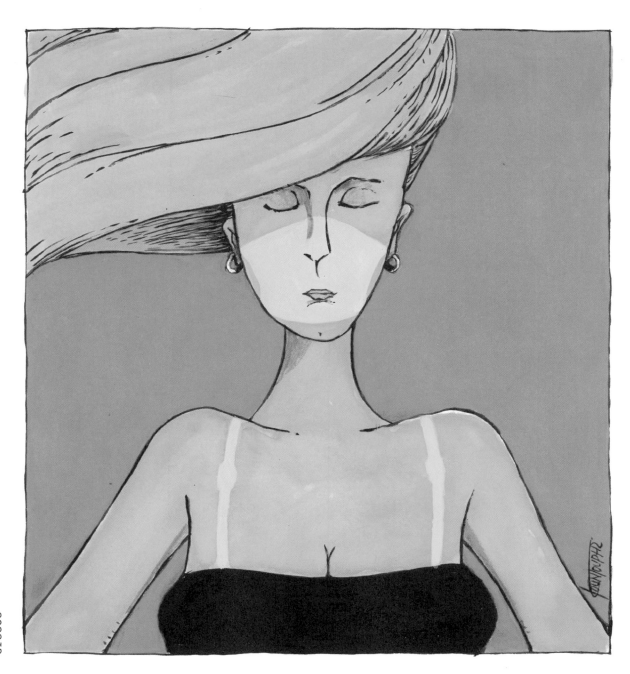

Michael Kountouris . Summer in Coronavirus Era

Greece

Say what you like, the masks make us much more individual.

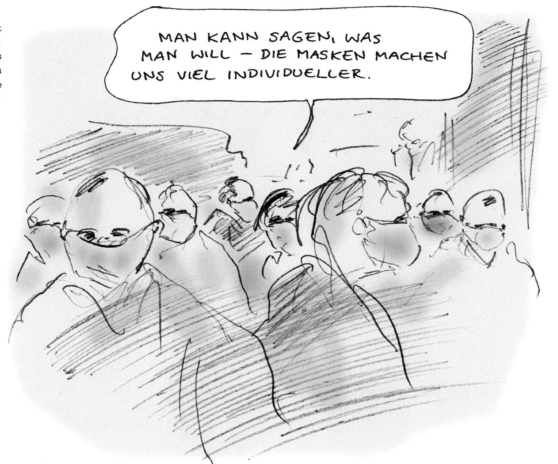

Bernd Zeller . Bunter
Germany

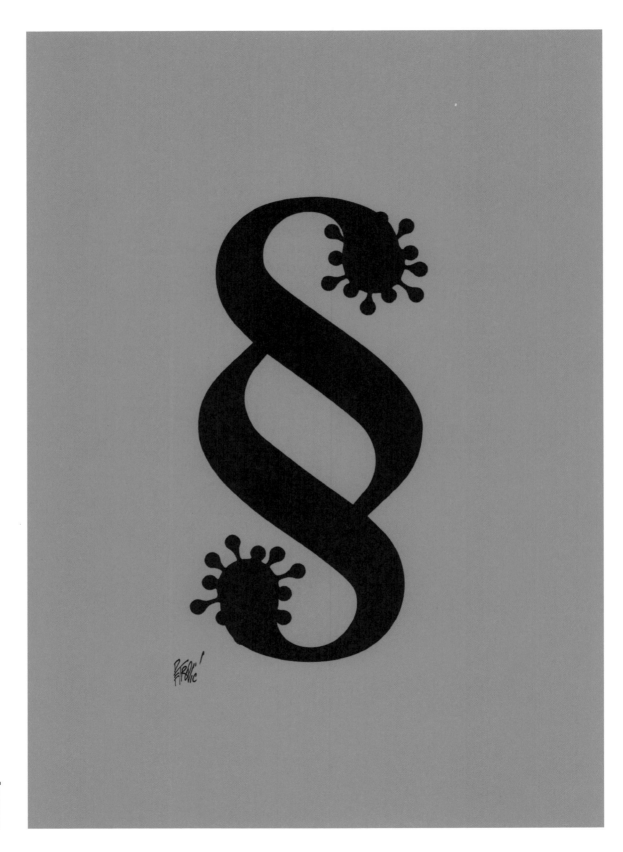

Zoran Petrovic
Germany

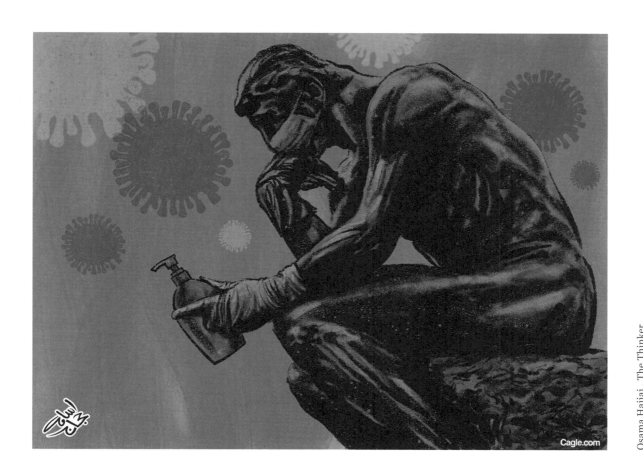

Osama Hajjaj . The Thinker

Jordan

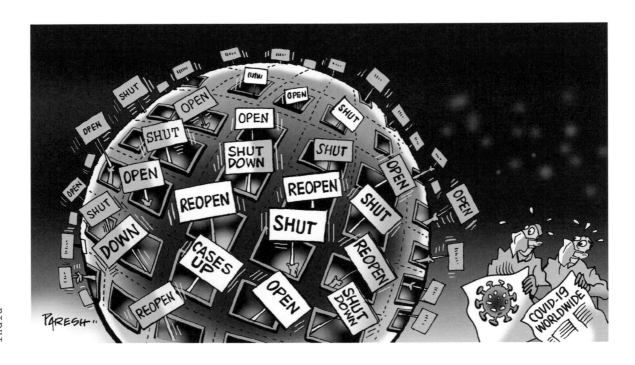

Paresh Nath . Covid-19 worldwide
India

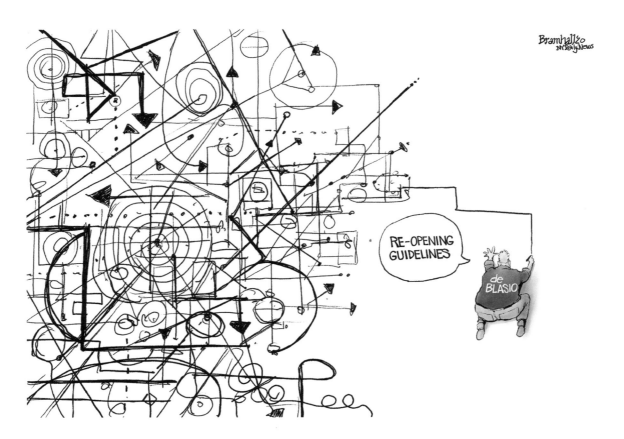

Bill Bramhall . Cartoon - Covid-19 de Blasio Re-Opening Guidelines
USA

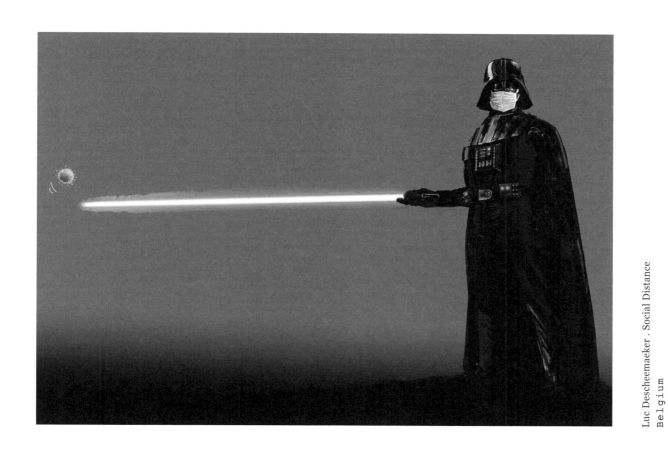

Luc Descheemaeker . Social Distance
Belgium

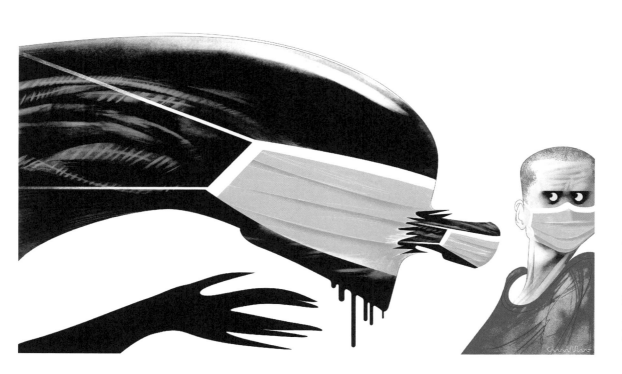

André Carrilho . Avoid Close Contact
Portugal

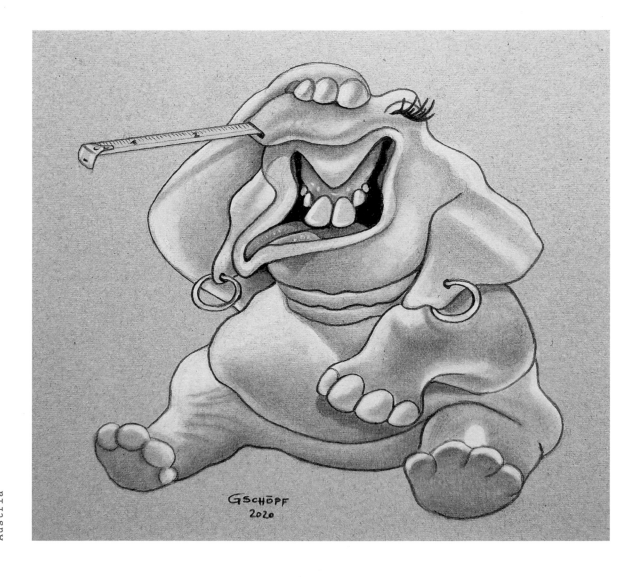

Christian Gschöpf . Der Baby-Elefant und sein Abstand
Austria

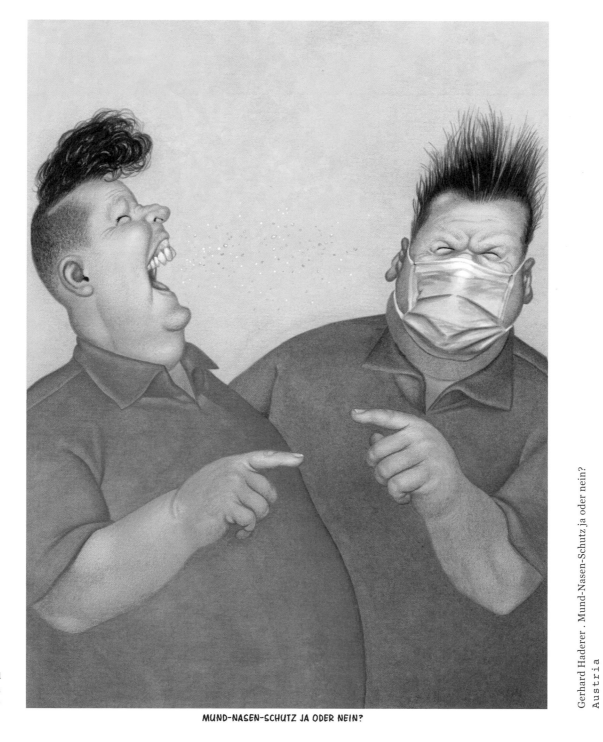

MUND-NASEN-SCHUTZ JA ODER NEIN?

Do we need
masks, yes
or no?

Gerhard Haderer . Mund-Nasen-Schutz ja oder nein?
Austria

Gerhard Haderer
Austria

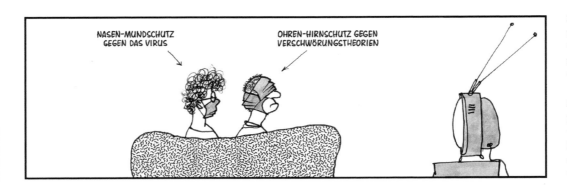

Mask for
protecting
the nose and
mouth from
the virus

Mask for
protecting
the ears and
brain from
conspiracy
theories

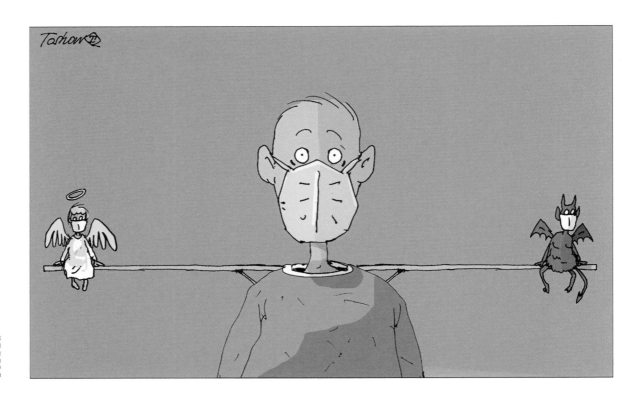

Toso Borkovic . Social Distance
Serbia

No, I'm not worried that my parents will catch anything.

They're great at social distancing. In fact, the only thing they've ever caught is me.

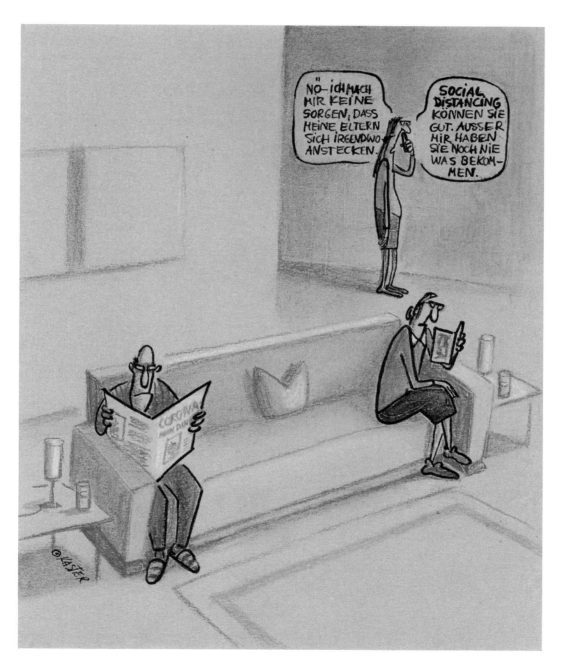

117

Petra Kaster . Social Distancing
Germany

Is it possible to douse Twitter with disinfectant?

Tex Rubinowitz
Austria

Dave Whamond . The Coronavirus Lockdown Diet
Canada

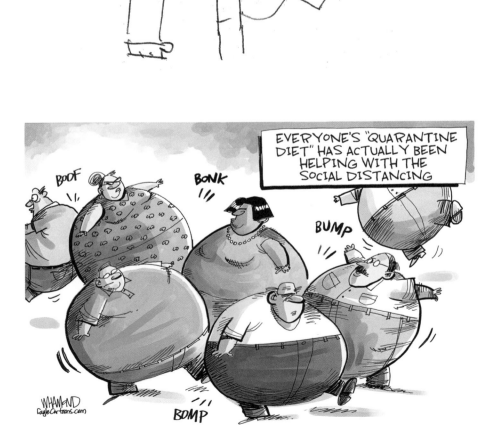

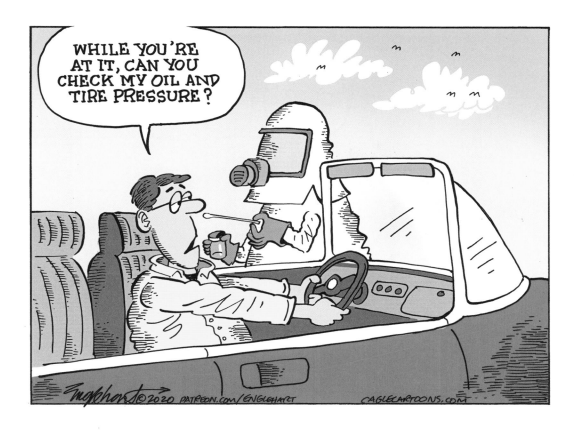

Bob Englehart . Multi Tasking
USA

119

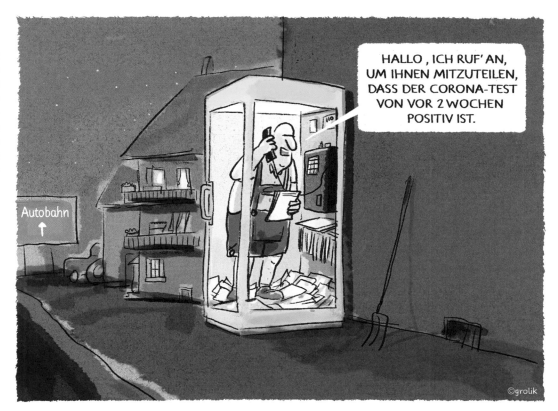

Hello, I'm calling to tell you that the coronavirus test you took two weeks ago was positive.

Markus Grolik . Bayern Testpannen
Germany

Lectrr . Een ongemaskerde man
Belgium

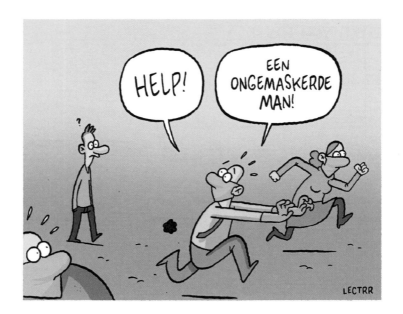

Help!
An unmasked
man!

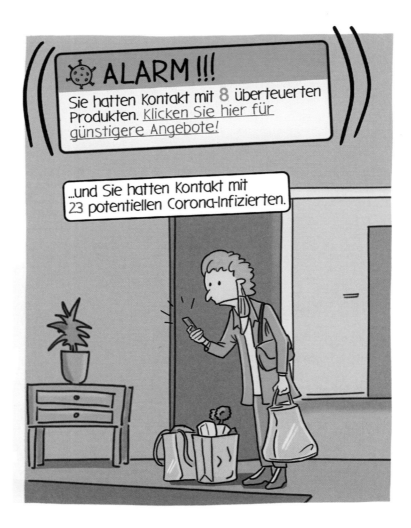

Red alert!!!

You came
into con-
tact with 8
overpriced
products.
Click here
for better
offers!

… And you
came into
contact with
23 people
who might
be infected
with the co-
ronavirus.

Christian Möller . Tracing-App
Germany

Oh my god!
No mask!

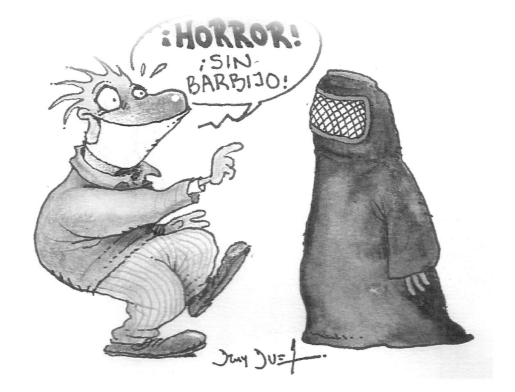

Dany Duel . Barbijo
Argentina

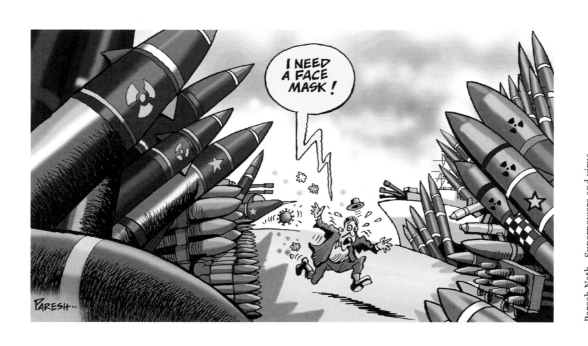

Paresh Nath . Superpowers and virus
India

No-rio Yamanoi
Japan

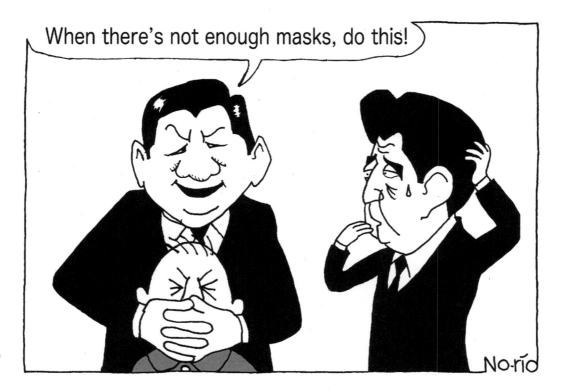

Randall Enos . The 3 Stages of Covid
USA

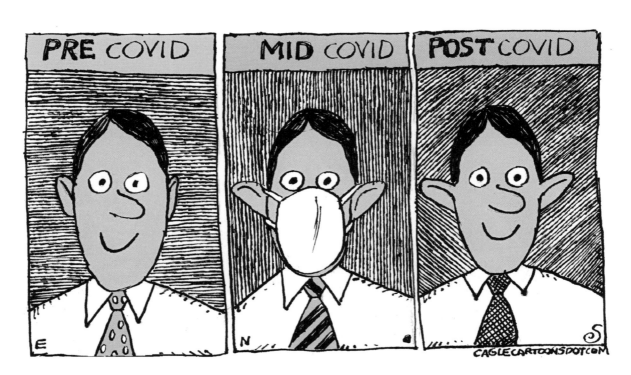

Don't for-
get your
mask when
you go out,
will you?

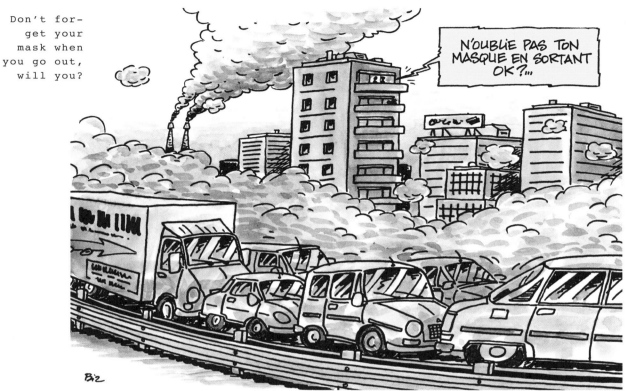

Biz (Pierre Bizalion) . Covid et pollution
France

Luc Vernimmen . Corona mouthmask duty
Belgium

Chicane . Bare necessities
United Kingdom

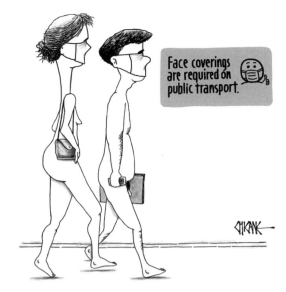
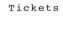

Ralf Böhme . Ticket to ride
Germany

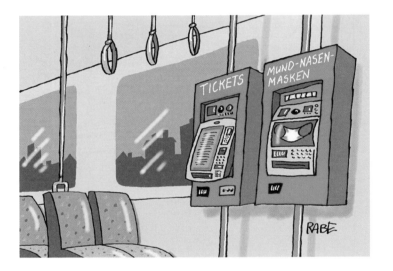

Tickets

Face
coverings

Markus Grolik . Maskenpflicht
Germany

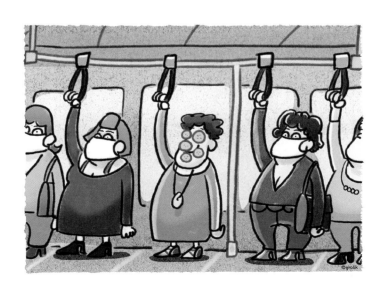

Keep safe
distance at
the station
and on the
train

Cristina Sampaio . Keep Safe Distance
Portugal

John Ditchburn . I call it poetic justice.
Australia

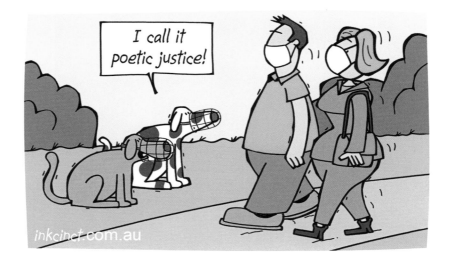

Marcin Bondarowicz
Poland

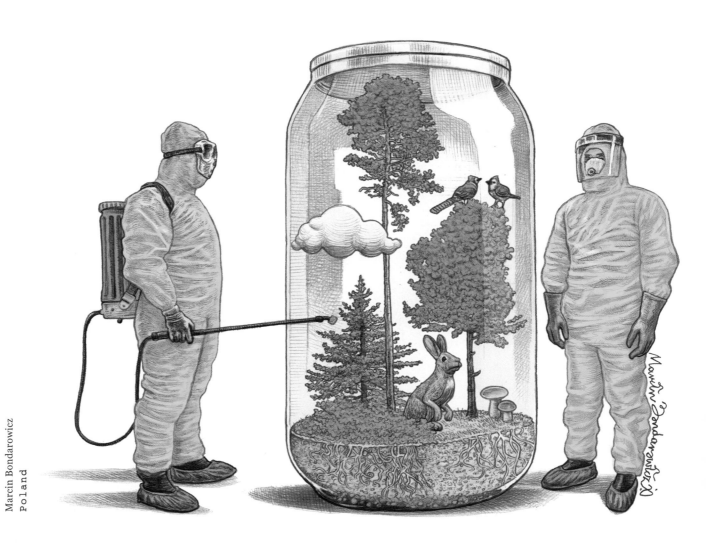

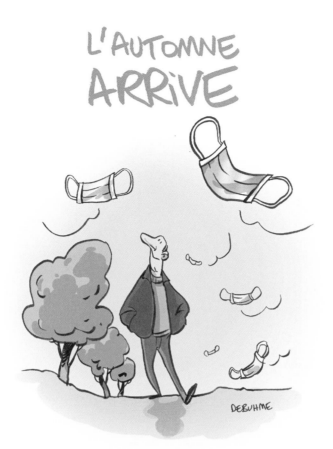

Debuhme . L'automne arrive
Switzerland

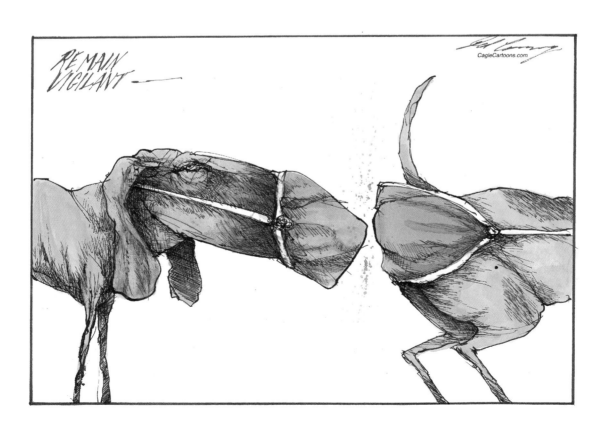

Dale Cummings . Remain Vigilant
Canada

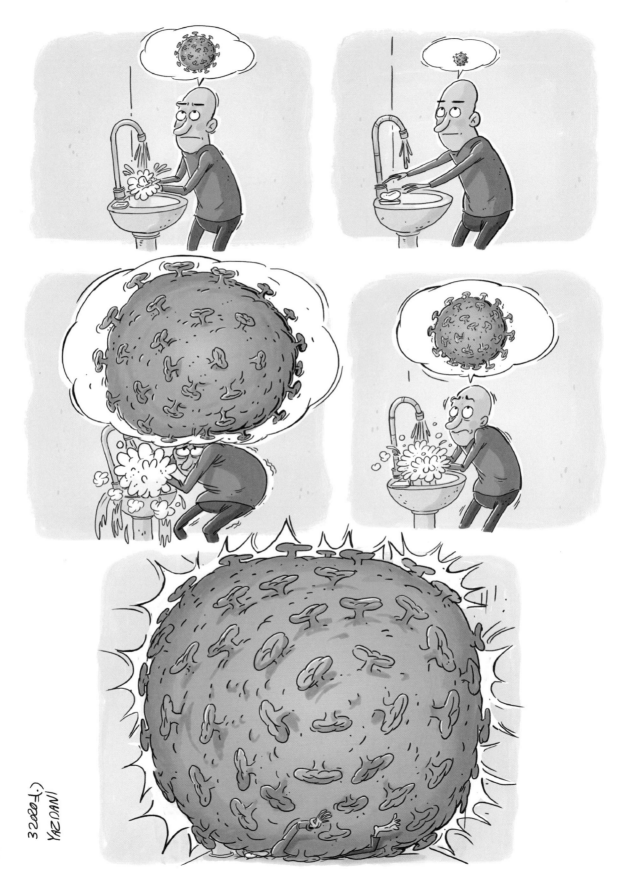

Mahnaz Yazdani . Corona Horror

Iran

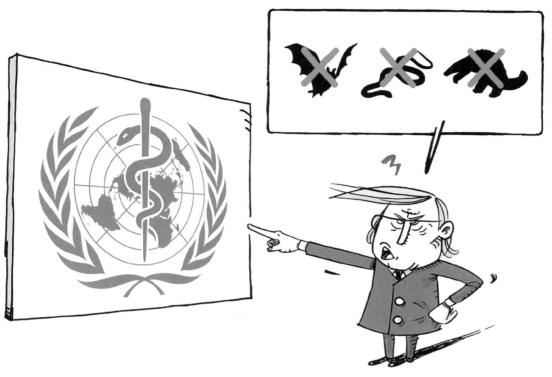

Amine Labter . Trump vs. OMS!
Algeria

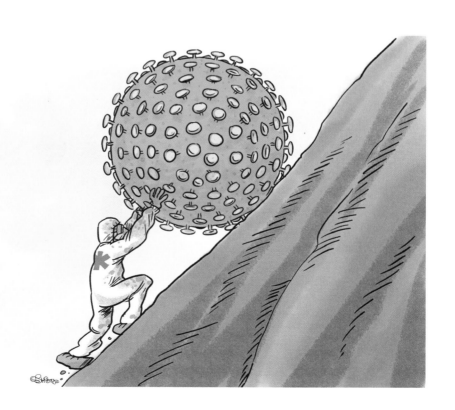

Martin Sutovec . Corona Sysiphos
Slovakia

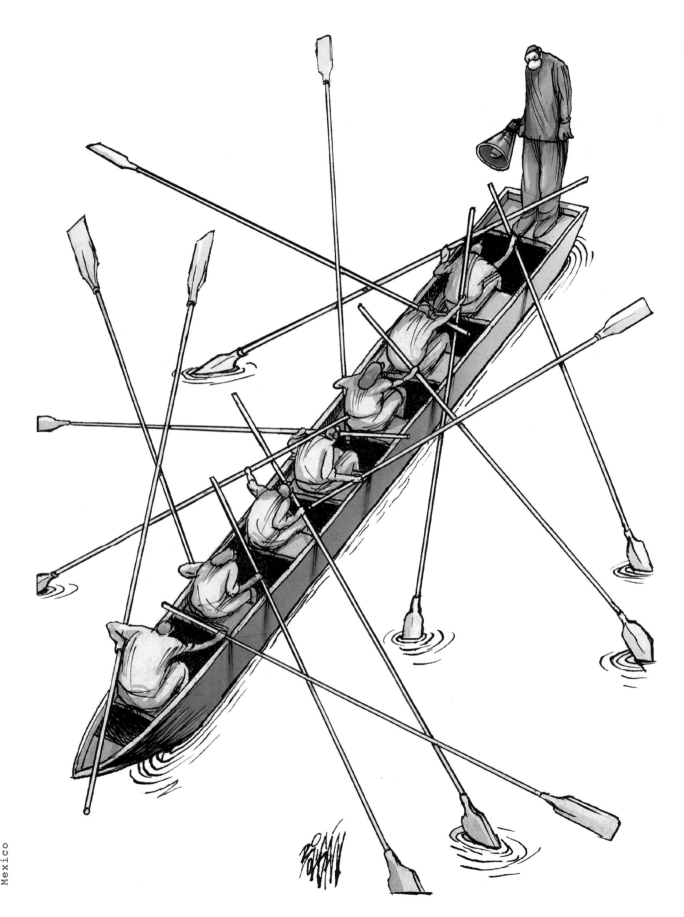

Angel Boligán . The Pandemic of Chaos
Mexico

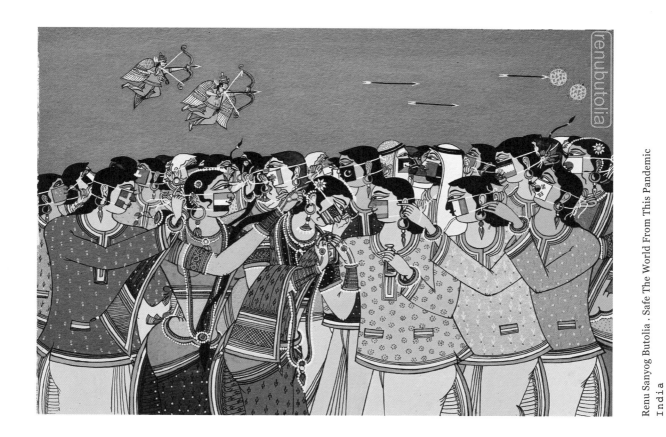

Renu Sanyog Butolia . Safe The World From This Pandemic
India

131

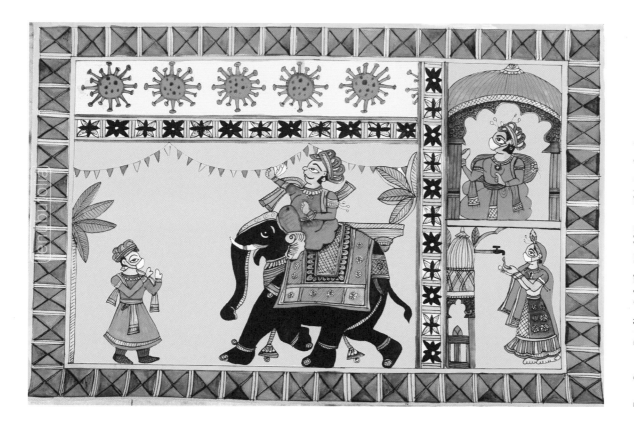

Renu Sanyog Butolia . Safe The World From This Pandemic
India

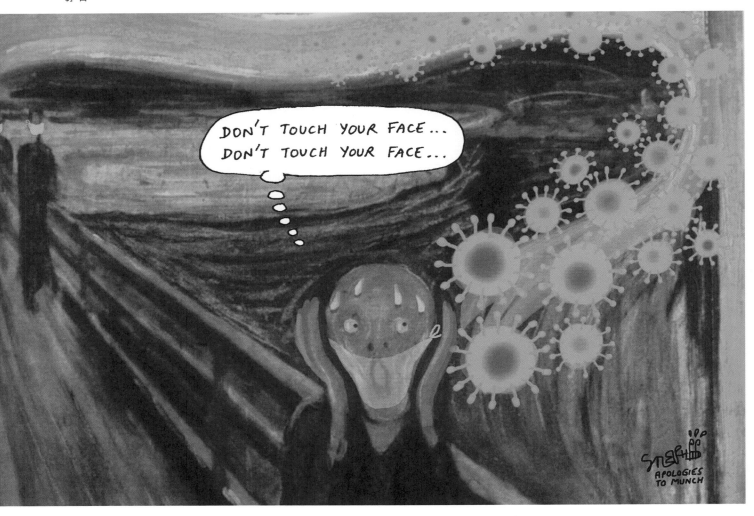

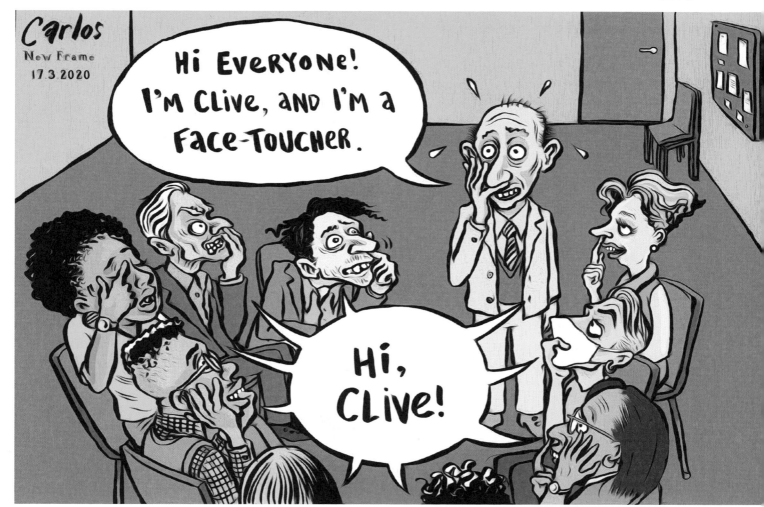

Carlos Amato . Face Touchers
(first published by NewFrame.com)
South Africa

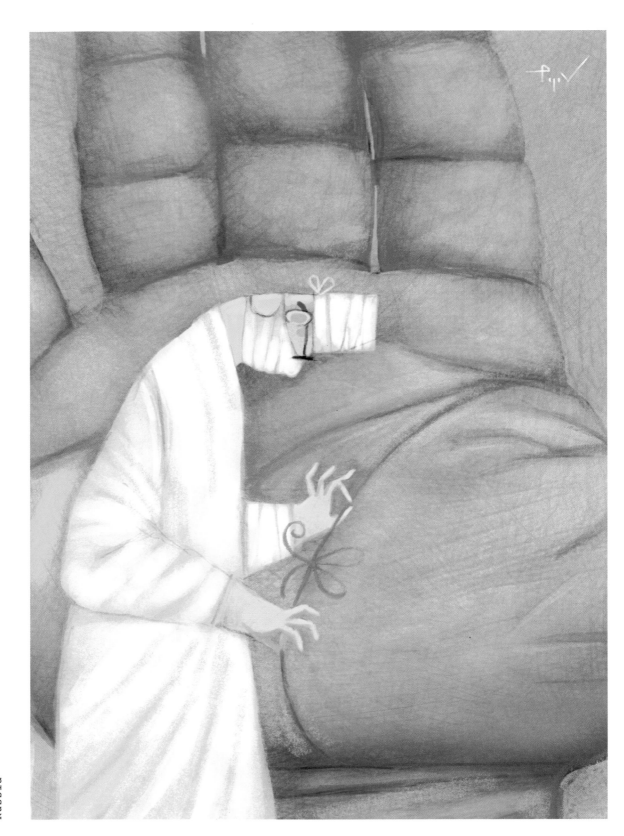

Andrei Popov . Doctor and life line
Russia

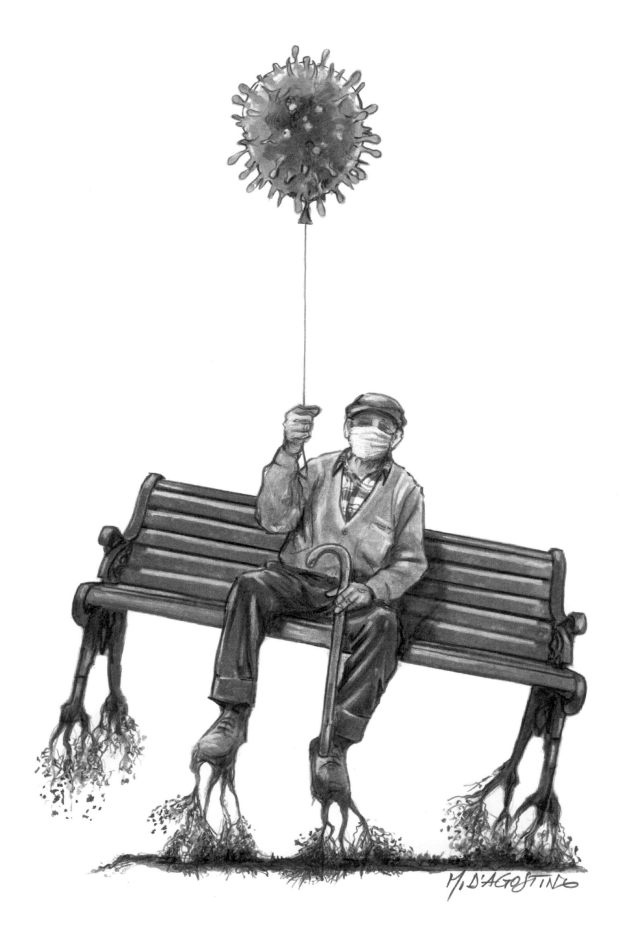

Marco D'Agostino . Nonno volante
Italy

Juancarlos Contreras . Total Mask
Spain

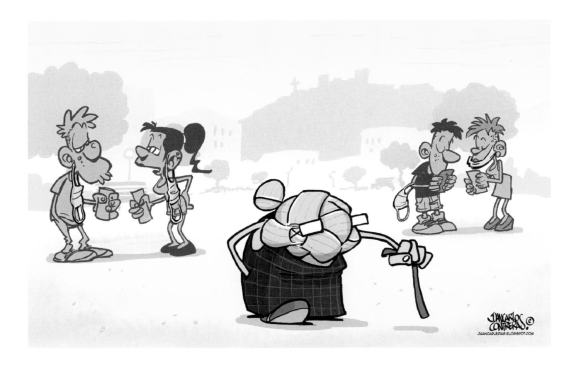

CONFINEMENT :
LES OBSÈQUES BOULEVERSÉES !

Lockdown:
funeral
comes to
grief

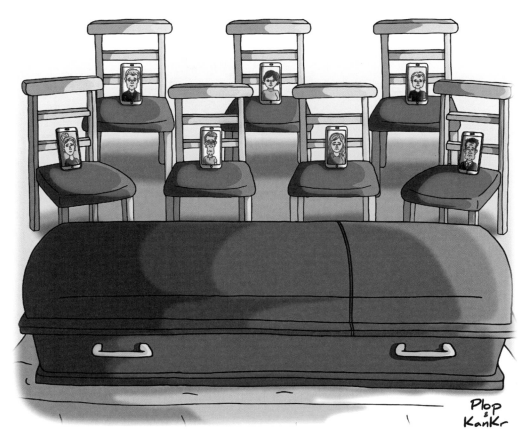

Plop & KanKr . les obsèques bouleversées
France

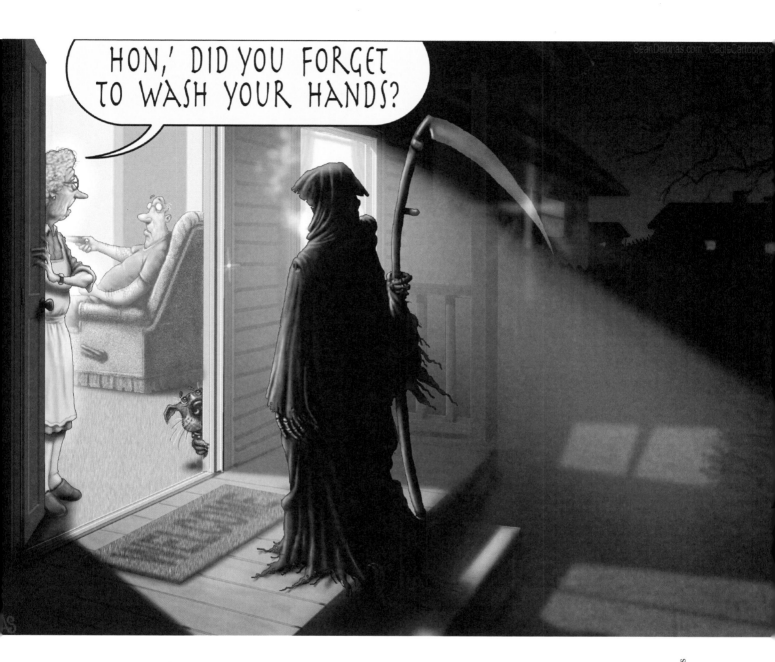

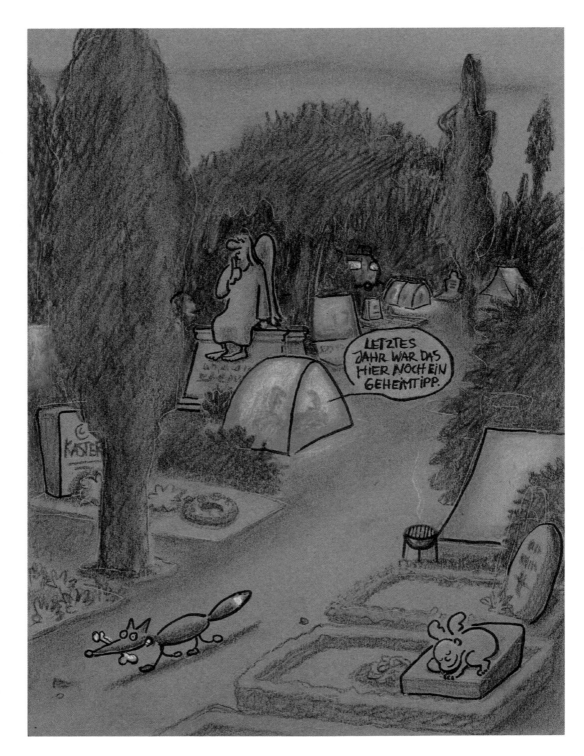

138

Last year, this was still a well-kept secret.

Petra Kaster . Friedplatz
Germany

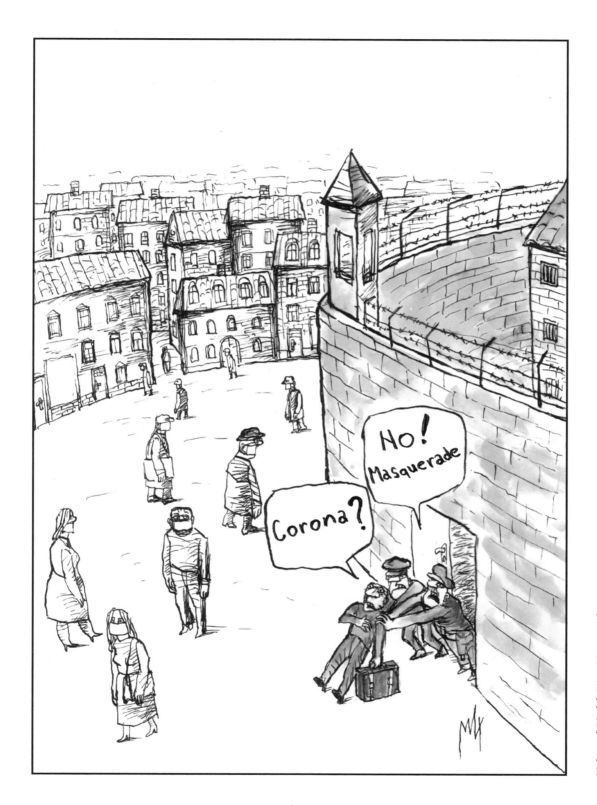

Muhamed Djerlek Max . Masquarade
Serbia

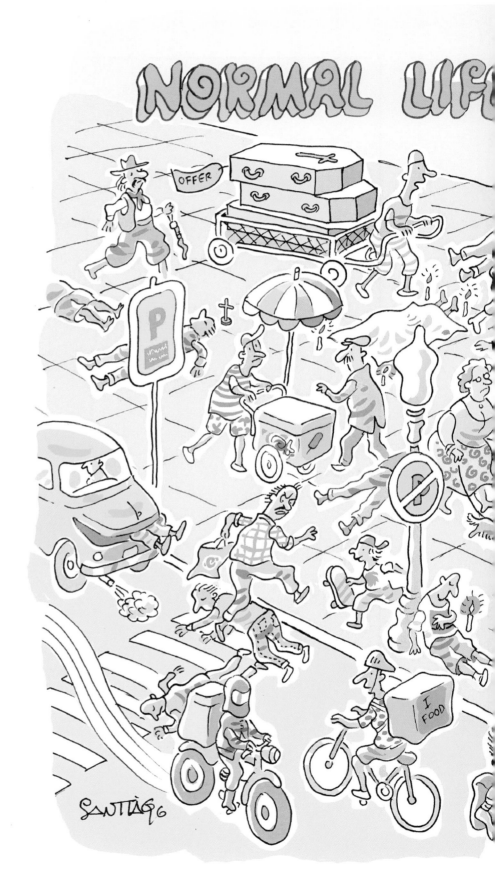

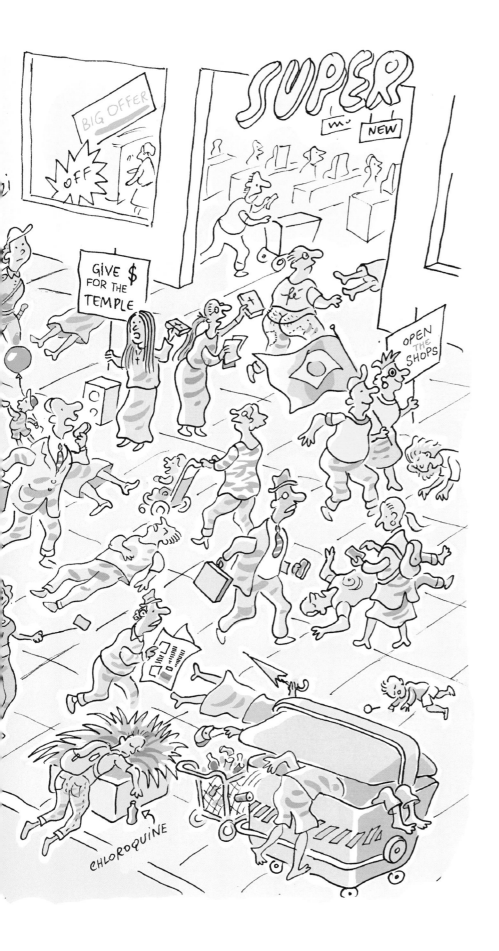

Tex Rubinowitz
Austria

In a better
world

What does
the A stand
for?

— Antibodies

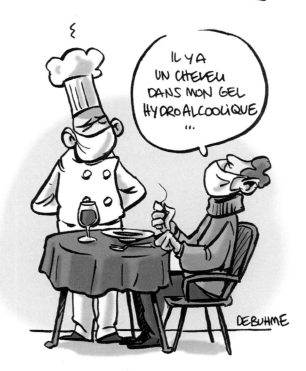

REOPENING OF
RESTAURANTS

There's a
hair in my
hydroalco-
holic gel …

Debuhme . Réouverture des restaurants
Switzerland

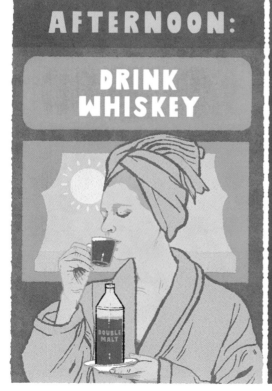

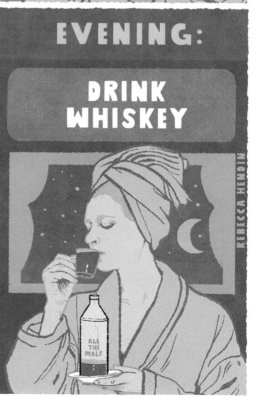

Rebecca Hendin . Self Care In The Time Of Covid

United Kingdom

143

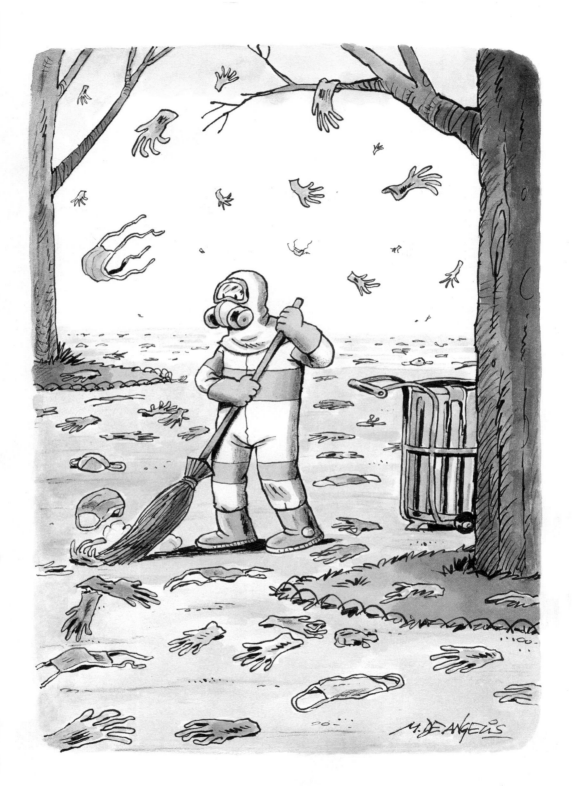

Marco De Angelis . Cleaning
Italy

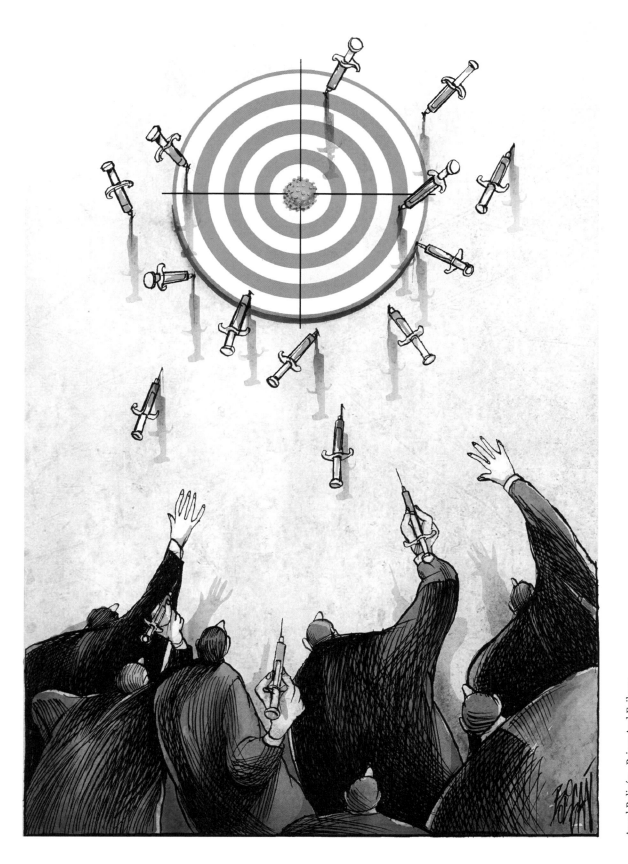

Angel Boligán . Prisas And Failures
Mexico

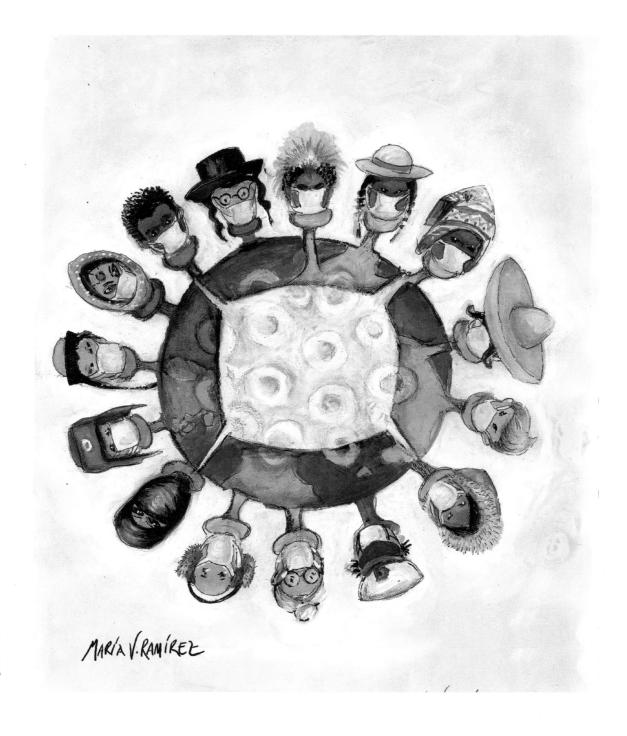

María Verónica Ramírez . Imagine there's no countries, It isn't hard to do...

Argentina

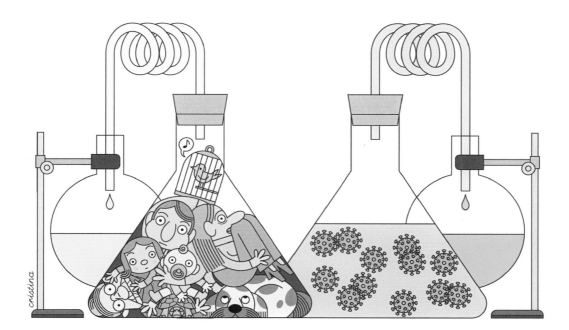

Cristina Sampaio . Lockdown
Portugal

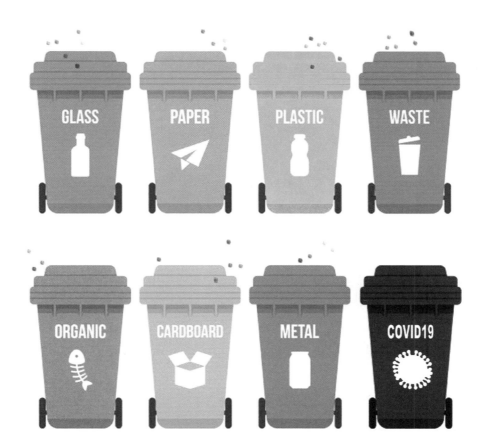

Luc Descheemaeker . Garbage
Belgium

148

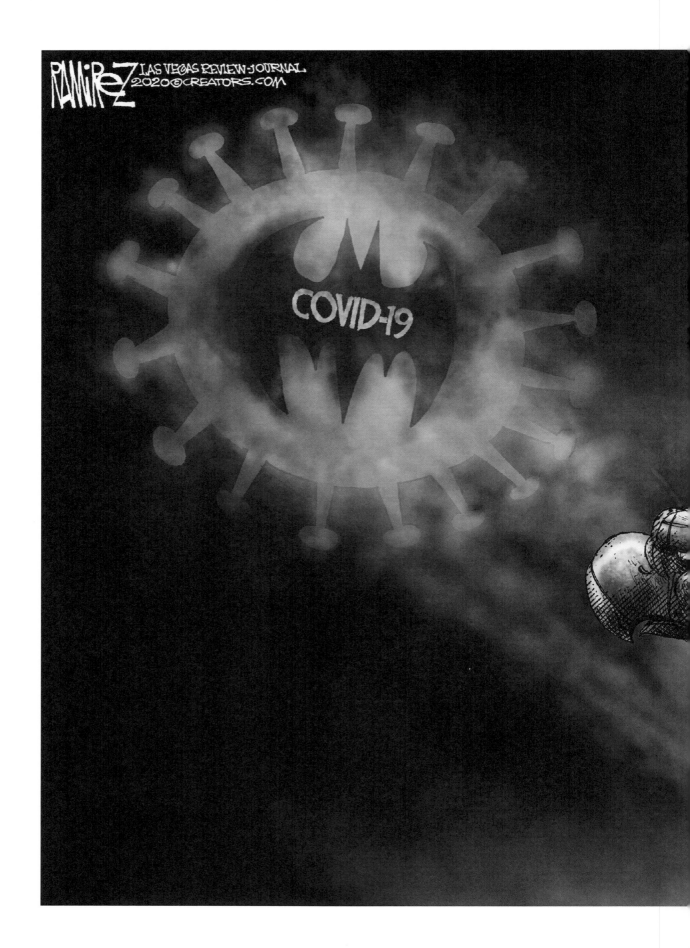

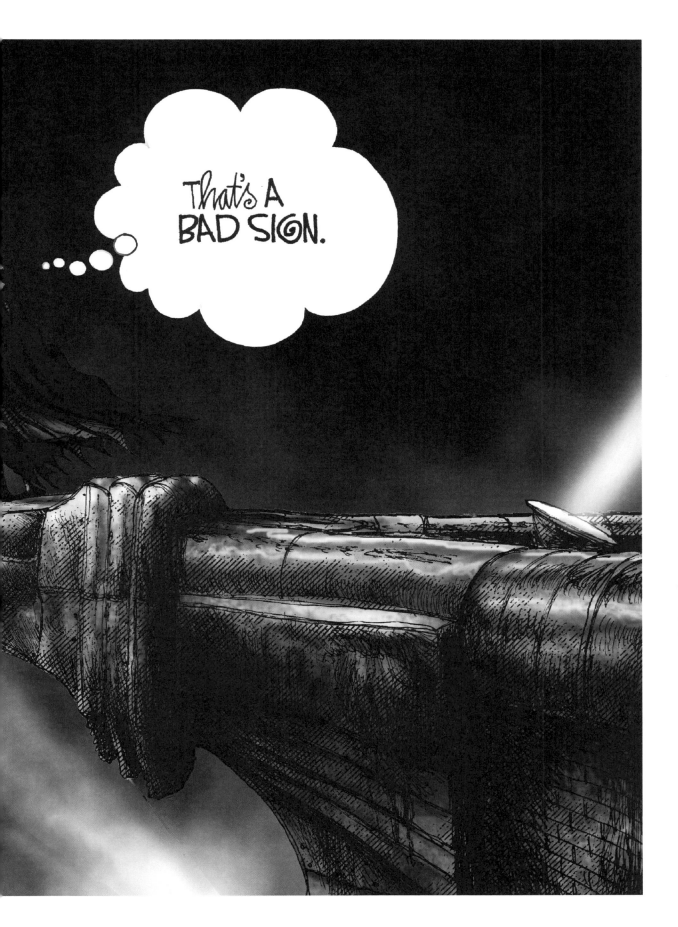

Michael Ramirez . Michael Ramirez Editorial Cartoons: That's a Bad Sign
USA

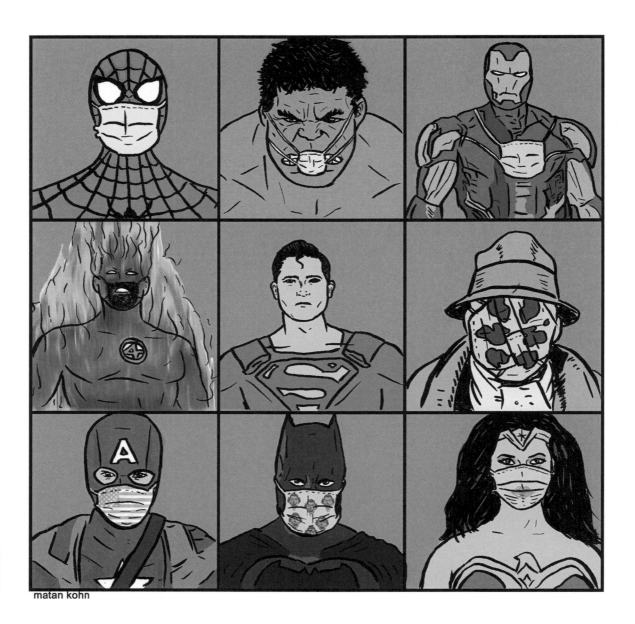

Matan Kohn . Superheroes with corona mask
I s r a e l

matan kohn

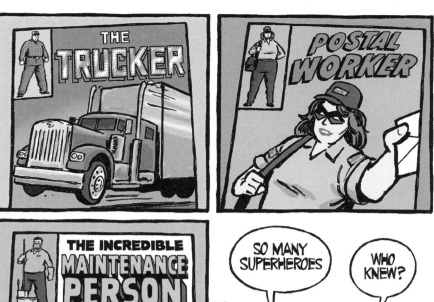

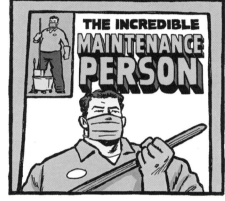

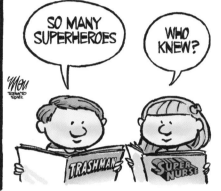

Theo Moudakis . Everyday Superheroes
Canada

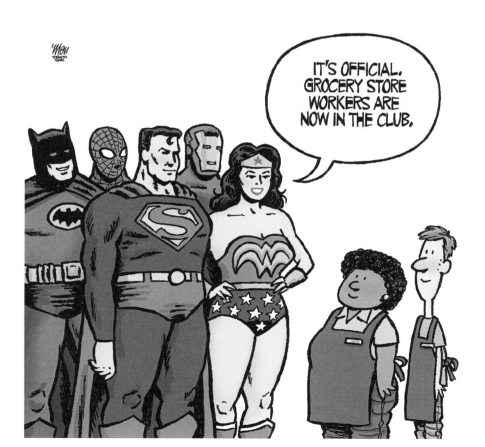

Theo Moudakis . Superhero Club
Canada

152

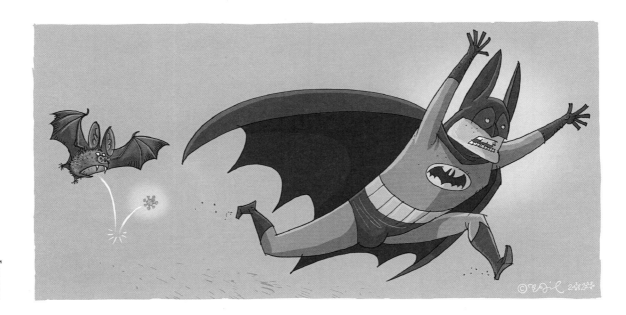

Egil . Corona 2020 - Fear
Norway

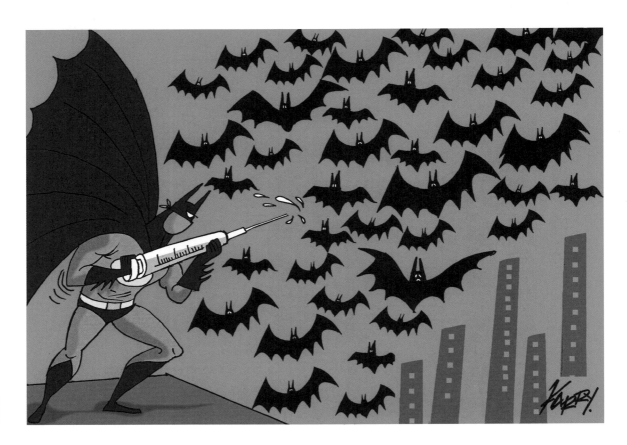

Karry Carrión . Batmáncorona (Karrycaturas Covid)
Peru

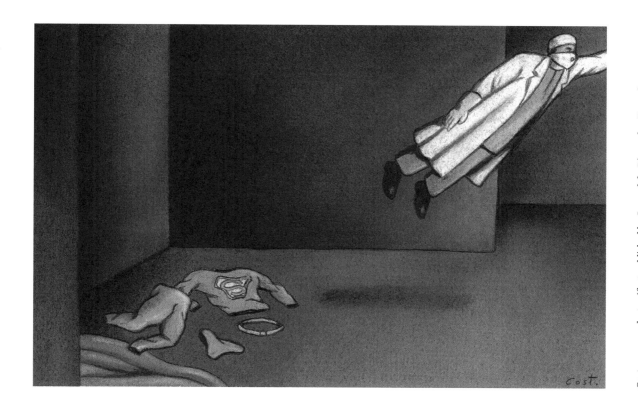

Cost. . corona doctor (first published by Journal du Dimanche, France)
Belgium

153

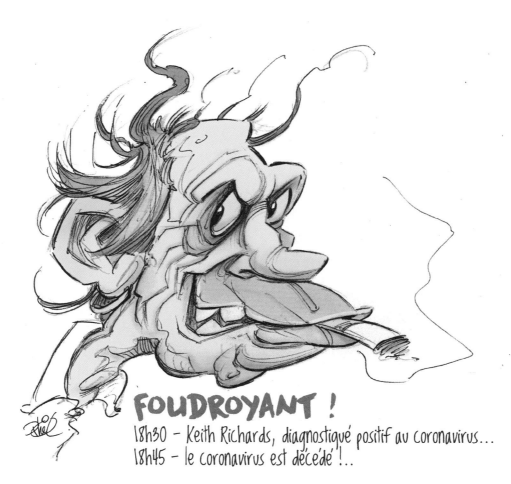

SMASH HIT!
6.30 pm Keith
Richards tests
positive for
corona
6.45 pm Corona-
virus dies

Phil Umbdenstock . Modern Times 2020
France

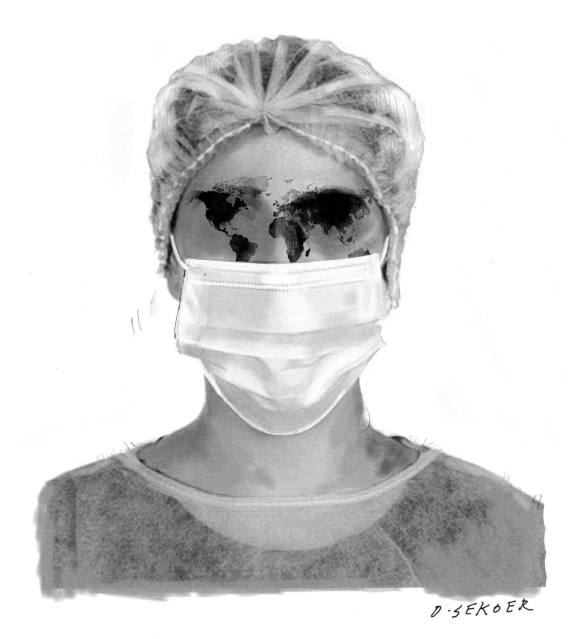

O-SEKOER

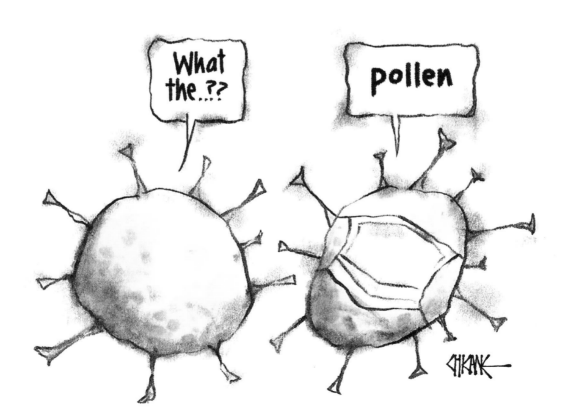

Pierre Ballouhey
France

Chicane . Virus protection
United Kingdom

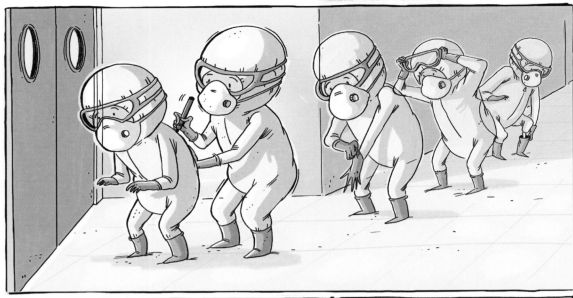

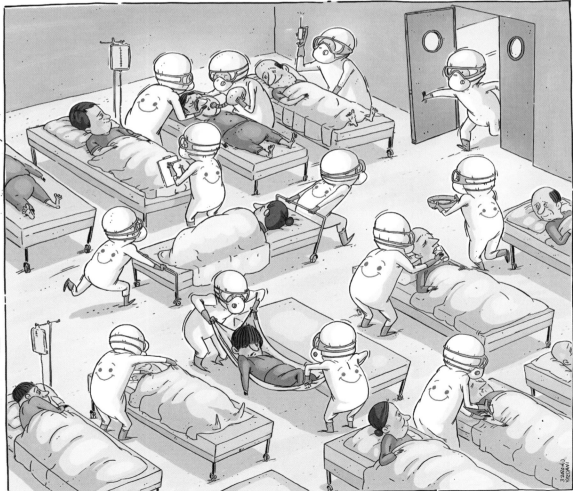

Mahnaz Yazdani . Giving Hope
Iran

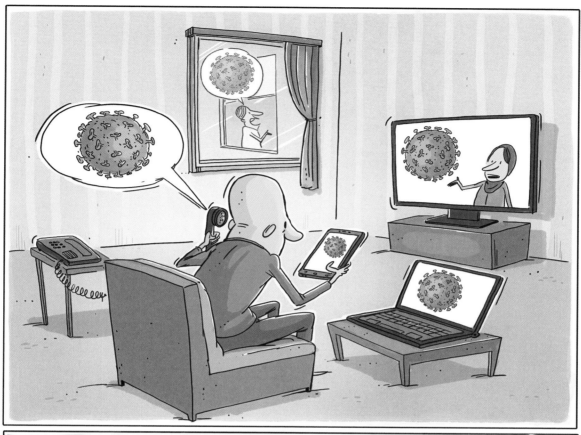

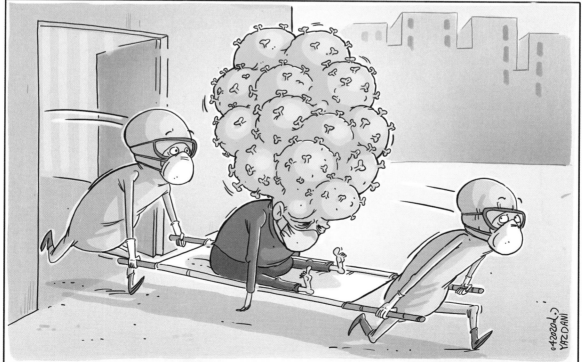

Mahnaz Yazdani . Corona News!
Iran

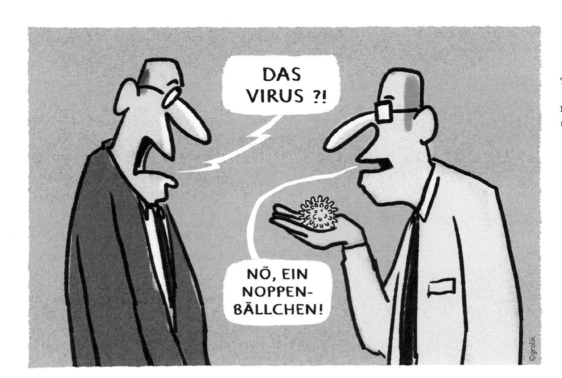

The virus?!

Nope, a mas-
sage ball!

Markus Grolik . Noppenbällchen
Germany

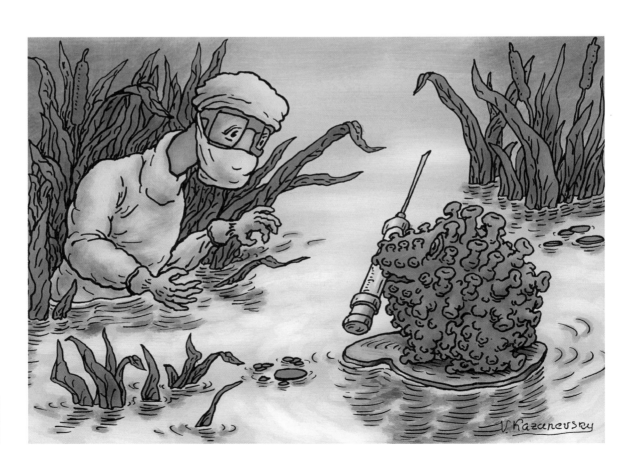

Vladimir Kazanevsky . Fabulous vaccine
Ukraine

Russian
vaccine

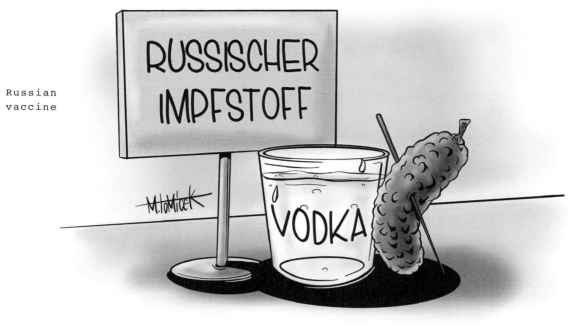

Home
remedies

HAUSMITTEL

Mirco Tomicek . Russisches Hausmittel
Germany

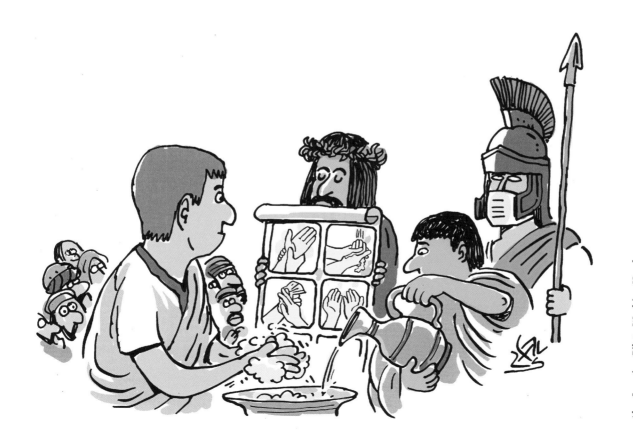

Alen Lauzán . Pilato Washing Hands
Chile

Jugoslav Vlahovic . Without Words
Serbia

Pichon . l'infirmière.
France

All too
much all
of a sud-
den ...

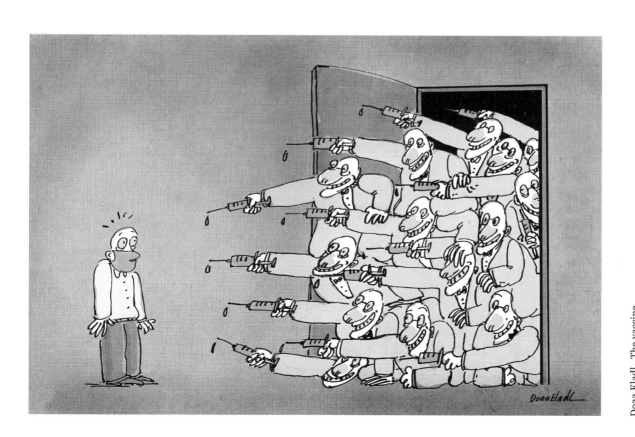

Santiago . The Criminal

Brazil

Doaa Eladl . The vaccine

Egypt

Peter Kuper . Open School Detention
USA

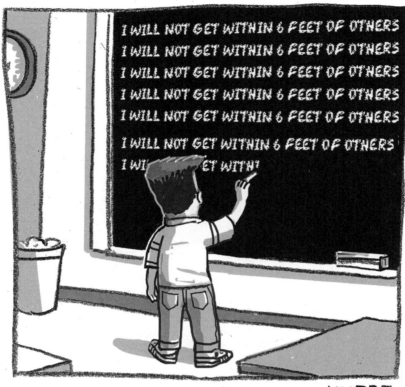

Martin Erl . Schule mit Maske
Germany

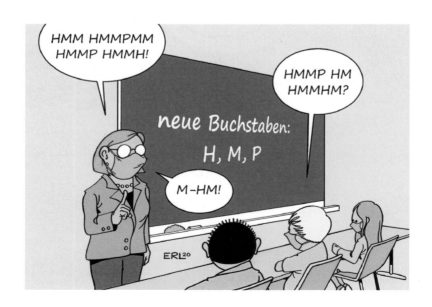

New letters:
H, M, P

Hmm Hmmmpmm
hmmp hmmh

Hmmp hm
hmmhm?

M-hm!

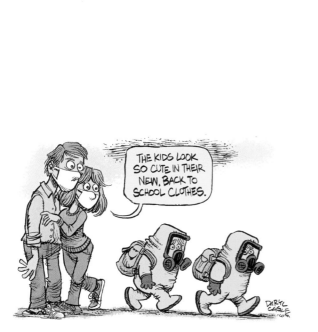

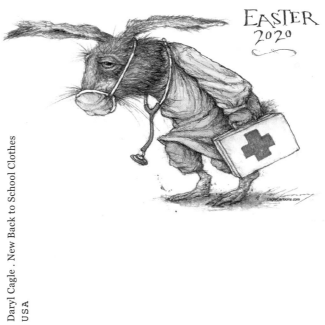

Daryl Cagle . New Back to School Clothes
USA

Dale Cummings . Easter 2020
Canada

Zoran Petrovic
Germany

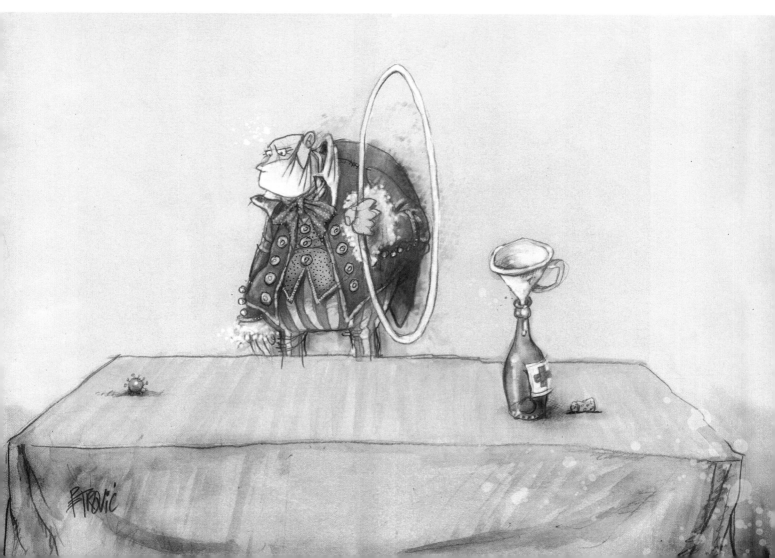

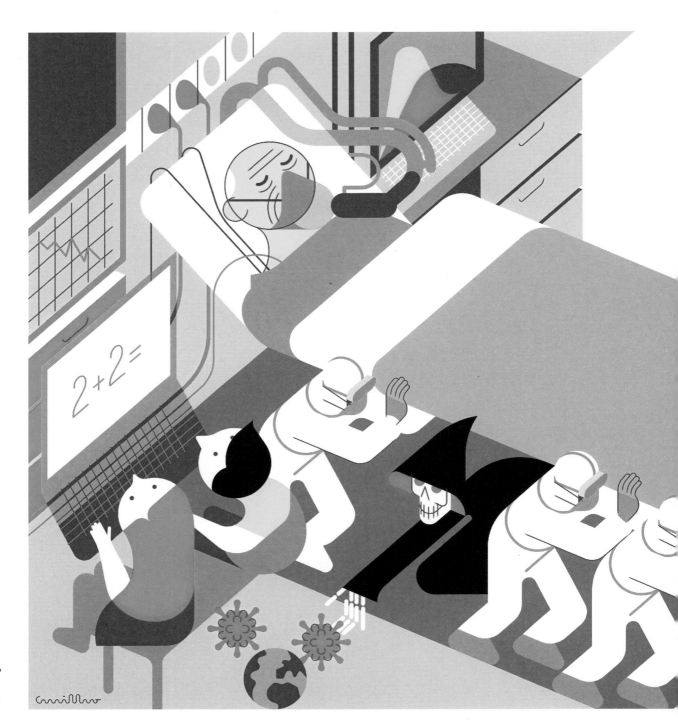

André Carrilho . 2 Months
Portugal

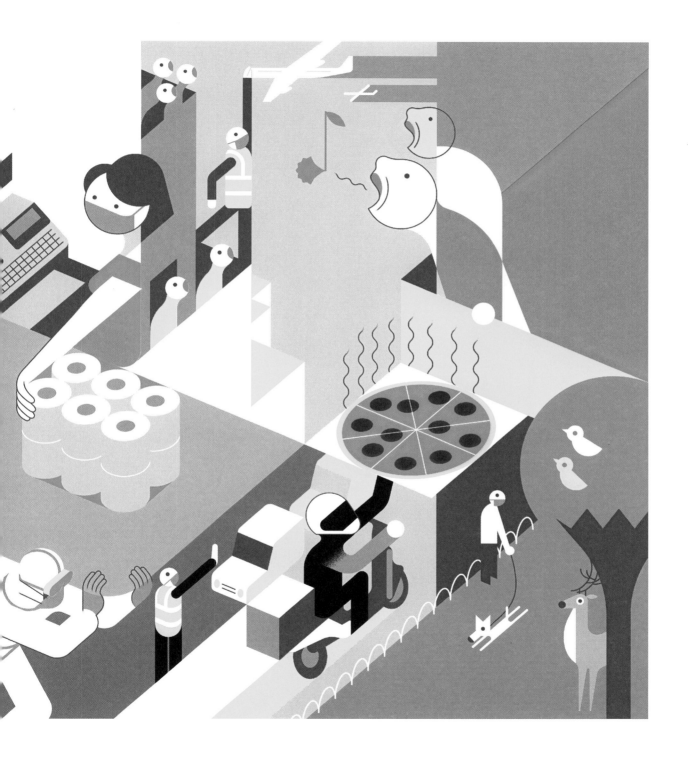

Jon Berkeley . Back to School
Irland

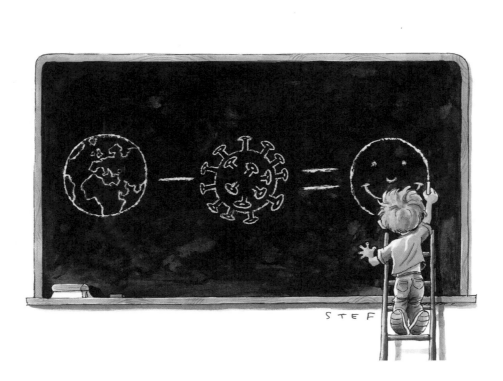

Stefaan Provijn . wishful drawing
Belgium

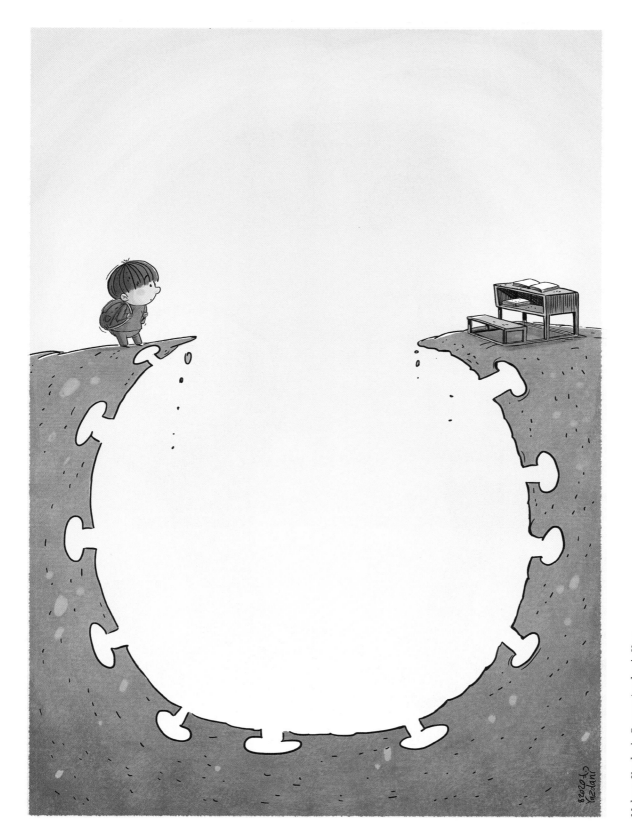

Mahnaz Yazdani . Corona Academic Year

I r a n

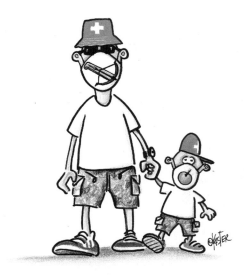

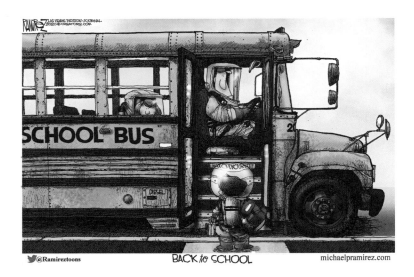

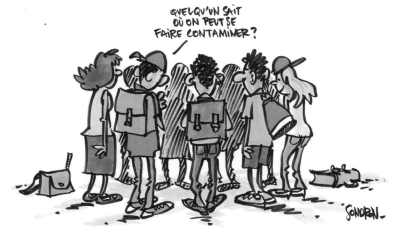

As soon as there are two positive cases, a class will be sent home …

Anyone know where you can get infected?

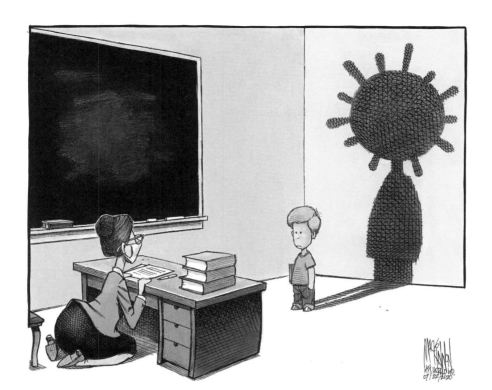

Bruce MacKinnon
Canada

Coool!

Children can kill!

The new child labeling laws are now in place!

Petra Kaster · Kennzeichnungspflicht
Germany

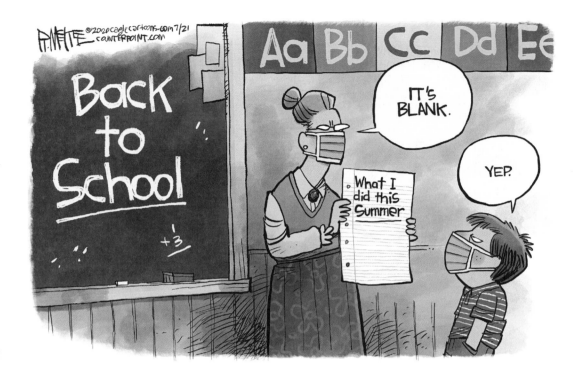

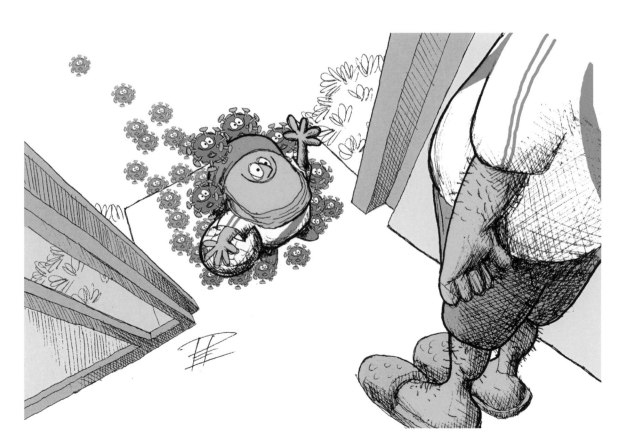

Face mask
smurf

And self-
sewn, you
say?

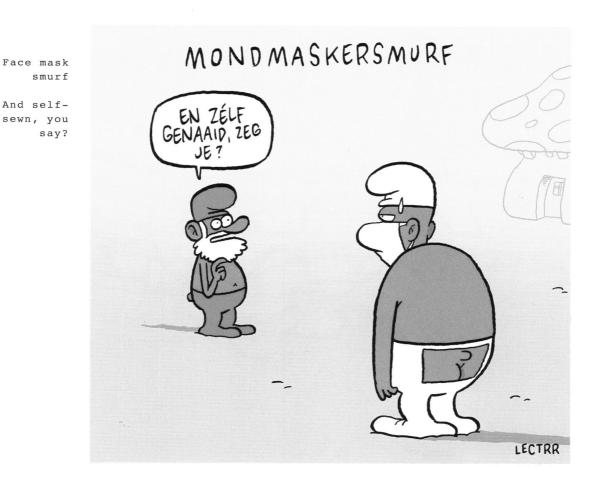

Lectrr . Mondmaskersmurf
Belgium

171

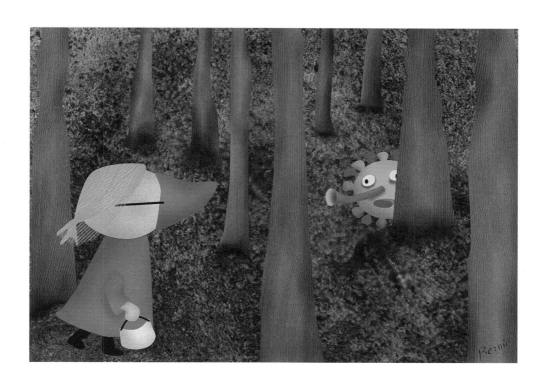

Bertrand Bouton . Little Red Riding Hood
France

172

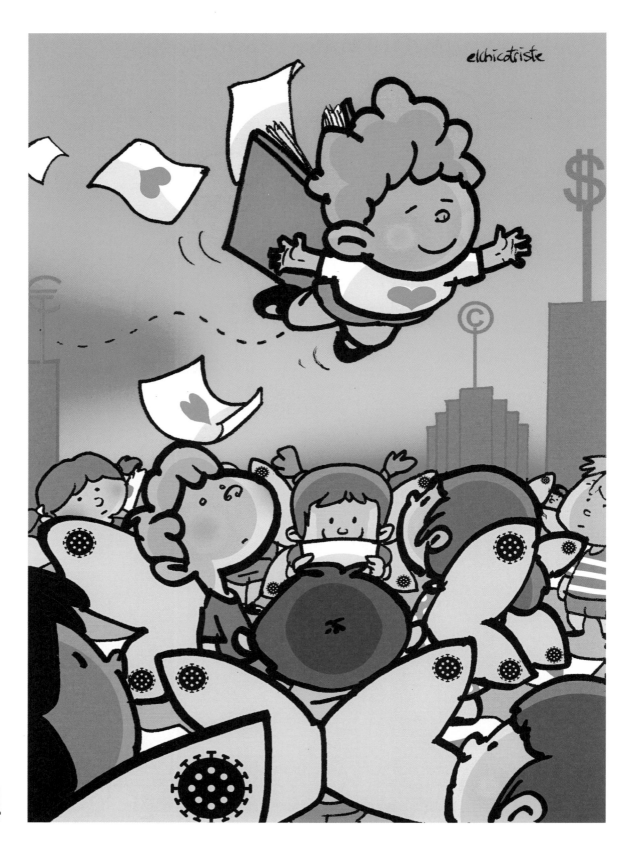

Miguel villalba Sánchez Elchicotriste . Spread the love virus
Spain

"So tell us, where do you see yourself in September?"

Ali Solomon . So tell us, where do you see yourself in September
USA

173

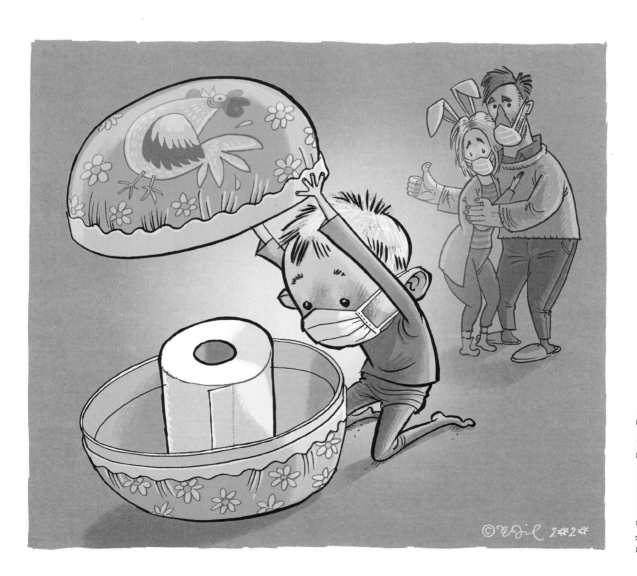

Egil . Corona 2020 - Easter-Egg
Norway

Agim Sulaj . Corona 2020
Italy

André Carrilho . Everything Will Be Alright
Portugal

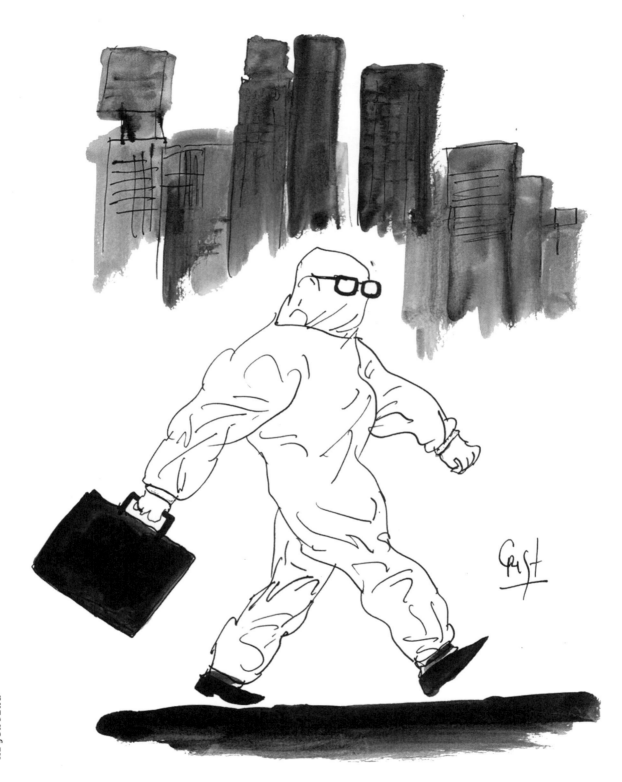

Cristobal Reinoso . A tour of the world
Argentina

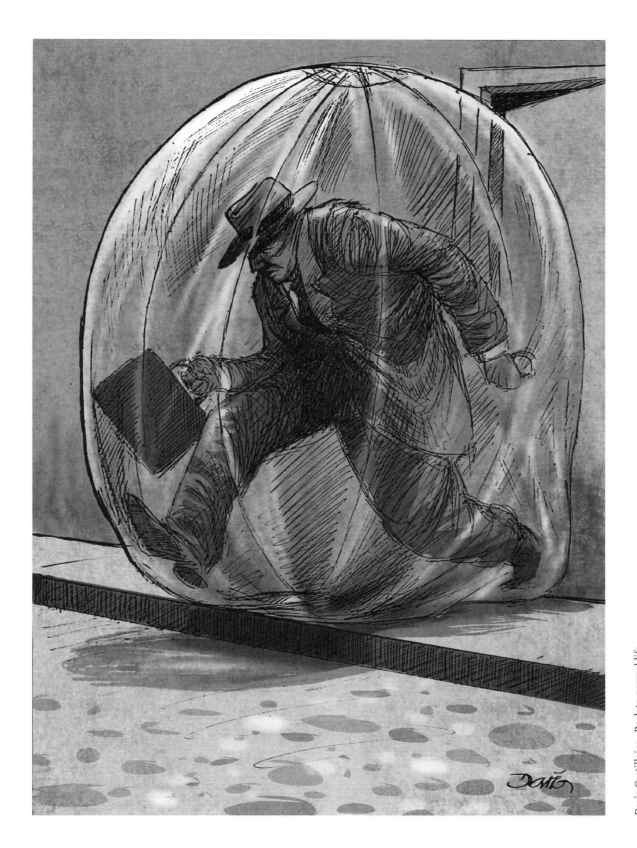

Dario Castillejos . Back to normal life
Mexico

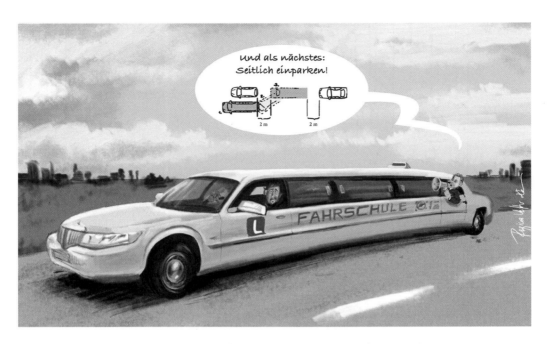

Warum die Fahrschüler in Zeiten von Social Distancing die besten sein werden

Regina Vetter . Fahrschüler 2020
Switzerland

And now: parallel parking!

Driving school

Why driving school students in the social distancing age will be the best ever.

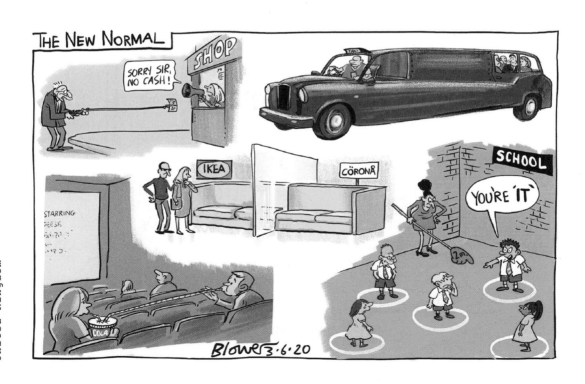

Patrick Blower . The New Normal
United Kingdom

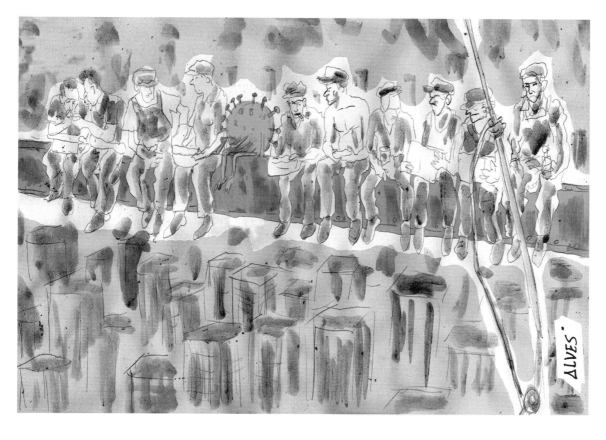

Evandro Alves . Snack time
B r a z i l

Paresh Nath . Lockdown exit plan
I n d i a

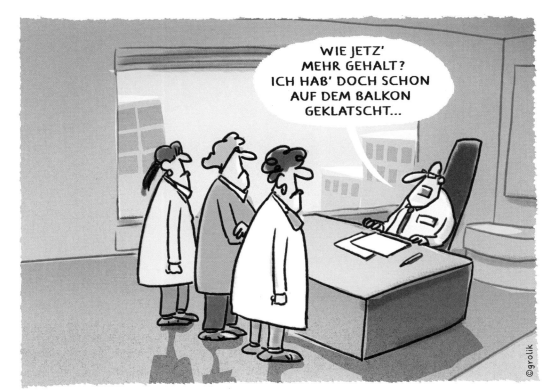

You want
more mon-
ey? But I
already ap-
plauded on
the balcony!

Markus Grolik . Geklatscht
Germany

Cristina Sampaio . Psychoanalysis Couchvid-19
Portugal

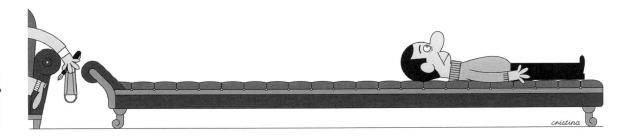

Caution: Morale among dentists dangerously low!

I can't work under these conditions!

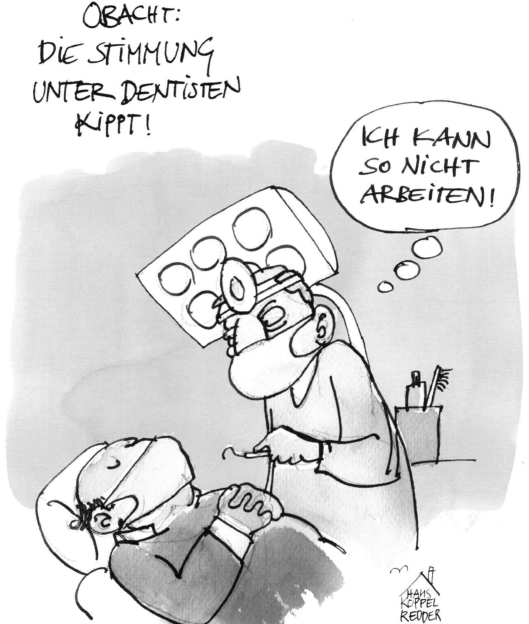

Hans Koppelredder · Dentisten
Germany

Gerhard Haderer
Austria

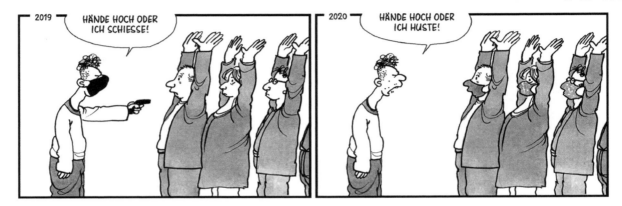

Hands up or
I'll shoot!

Hands up or
I'll cough!

This is a
robbery!

Thank god.

I already
thought it
was Corona.

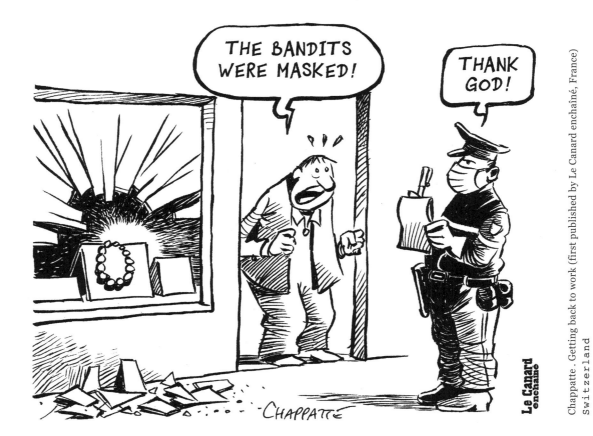

Le Canard enchaîné
Switzerland

Chappatte . Getting back to work (first published by Le Canard enchaîné, France)

183

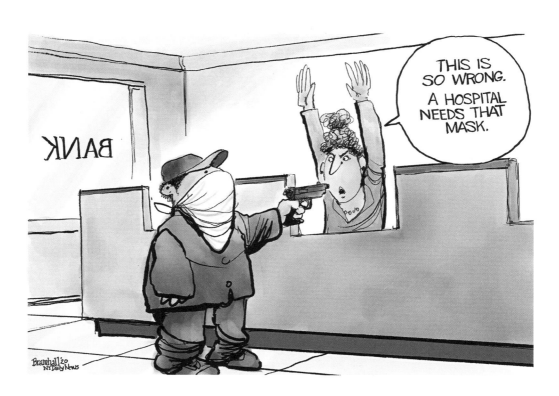

Bill Bramhall . Cartoon - Covid-19 Bank Robbery Face Masks
USA

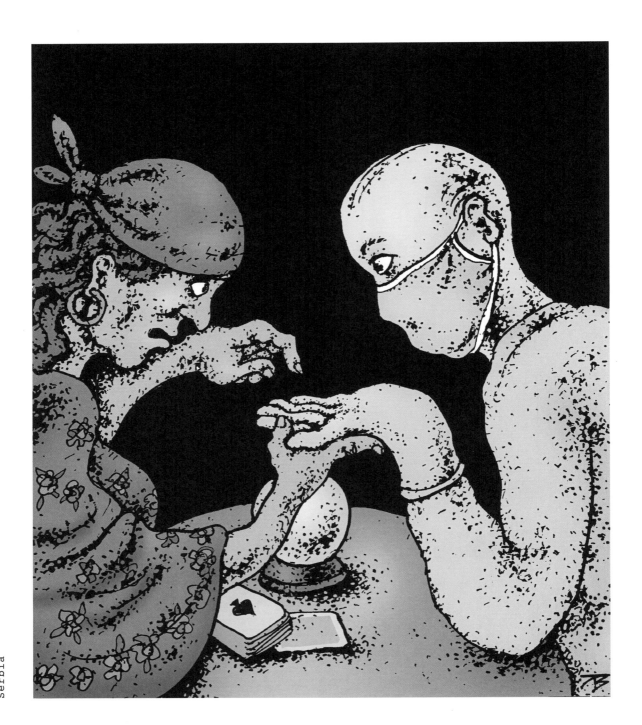

Jugoslav Vlahovic . Without Words
Serbia

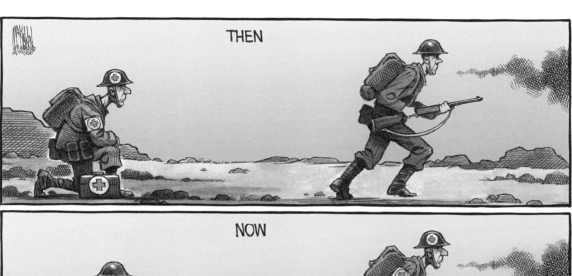

THEN

NOW

Bruce MacKinnon
Canada

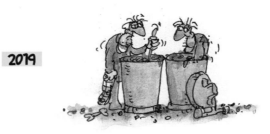

2019

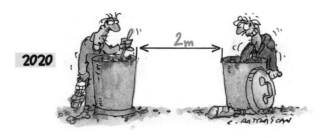

2020

Costel Patrascan . Distancing
Romania

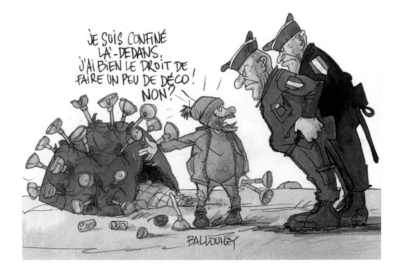

Pierre Ballouhey
France

I'm locked up in there. I have the right to decorate a little! No?

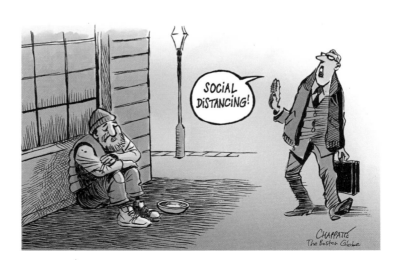

Chappatte . Covid health crisis is deepending inequalities (first published in The Boston Globe)
Switzerland

Yet another victim of covid-19!!!

He had invested everything in facial recognition software …

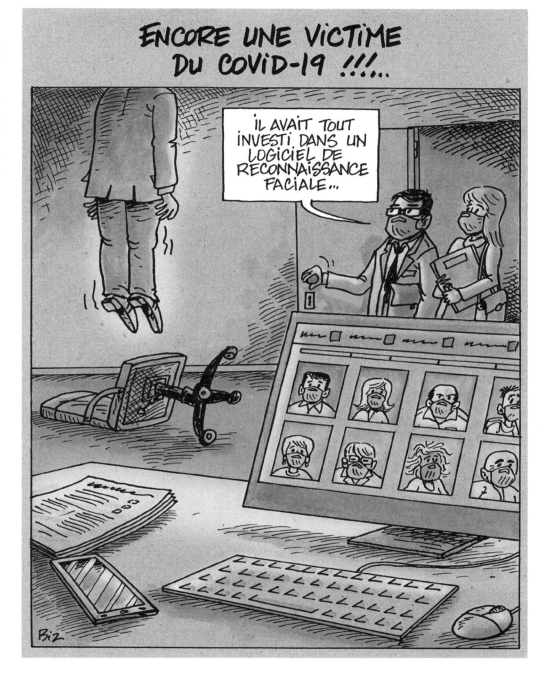

Biz (Pierre Bizalion) . Covid à la plage
France

Géza Halász . Smart Mask
Hungary

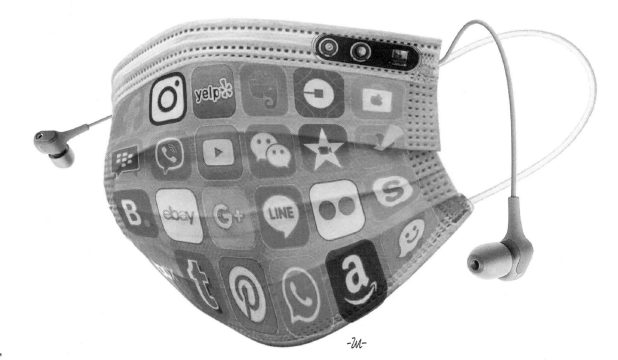

Smart Mask

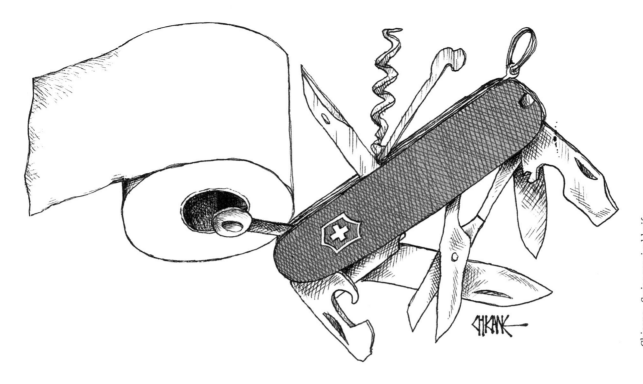

Chicane . Swiss survival knife
United Kingdom

189

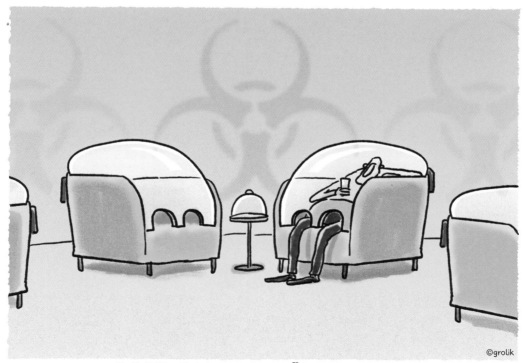

POST CORONA MÖBELDESIGN

Post-corona-
virus furni-
ture design

Markus Grolik . Post Corona Möbel
Germany

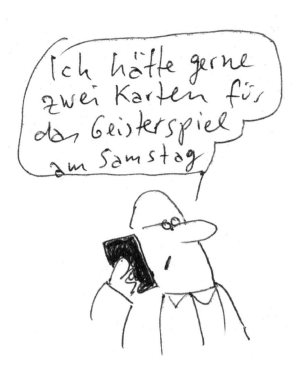

Two tickets for the match behind closed doors on Saturday, please!

Tex Rubinowitz
Austria

Alen Lauzán . New Musical Normality
Chile

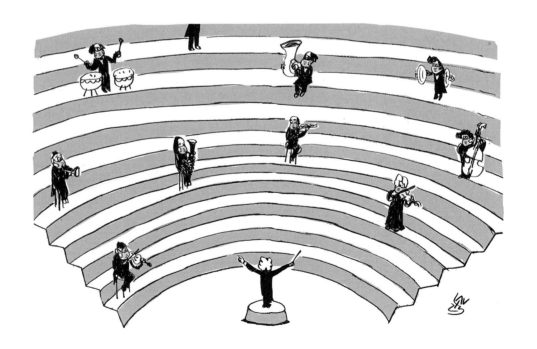

DISTANCIATION SOCIALE OVERTURE

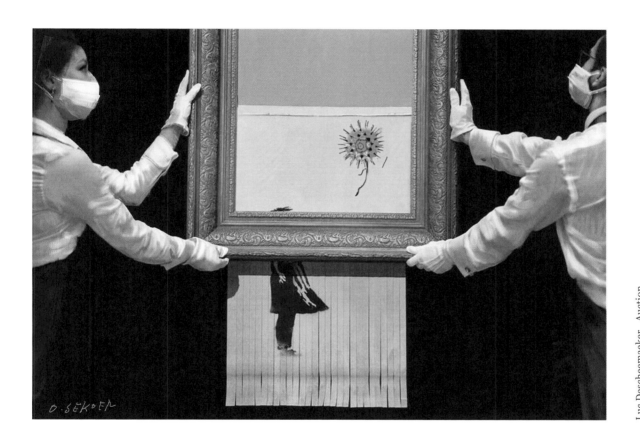

Luc Descheemaeker . Auction

Belgium

L'ART EN TEMPS DE PANDÉMIE

TOMATO GEL

ONION GEL

GREEN PEA GEL

VANILLA GEL

CREAM OF MUSHROOM GEL

JASMINE GEL

YLANG YLANG GEL

CEDAR WOOD CHEESE GEL

BEAN GEL

CARDAMON GEL

FEET WARM MUSK GEL

BERGAMOT GEL

Cambon . Campbell's gel cans after Warhol
France

CAMPBELL'S GEL CANS PAR ANDY WARHOL

Campbell's
gel cans by
Andy Warhol

L'ART EN TEMPS DE PANDÉMIE

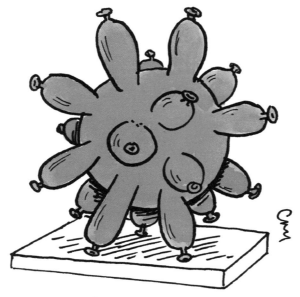

CORONA BALLOON
DE JEFF KOONS

Balloon
Corona by
Jeff Koons

Cambon . Corona balloon by Koons
France

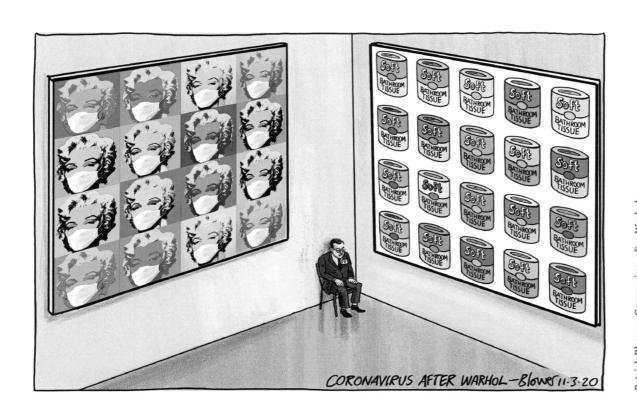

CORONAVIRUS AFTER WARHOL — Blower 11·3·20

Patrick Blower . Coronavirus after Warhol
United Kingdom

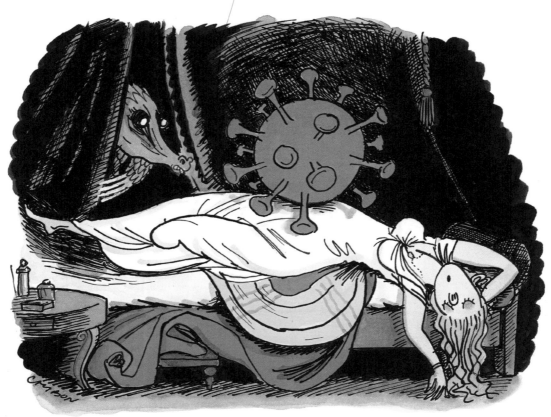

L'ART EN TEMPS DE PANDÉMIE - D'APRÈS FÜSSLI (LE CAUCHEMAR)

Cambon . L'art en temps de pandémie d'après (art in pandemic time after) Füssli
France

Art in the time of Corona – according to Feseli ("The nightmare")

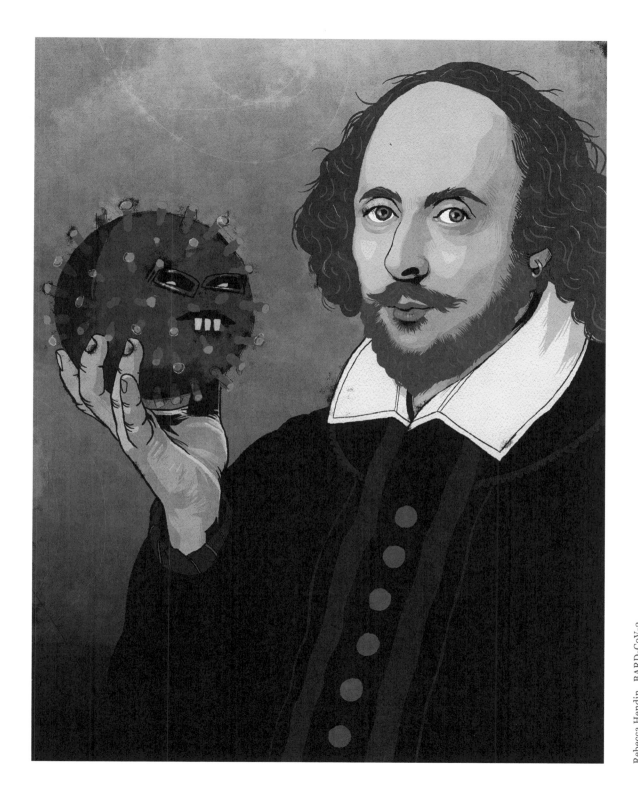

Rebecca Hendin. BARD-CoV-2
United Kingdom

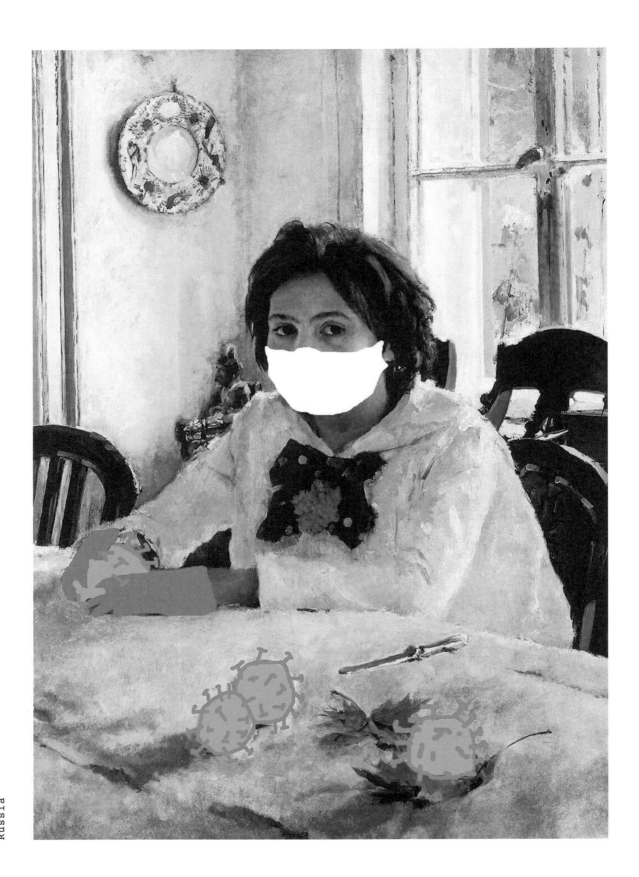

Viacheslav Shilov . Girl with viruses
Russia

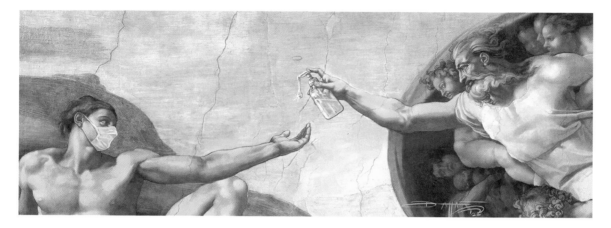

Dattatreya Chiluveru . The Creation of adam Covid-19
India

197

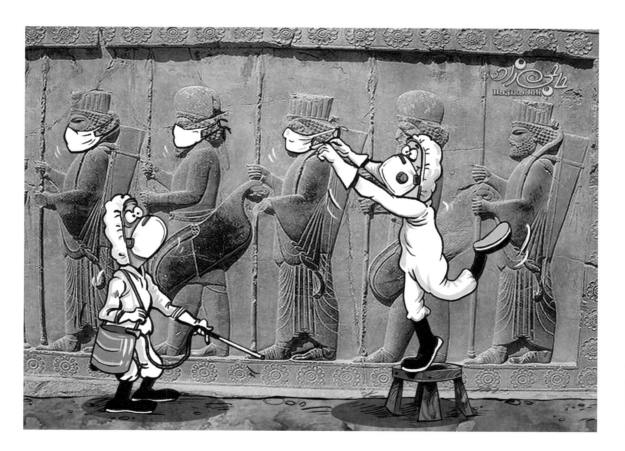

Rasoul Hajizade
Iran

Karry Carrión . Artista Callejero (Karrycaturas Covid)

Peru

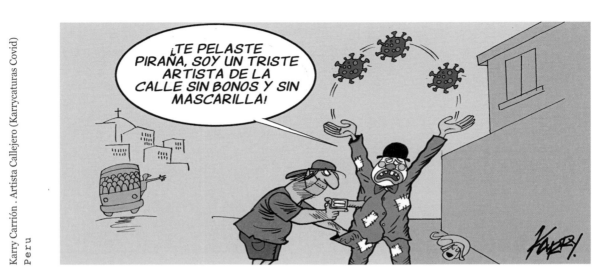

Bad choice, buddy. I'm just a poor street performer with no dough and no mask!

Vadim Siminoga (Вадим Симинога) . Self Care In The Time Of Covid

Ukraine

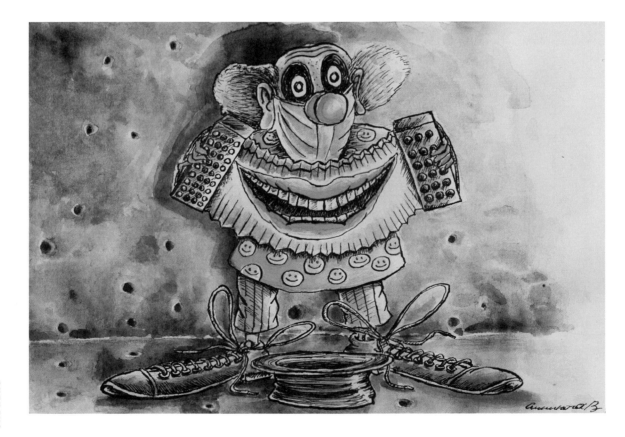

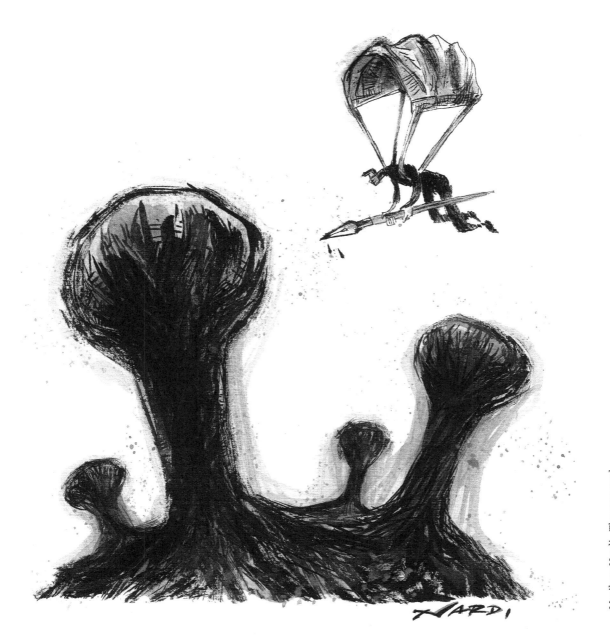

Marilena Nardi . The vanguard
Italy

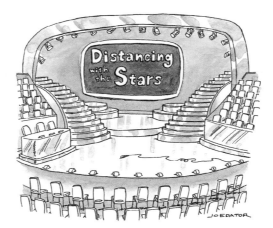

Joe Dator
USA

Seth Fleishman
USA

Ralf Böhme . Blaskonzert
Germany

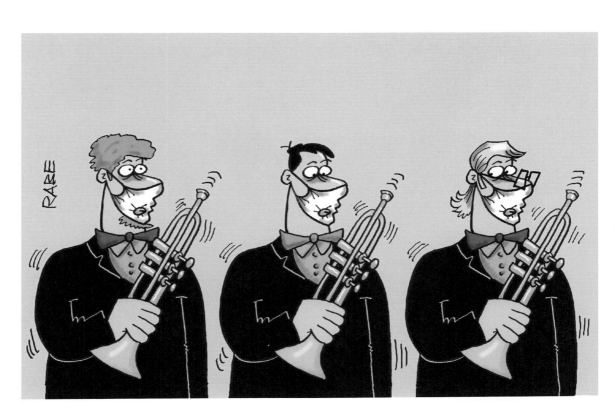

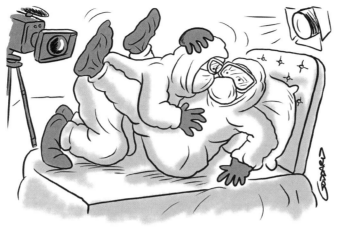

The Future of Adult Films.

Clive Goddard . The Future of Adult Films
United Kingdom

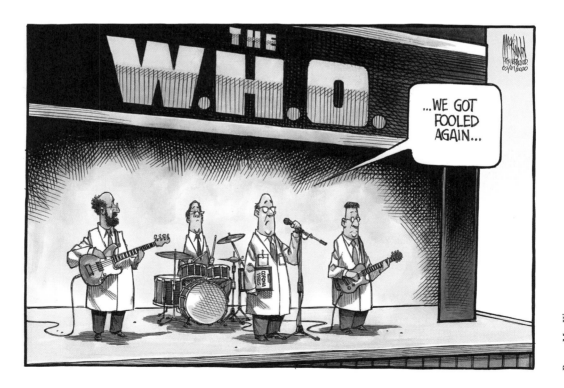

Bruce MacKinnon
Canada

Patrick Blower . Rip Enrico Morricone
United Kingdom

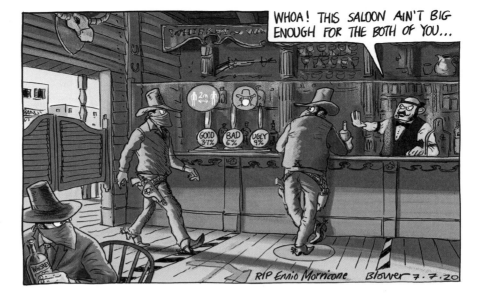

Phil Umbdenstock . Modern Times 2020
France

MODERN TIMES 2020

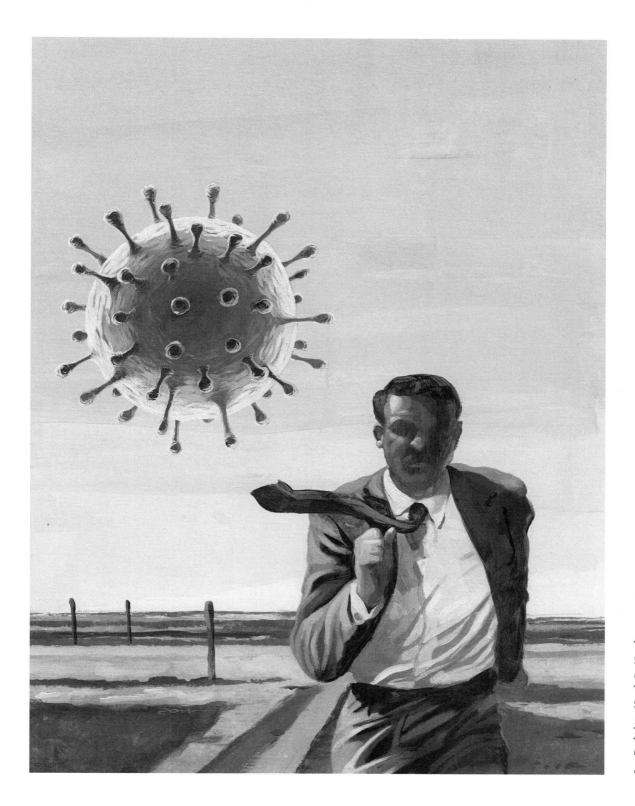

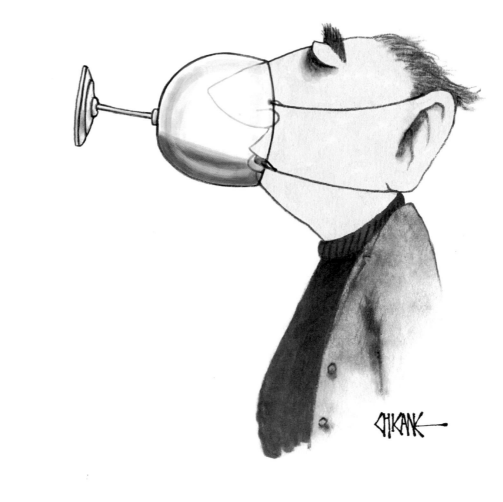

Chicane . Virus vino visor
United Kingdom

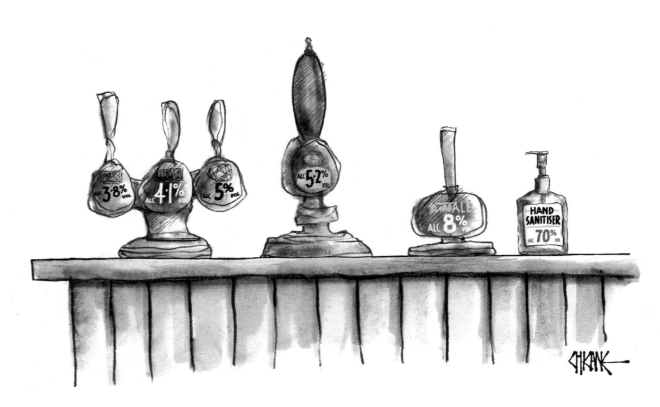

Chicane . Virus volume variation
United Kingdom

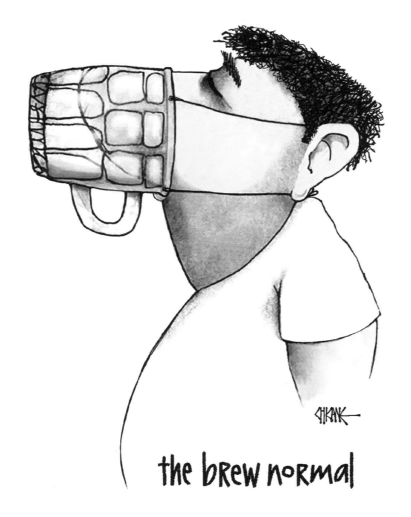

the brew normal

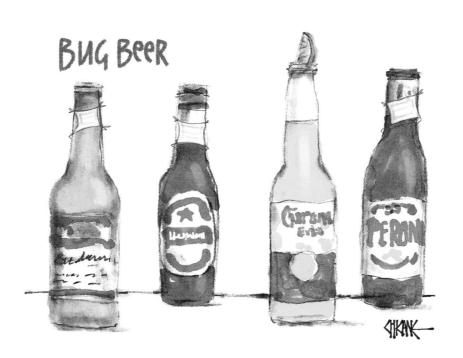

BUG BEER

Chicane . The brew normal
United Kingdom

Chicane . Bug beer
United Kingdom

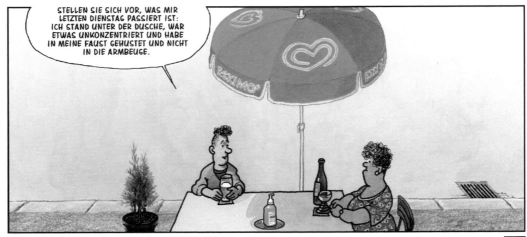

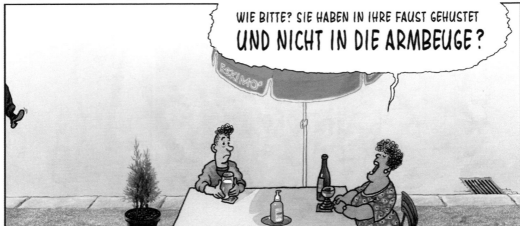

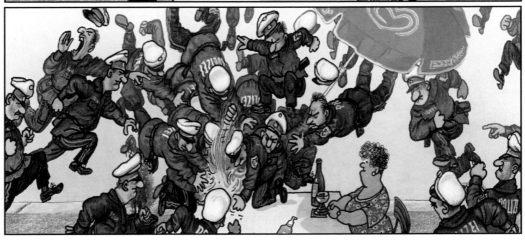

You'll never guess what happened to me last Tuesday: I was in the shower, wasn't really concentrating and coughed into my fist instead of the crook of my arm.

What?! You coughed into your fist INSTEAD OF THE CROOK OF YOUR ARM?!

Gerhard Haderer . Viruspolizei
Austria

Austria

A car from
out of town?

In our vil-
lage?

Not on our
watch — re-
port it!

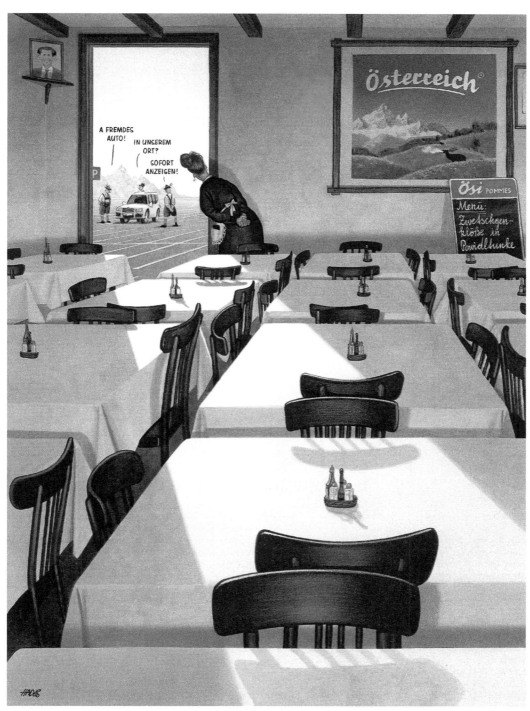

TOURISMUS UND DAS VIRUS

Tourism and
the virus

Gerhard Haderer . Tourismus und das Virus
Austria

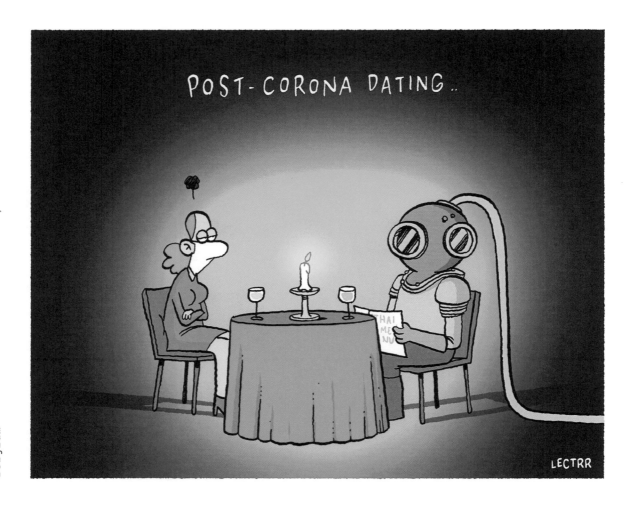

ALCOHOL? I'LL
TAKE THE LOT!

Alcohol gel

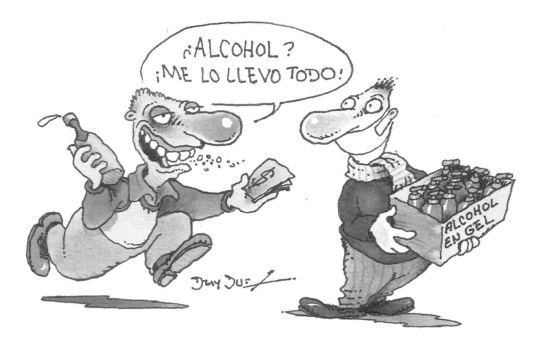

Dany Duel . Alcohol
Argentina

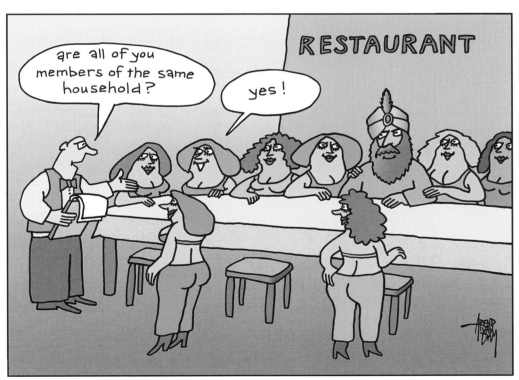

members of the same household

Arend van Dam . same household
Netherlands

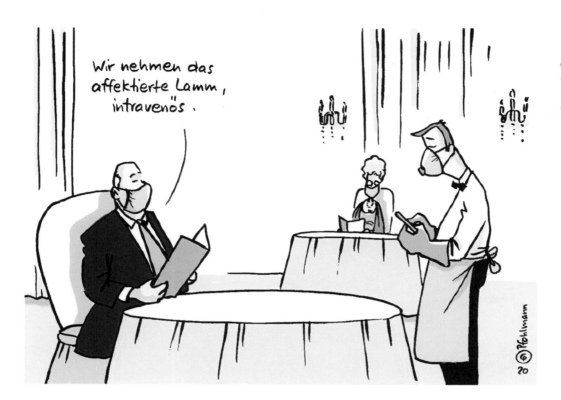

We'll have
the synthet-
ic lamb, in-
travenously.

Christiane Pfohlmann . Hygiene-Gastronomie
Germany

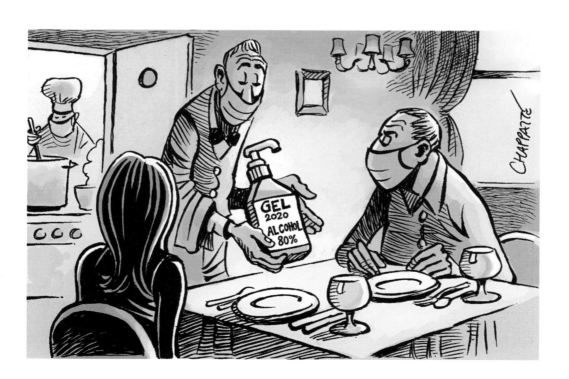

Chappatte . Reopening restaurants (first published in Der Spiegel, Germany)
Switzerland

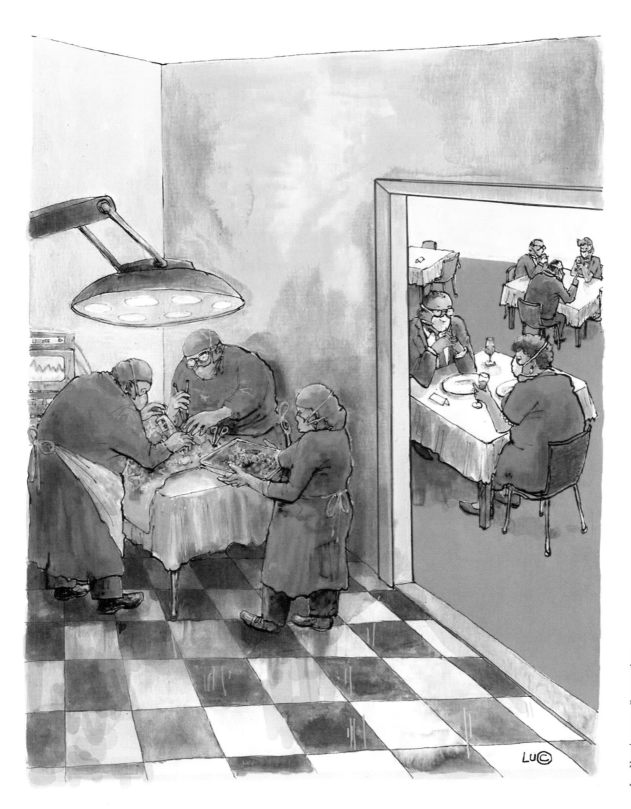

Luc Vernimmen . Corona time
Belgium

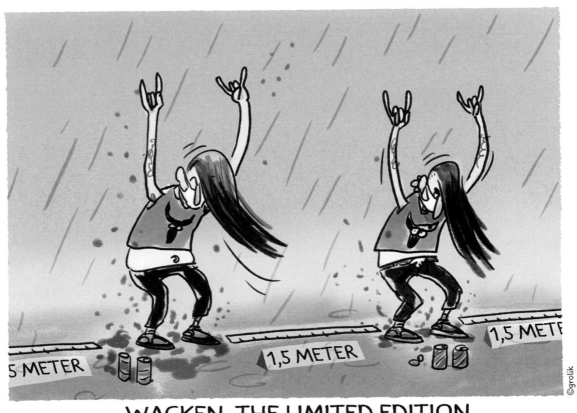

WACKEN, THE LIMITED EDITION

Markus Grolik . Wacken
Germany

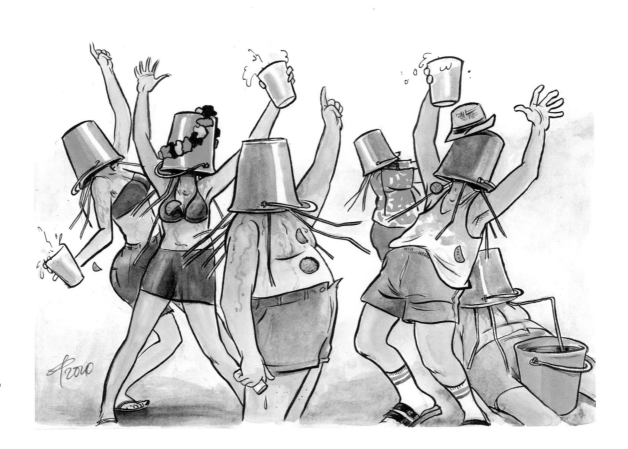

Paolo Calleri . Kompromissvorschlag
Germany

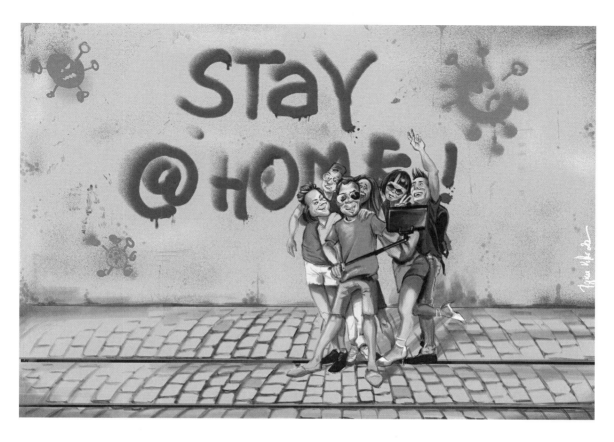

213

Regina Vetter . stay@home!
Switzerland

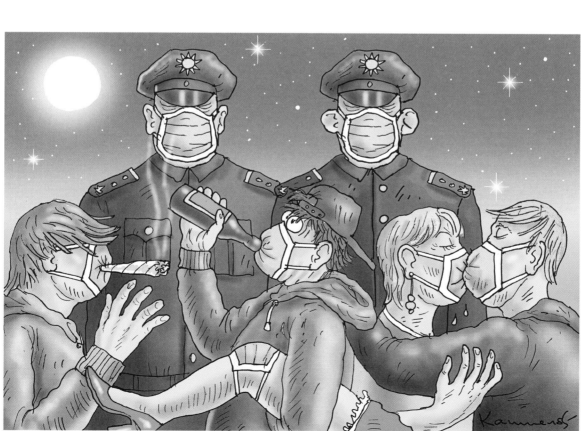

Marian Kamensky . Sex Drugs Rock and Roll nur mit
Austria

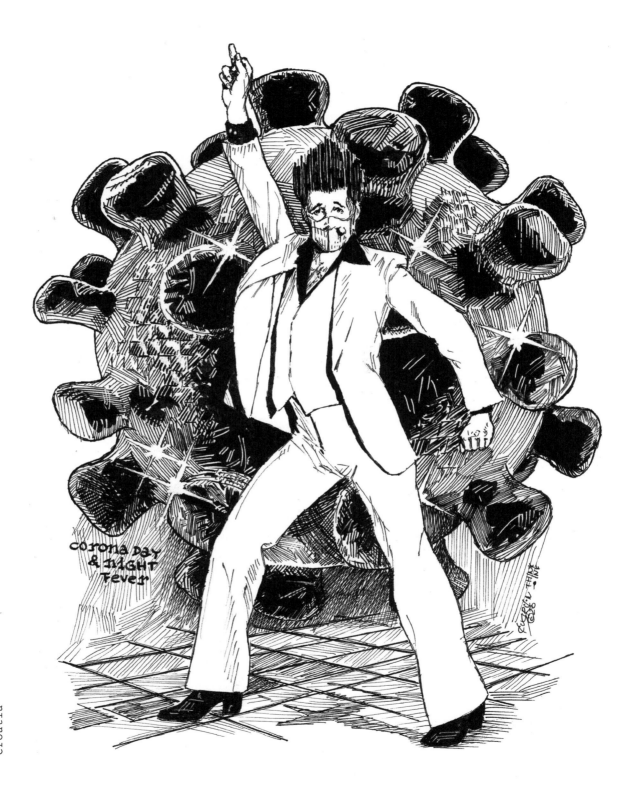

CORONA DAY & NIGHT FEVER

Alem Curin . Day Night Fever
Croatia

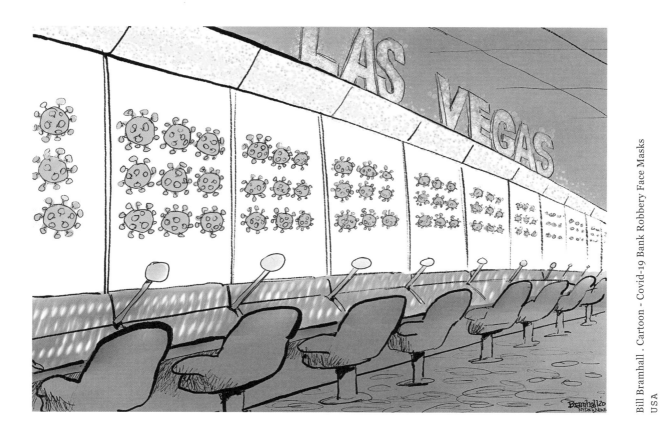

Bill Bramhall · Cartoon - Covid-19 Bank Robbery Face Masks
USA

Andy Marlette · Maskey Mouse, July 17 2020
USA

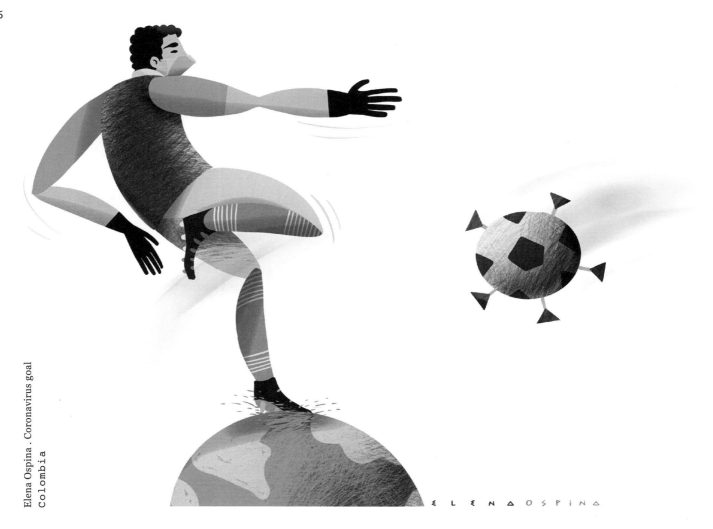

Elena Ospina . Coronavirus goal
Colombia

Soccer
rules …

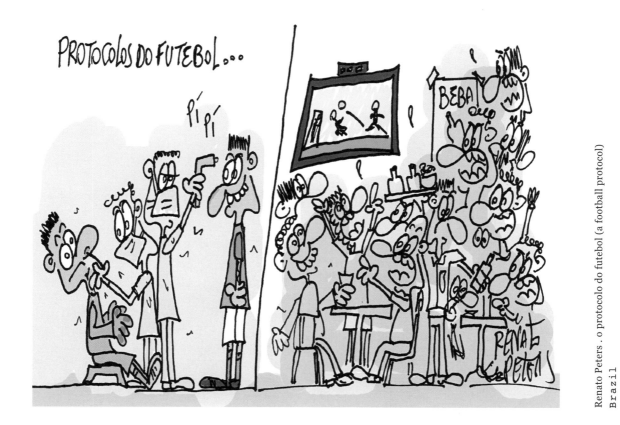

Renato Peters . o protocolo do futebol (a football protocol)
Brazil

217

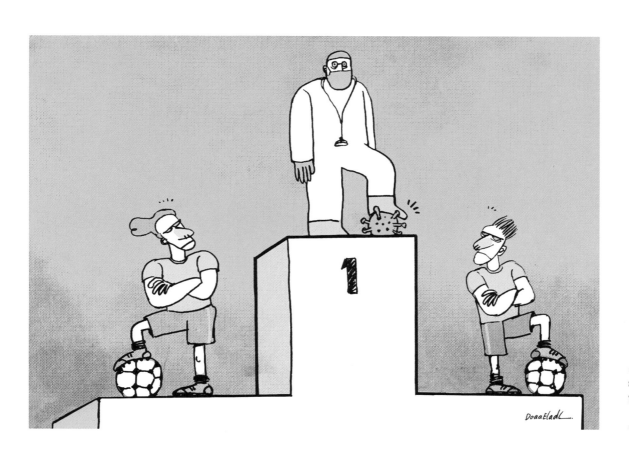

Doaa Eladl . Doctors
Egypt

While working
from home there
is time to clar-
ify the most im-
portant job-re-
lated issues:

Zeit im Homeoffice **hilft, die** wichtigsten berufliche

Trendfrisur «Social Distancing»
Wenn man auf Abstand gehen möchte

Trendfrisur «Lockdown»
Wenn gar nichts mehr geht

Trendfrisur «Vorsichtsmassnah
Wenns nichts mehr gibt

Trend hairstyle
"Social Distancing"

For keeping
your distance

Trend hairstyle
"Lockdown"

When nothing
else works

Trend hairstyle
"Precautions"

When there's
nothing left

Trendfrisur «Flatten-the-curve»
Ball und Kurve flach halten

Trendfrisur «Wuhan Shake»
Einfach mal den Kopf über die Zustände schütteln

www.regina-vetter.ch

Regina Vetter . Homeoffice
Switzerland

```
Trend hairstyle          Trend hairstyle
"Flatten-the-curve"      "Wuhan Shake"

Keep the ball            Just shake your head
and curve flat           about the state of things
```

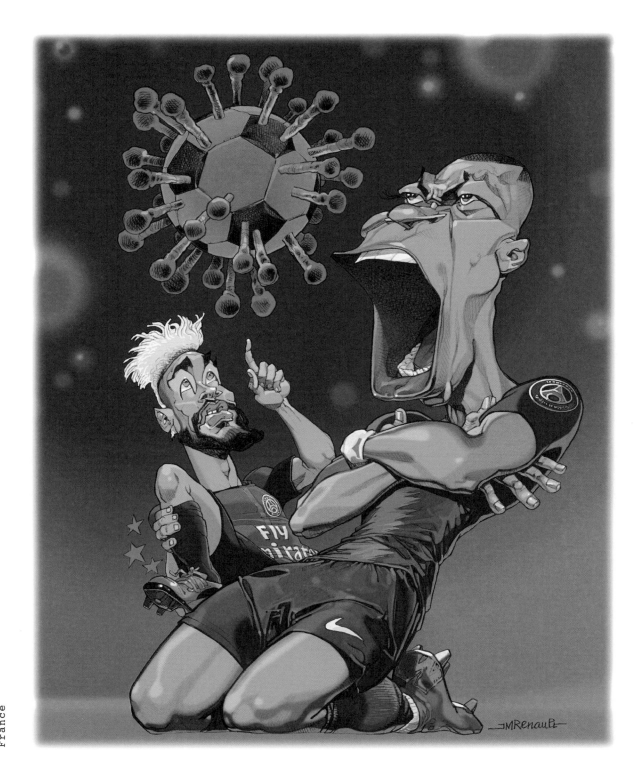

Jean-Michel Renault . La nuit tombe sur la planète Foot
France

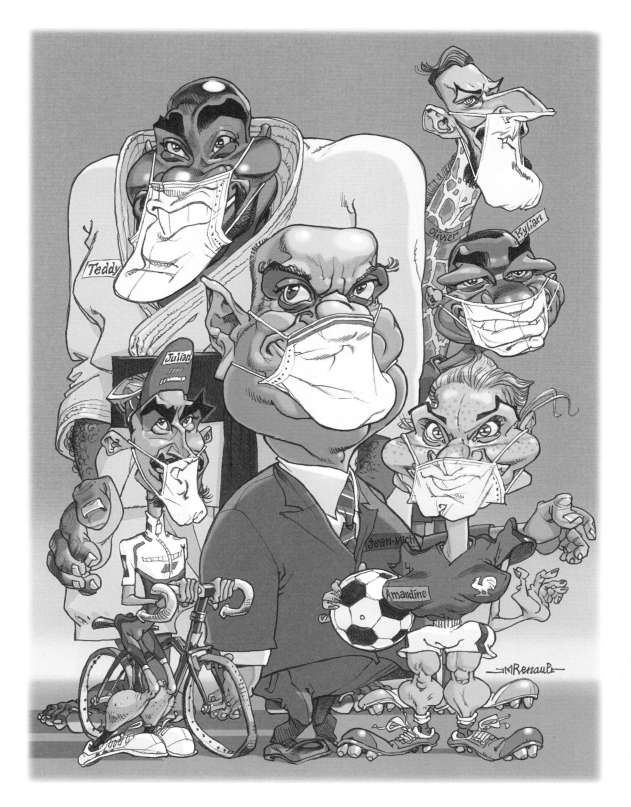

Jean-Michel Renault . le bal des sports reprend, mais masqué

France

Clive Goddard . The Future of Athletics
United Kingdom

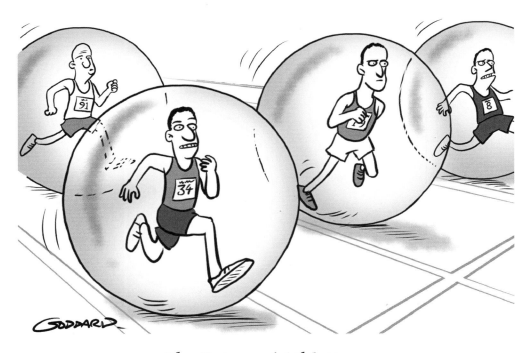

The Future of Athletics.

Christian Berger . Relativ unspannend: Boxkämpfe mit Corona-Abstand
Germany

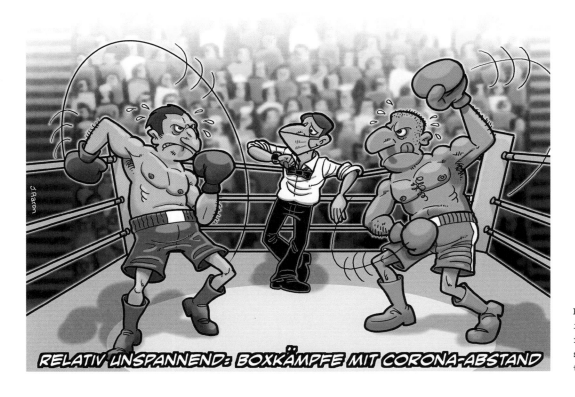

Rather boring: boxing fights with social distancing

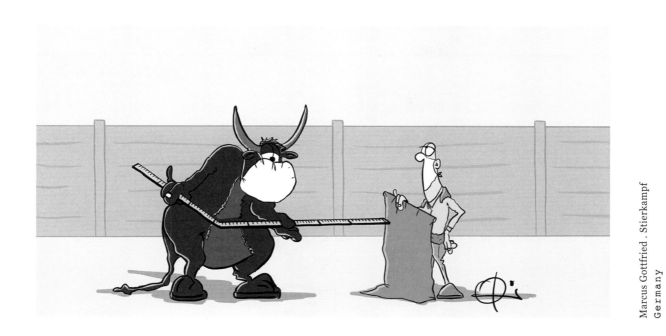

223

Marcus Gottfried . Stierkampf
Germany

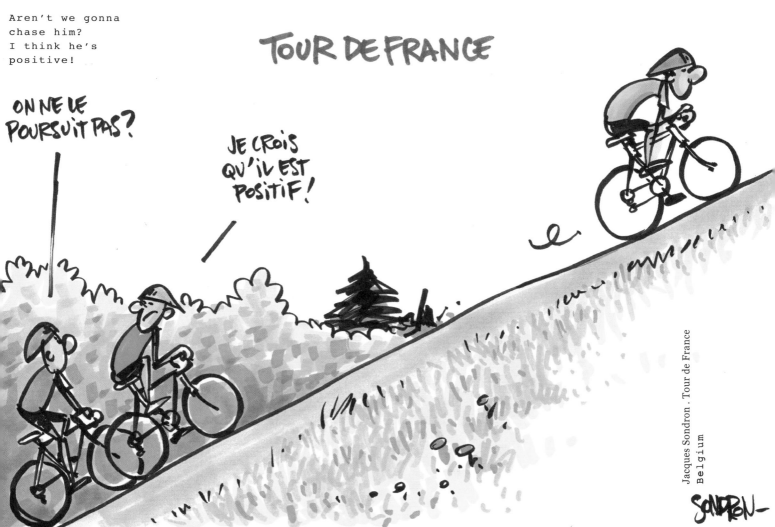

Aren't we gonna
chase him?
I think he's
positive!

TOUR DE FRANCE

Jacques Sondron . Tour de France
Belgium

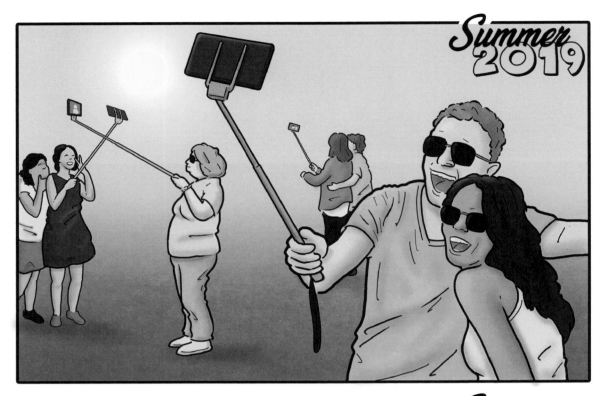

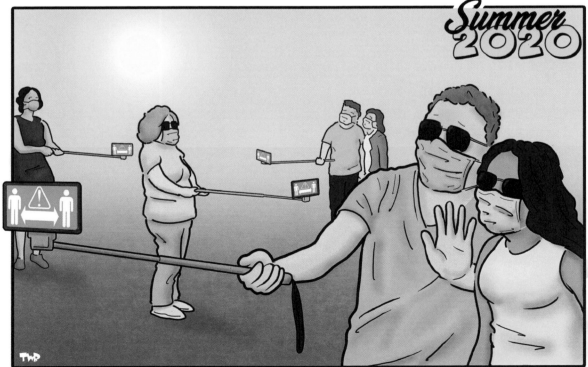

Tjeerd Royaards · Summer 2020
Netherlands

City map

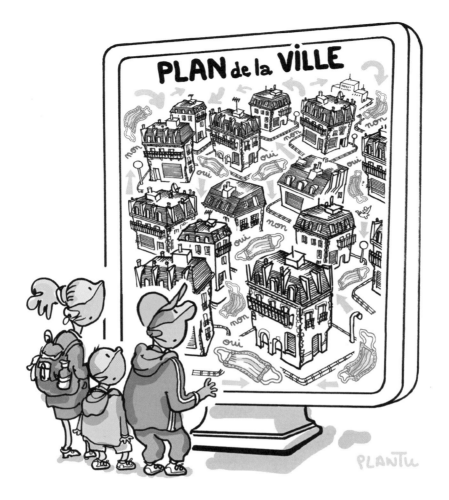

Plantu . Dessin paru dans le Monde
France

225

Ah!
This weeks
activities!

Morning:
measurement
of tempera-
ture

Noon:
evacuation of
sick people

Evening:
temperature
measurement

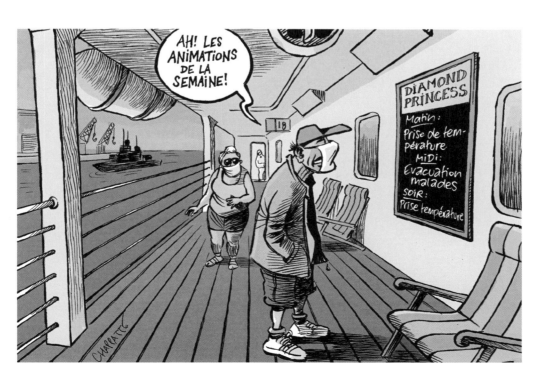

Chappatte . The coronavirus cruise (first published by Le Temps, Switzerland)
Switzerland

Lo Graf von Blickensdorf . Urlaub
Germany

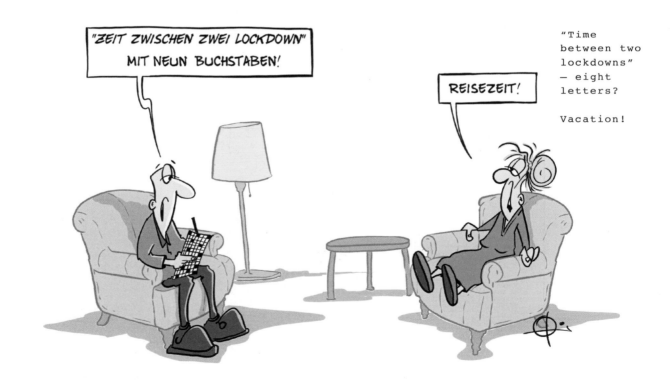

Are you on vacation in the Canaries again?

No, Coronaries this year.

"Time between two lockdowns" — eight letters?

Vacation!

Marcus Gottfried . Lockdown
Germany

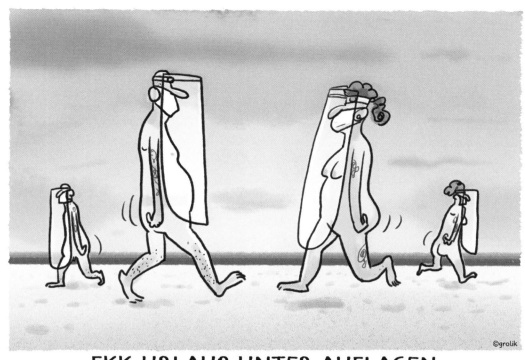

Nudist holidays with restrictions

FKK-URLAUB UNTER AUFLAGEN

Markus Grolik . FKK-Urlaub
Germany

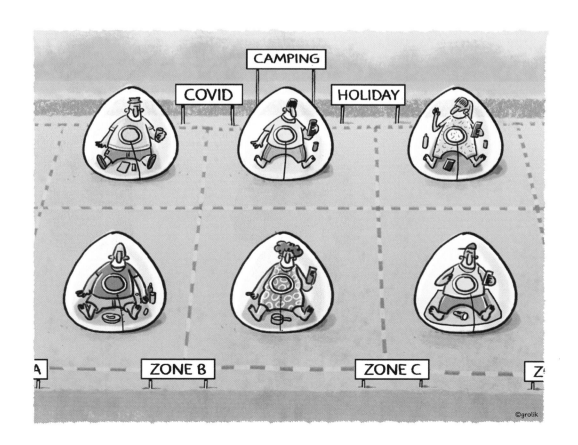

Markus Grolik . Bubble
Germany

228

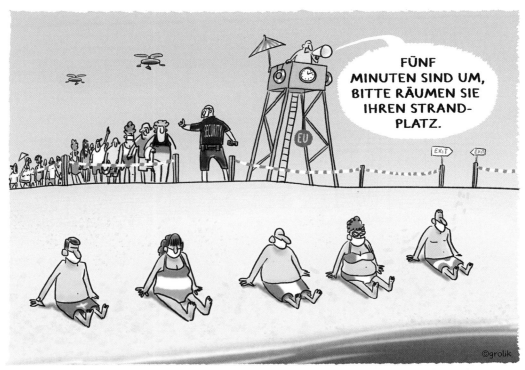

EU-SOMMERURLAUB IM SCHICHTBETRIEB

Your five minutes are up. Please leave and take your belongings with you.

EU summer holidays … in shifts

Markus Grolik . EU-Sommer
Germany

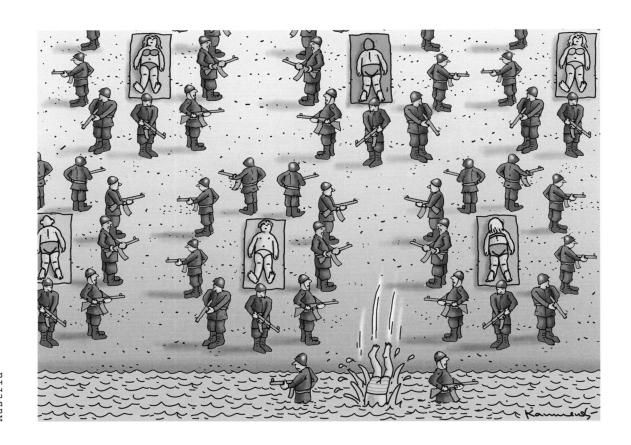

Marian Kamensky . Sommerurlaub 2020
Austria

Ladies and Gentlemen, this is your captain speaking. Due to the new coronavirus regulations, I will be working from home today …

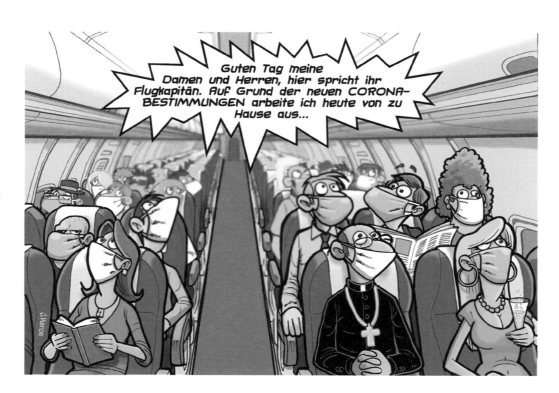

Christian Berger . Homeoffice
Germany

Cristina Sampaio . The Traveler
Portugal

André Carrilho . The Opposite of Panic
Portugal

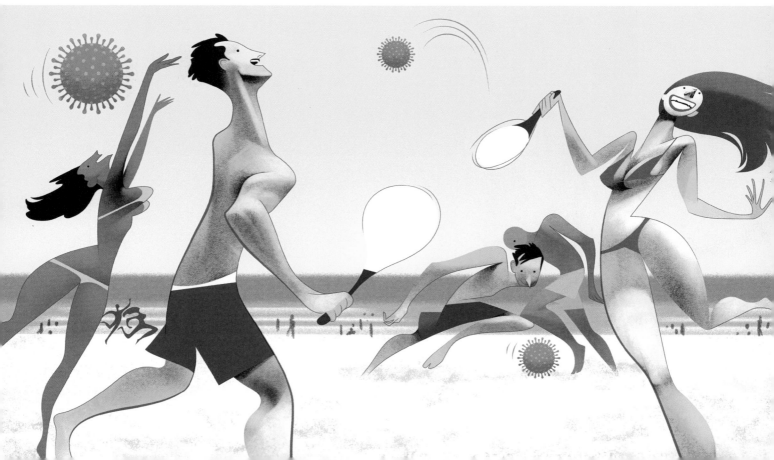

DER LETZTE SCHREI

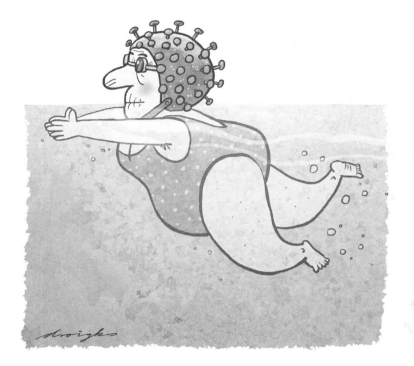

Sylvio Droigk . Der letzte Schrei
Germany

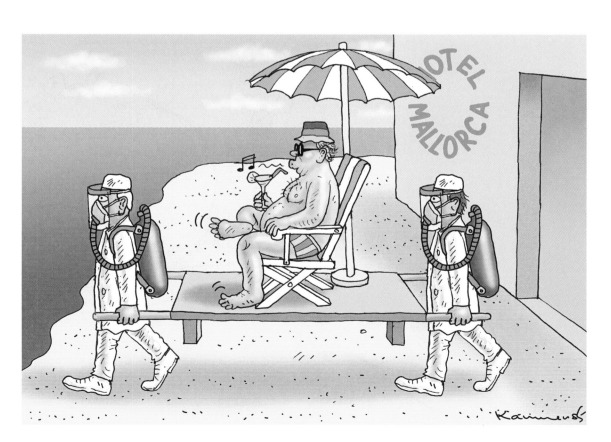

Marian Kamensky . Deutsch-Urlaub auf Mallorca
Austria

Toso Borkovic . Obscuration
Serbia

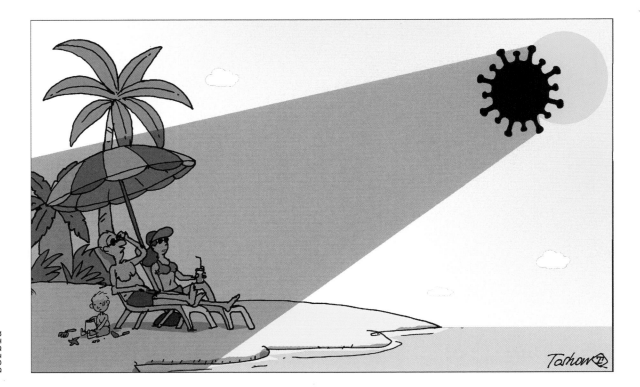

Biz (Pierre Bizalion) . Covid à la plage
France

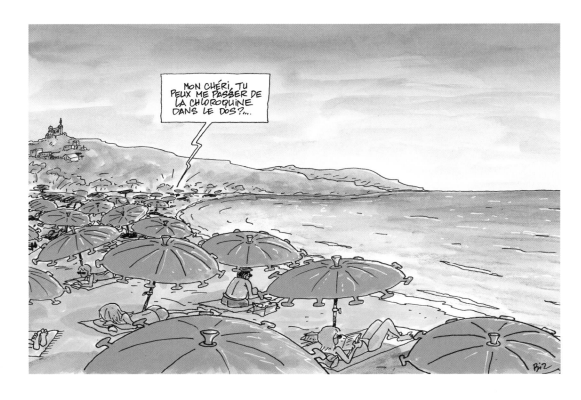

Honey,
could you
rub some
chloro-
quine into
my back?

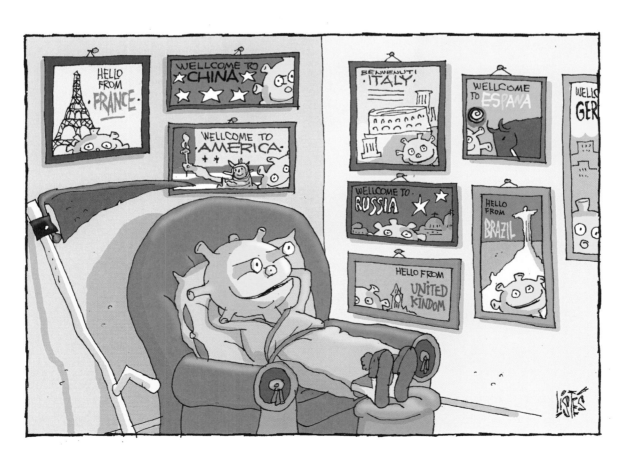

Santiago . Dangerous Travelers
Brazil

Nikola Listeš . Corona's Travels
Croatia

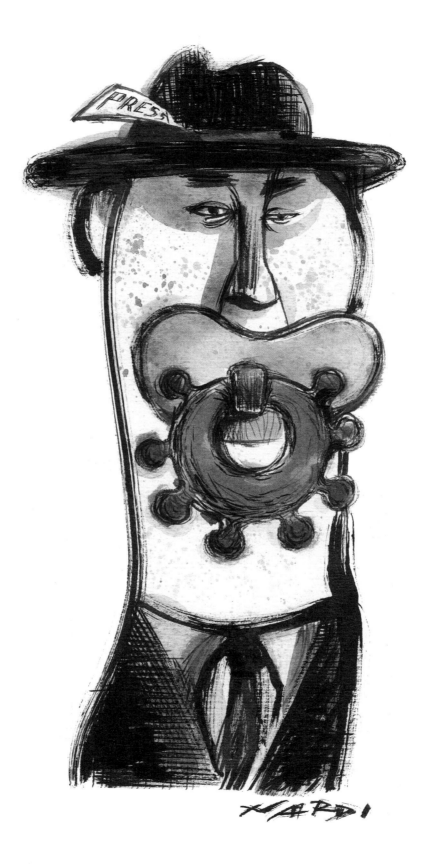

Marilena Nardi . Tout va bien/Everything good
Italy

U.S. VIRUS WARNING ROCKS MARKETS
The Wall Street Journal, February 26, 2020

«AT ALL COSTS»
Libération, March 13, 2020

JOB LOSSES SOAR; U.S. VIRUS CASES TOP WORLD
The New York Times, March 27, 2020

QUESTIONS WITHOUT ANSWERS
The Daily Telegraph, April 2, 2020

ECONOMY IN FREE FALL AS JOBLESS CLAIM SURGE
The Washington Post, April 10, 2020

THE BUSINESS OF SURVIVAL
The Economist, April 11, 2020

THEY WERE WARNED
aily Mirror, April 25, 2020

THE HOUR OF CONSPIRACY THEORIES
Die Zeit, May 14, 2020

Ilya Katz . Coronavirus Pandemic
Israel

André Carrilho . Ocean Trash
Portugal

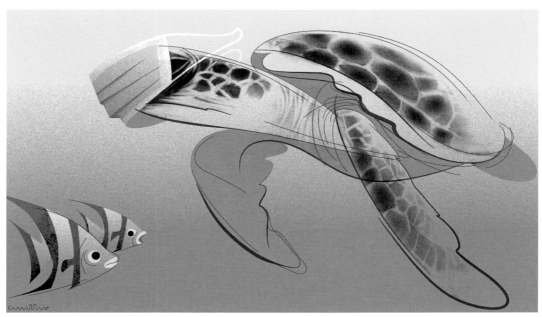

"I don't think it's about an illness, that's just ocean trash…"

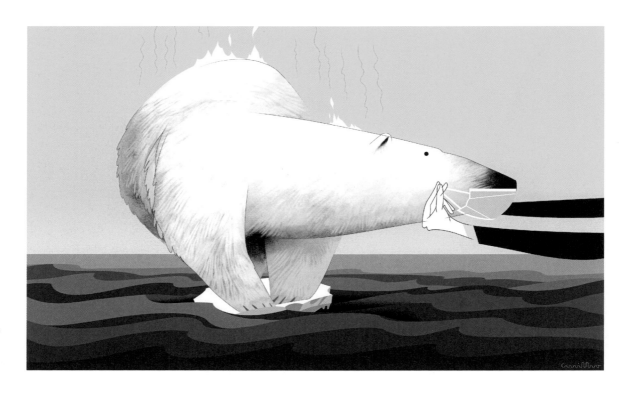

André Carrilho . Priorities
Portugal

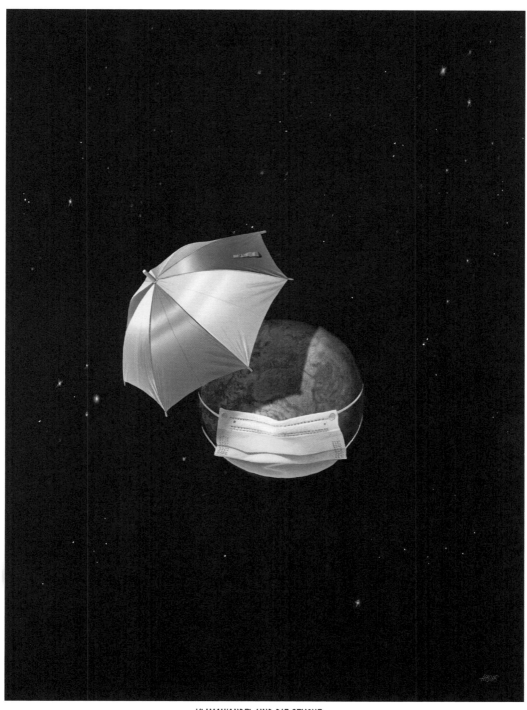

KLIMAWANDEL UND DIE SEUCHE

Climate
change and
the epidemic

Gerhard Haderer . Klimawandel und die Seuche

Austria

Chicane . Mosquito test+taste
United Kingdom

Vladimir Stankovski . All Together
Serbia

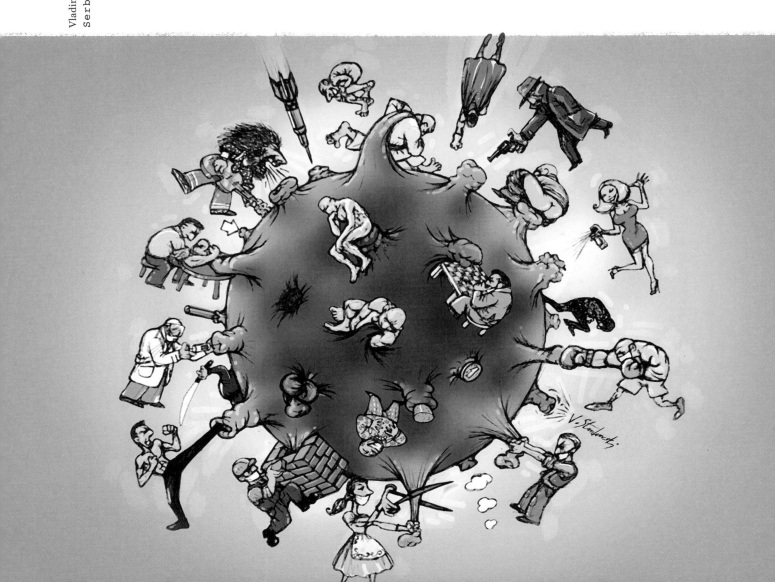

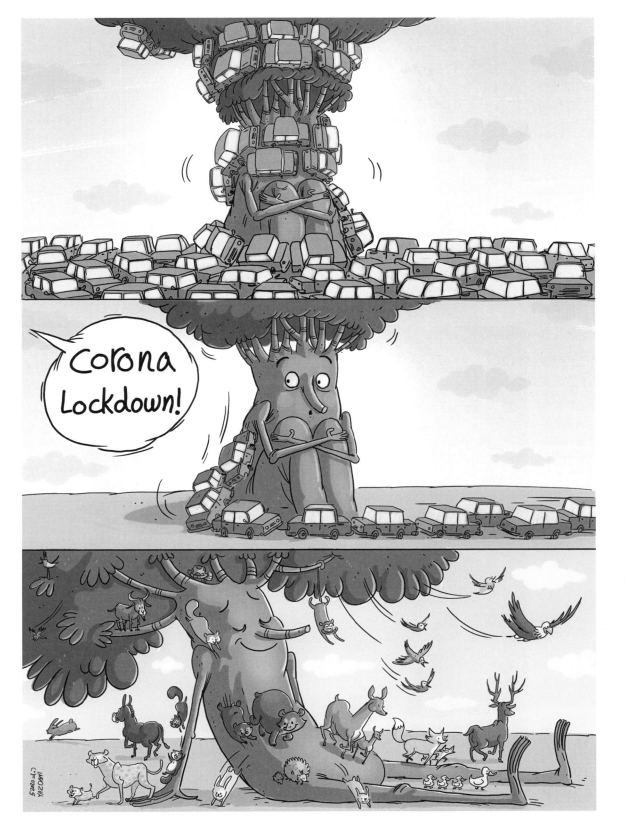

Mahnaz Yazdani . Lock Down & Nature Reconstruction

Iran

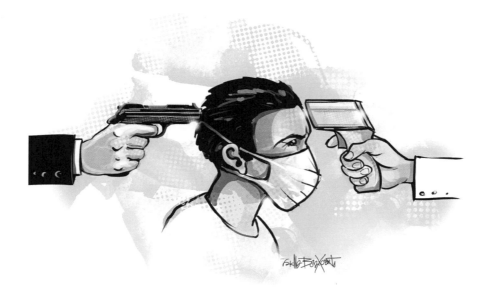

Jaksa Vlahovic . Guns
Serbia

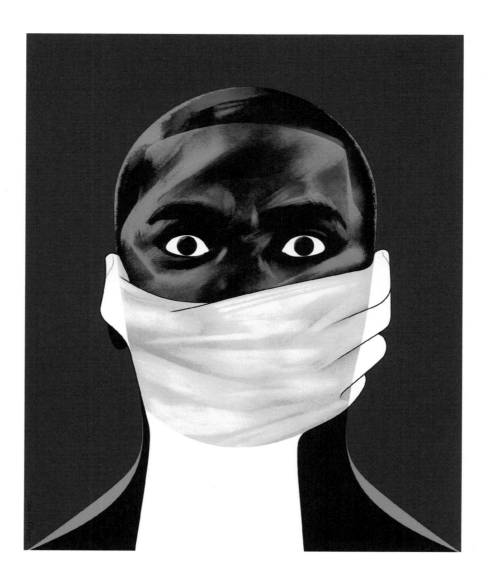

André Carrilho . We Can't Breathe
Portugal

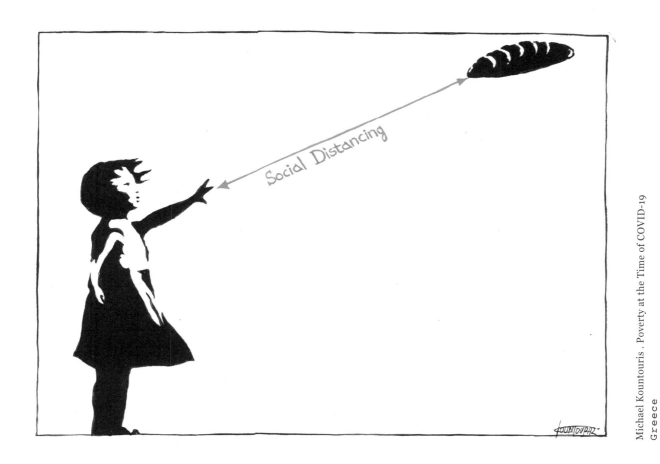

Michael Kountouris . Poverty at the Time of COVID-19
Greece

243

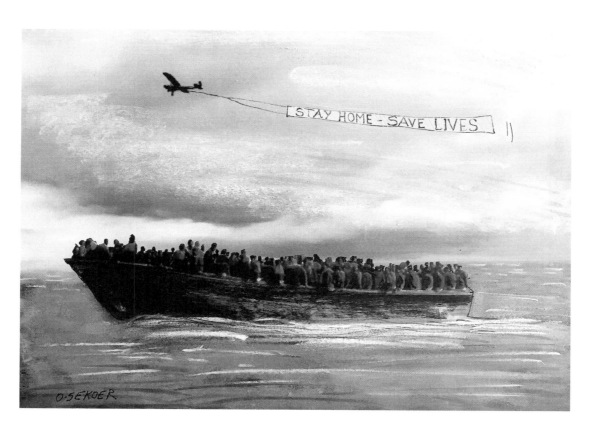

Luc Descheemaeker . Stay Home
Belgium

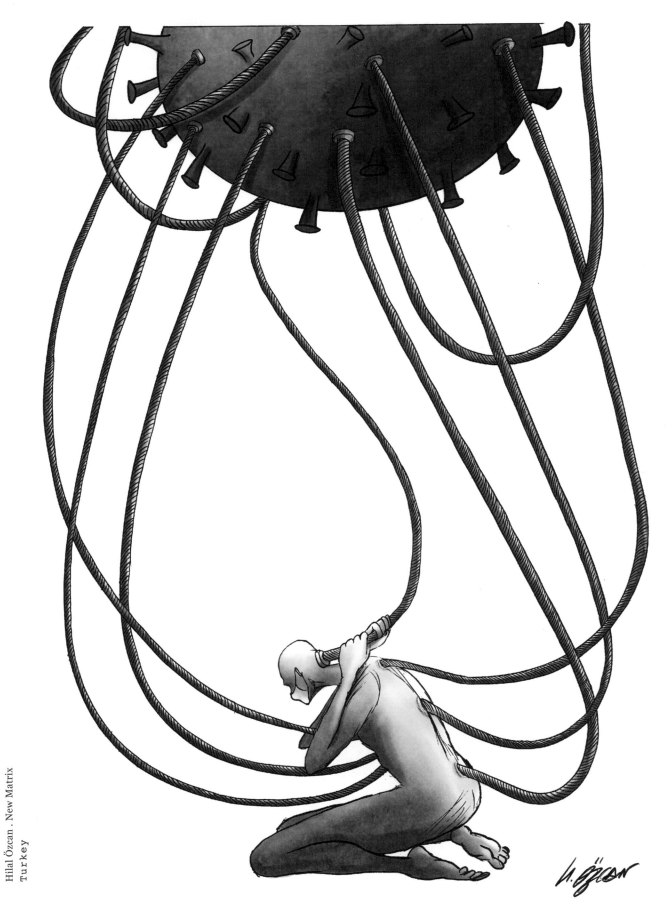

Hilal Özcan . New Matrix
Turkey

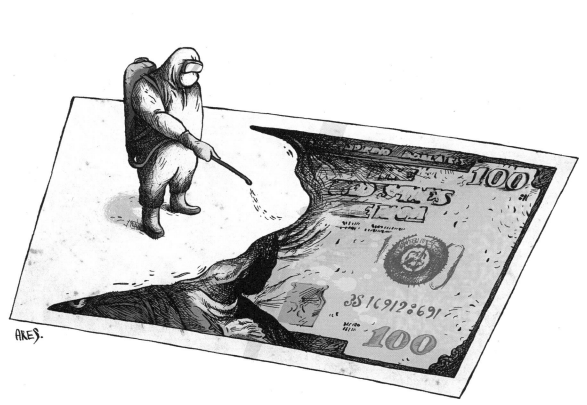

Juancarlos Contreras . Hungry Virus
Spain

Ares
Cuba

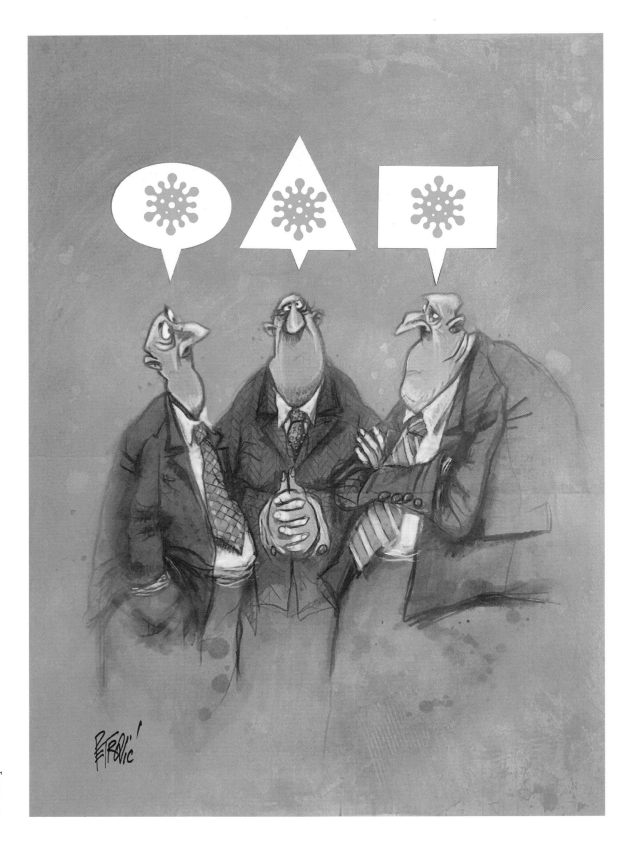

Zoran Petrovic
Germany

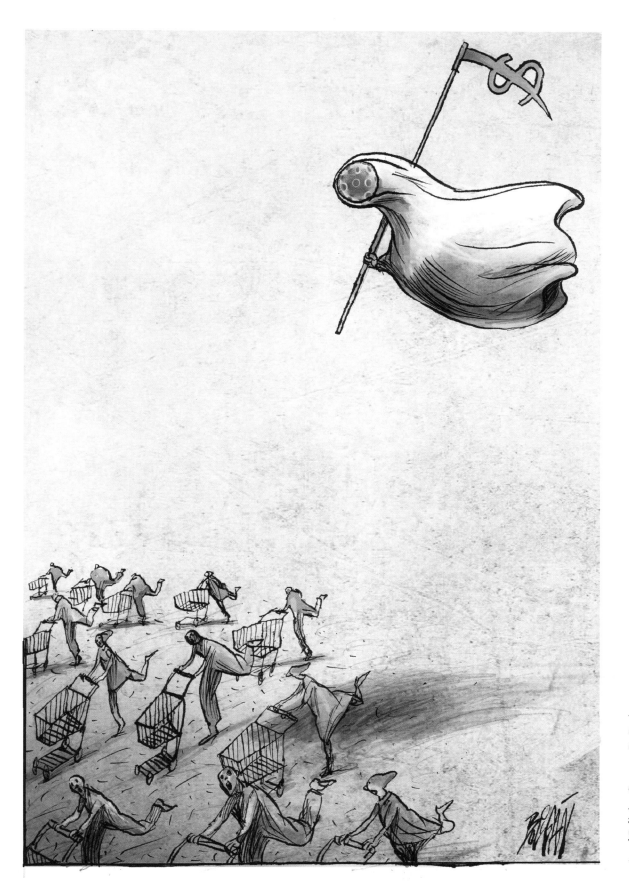

Angel Boligán . Compras De Panico
Mexico

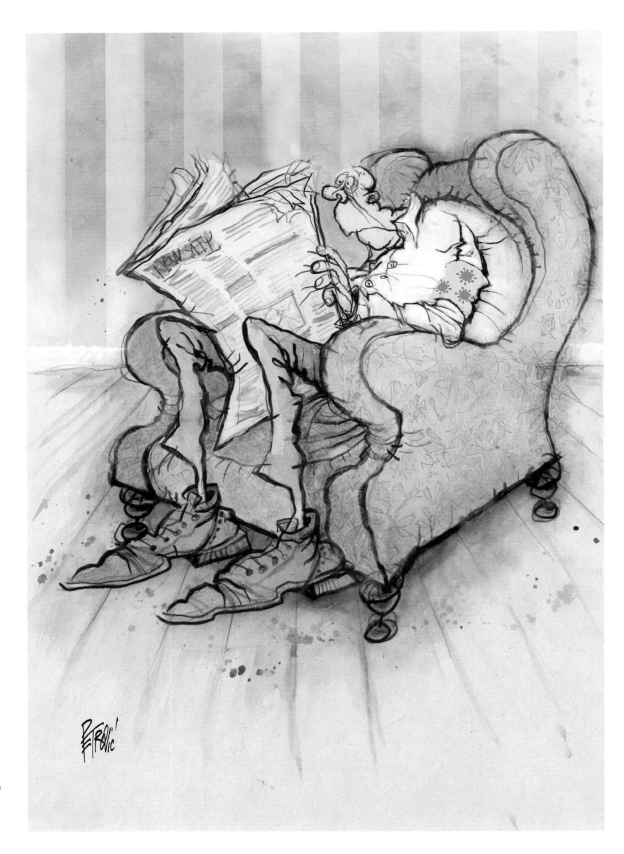

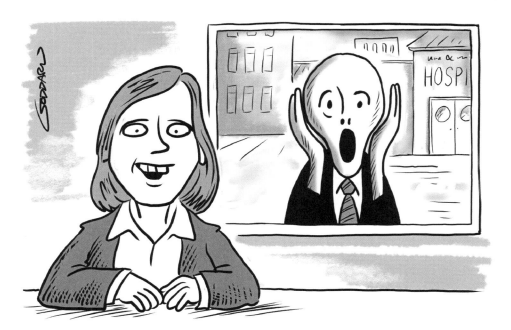

"Now over to our healthcare correspondent…"

Clive Goddard . Health Correspondent
United Kingdom

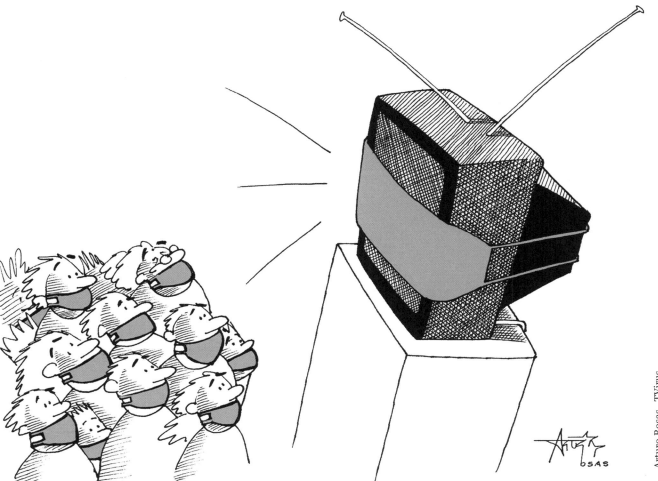

Arturo Rosas . TVirus
Mexico

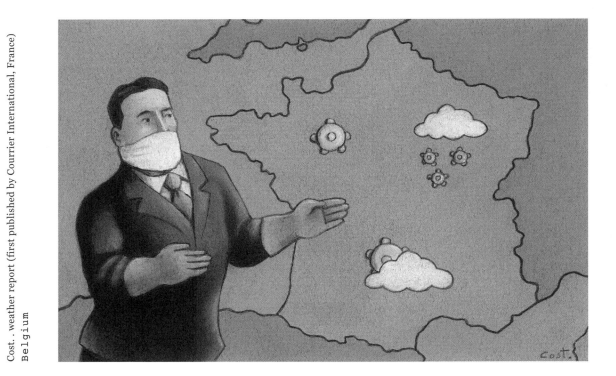

Cost. . weather report (first published by Courrier International, France)
Belgium

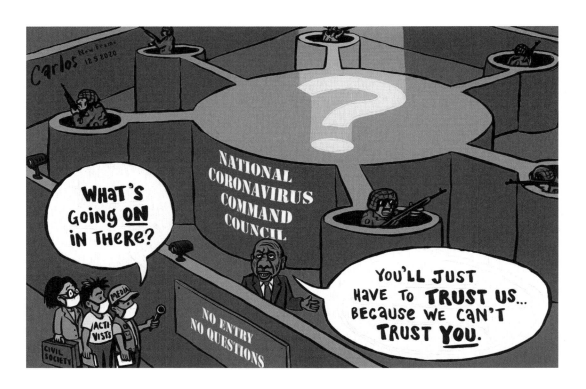

Carlos Amato . Command (first published by NewFrame.com)
South Africa

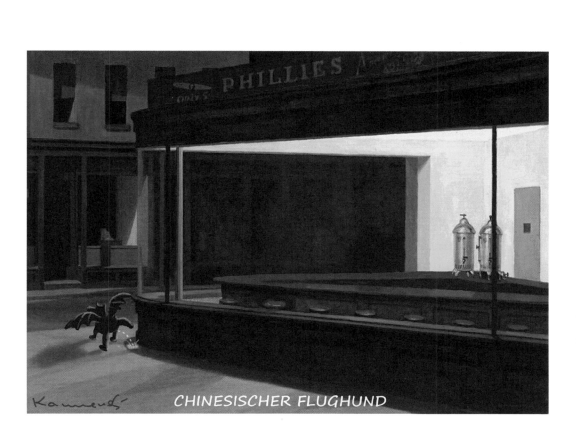

Chinese
flying fox

CHINESISCHER FLUGHUND

Doru Bosiok
Serbia

Marian Kamensky . Chinesischer Flughund in Amerika
Austria

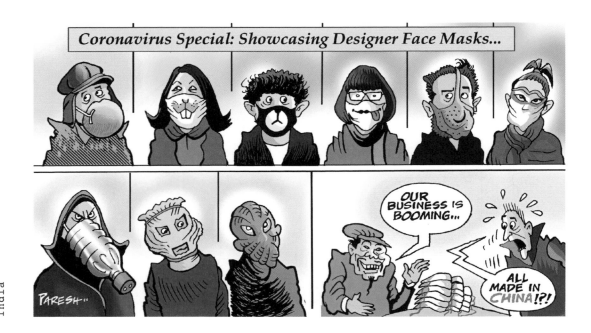

Paresh Nath . Coronavirus face masks
India

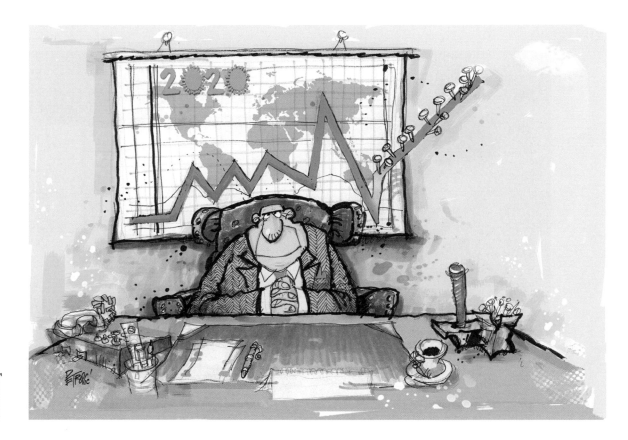

Zoran Petrovic
Germany

Sorry, I can't find the title "The Book Trade and the Coronavirus Conspiracy" anywhere in the system.

Typical — you're part of the conspiracy!

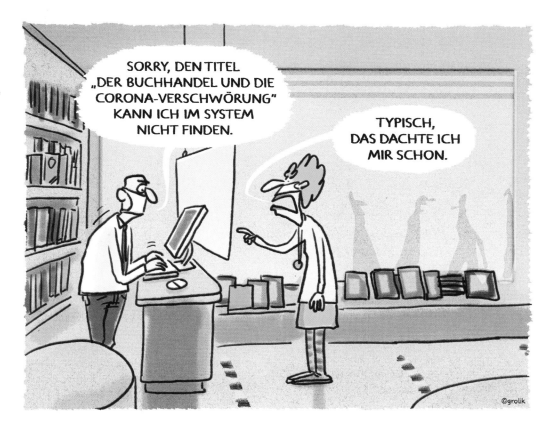

Markus Grolik . Buchhandel
Germany

Bas van der Schot . Corona virus
Netherlands

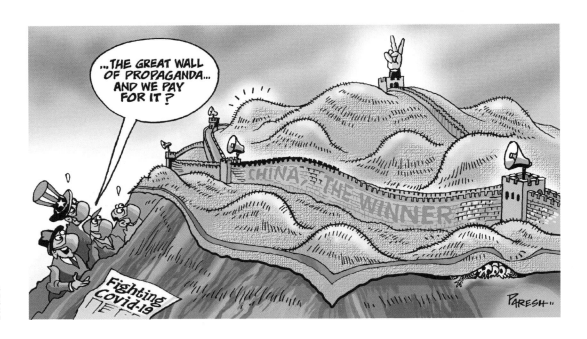

Paresh Nath . China wall of propaganda
India

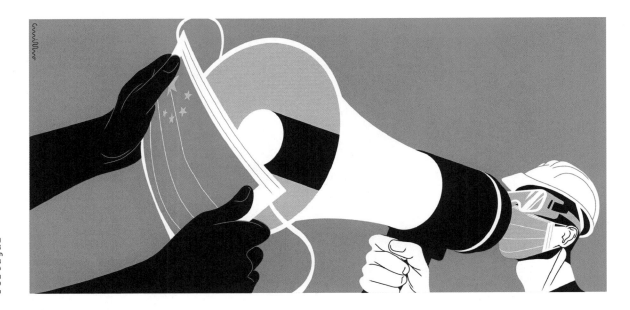

André Carrilho . Repression in Hong Kong
Portugal

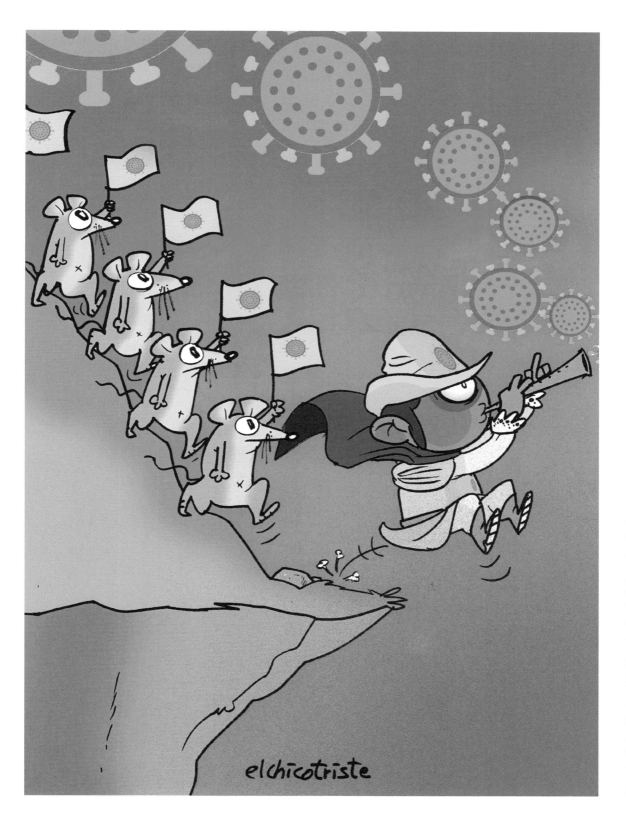

255

Miguel villalba Sánchez "Elchicotriste" . Viral obsession flutist
spain

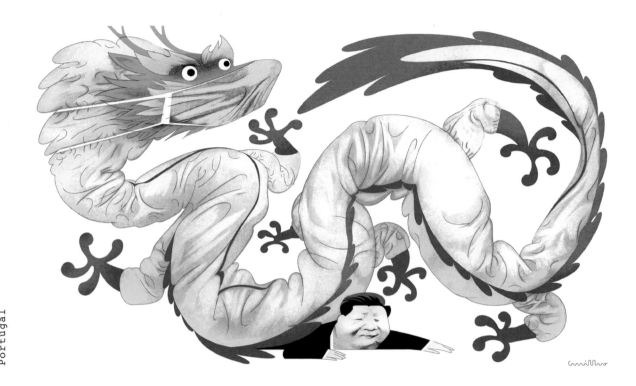

André Carrilho . Quarantine
Portugal

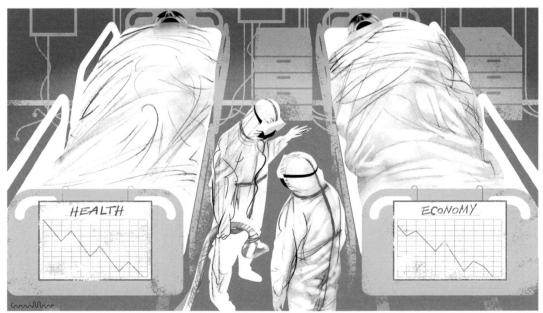

André Carrilho . Health vs Economy
Portugal

"I'm afraid we only have ONE ventilator..."

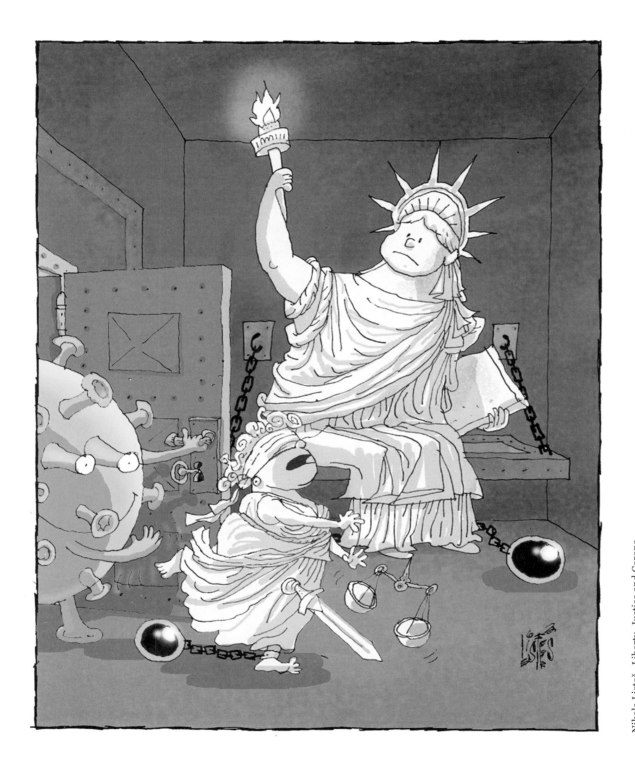

Nikola Listeš . Liberty, Justice and Corona
Croatia

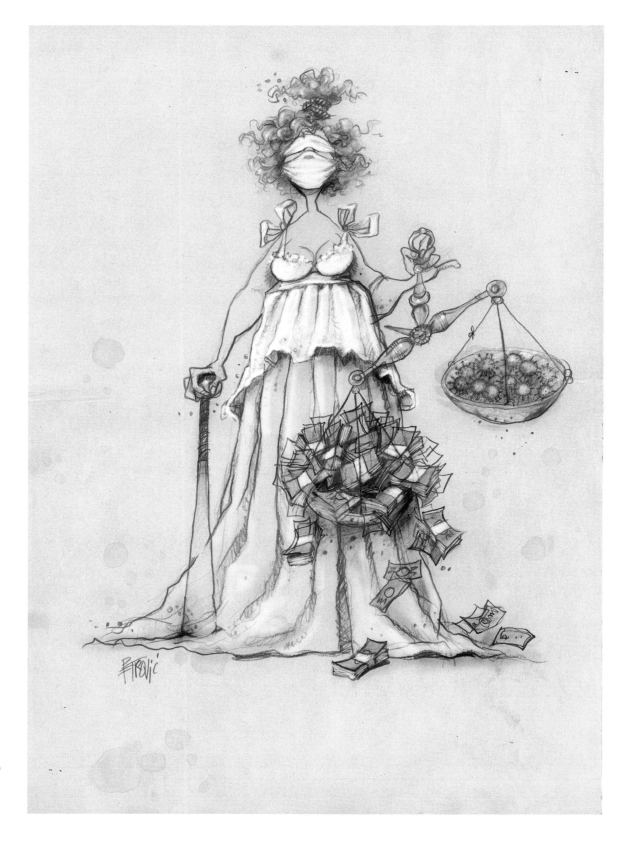

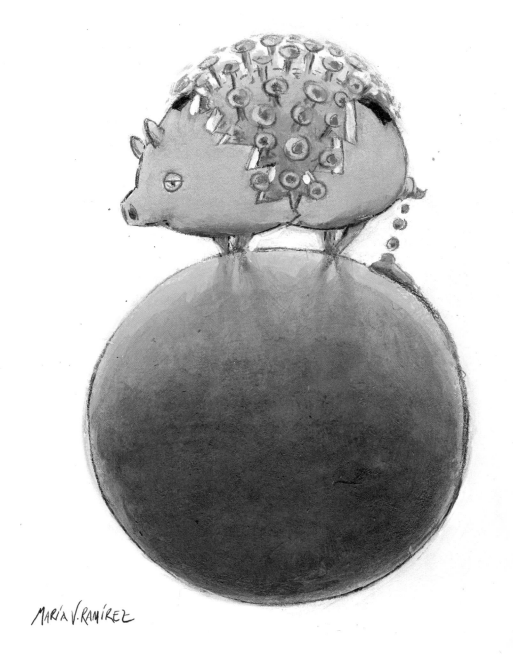

MARÍA V. RAMÍREZ

María Verónica Ramírez . Crack
Argentina

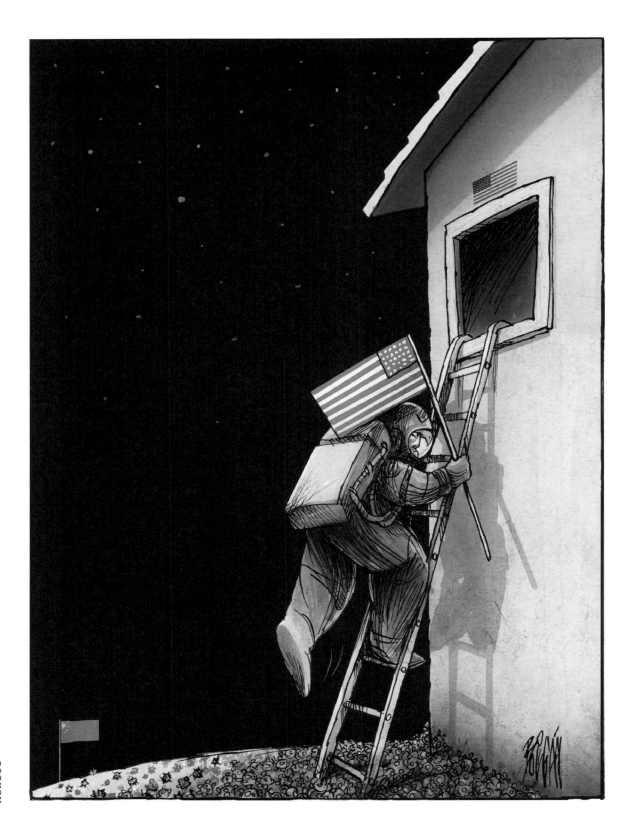

Angel Boligán . La Conquista del Planeta
México

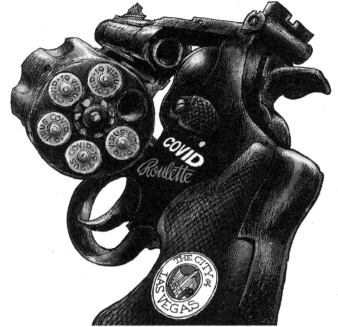

LAS VEGAS MAYOR GOODMAN'S GAMBLE.

michaelpramirez.com

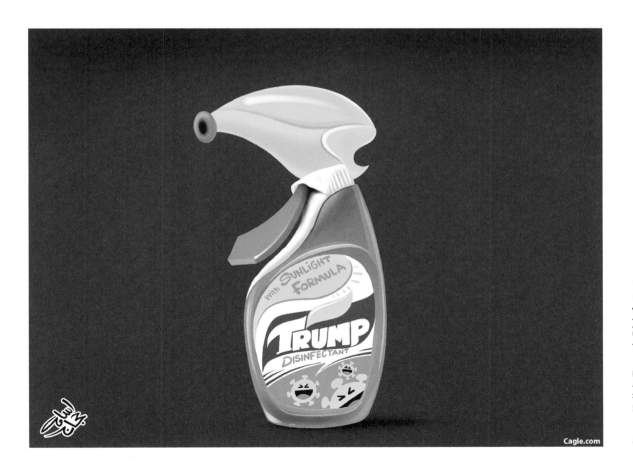

261

Michael Pramirez . Las Vegas Mayor Goodman's Gamble
USA

Osama Hajjaj . Trump's Disinfectant
Jordan

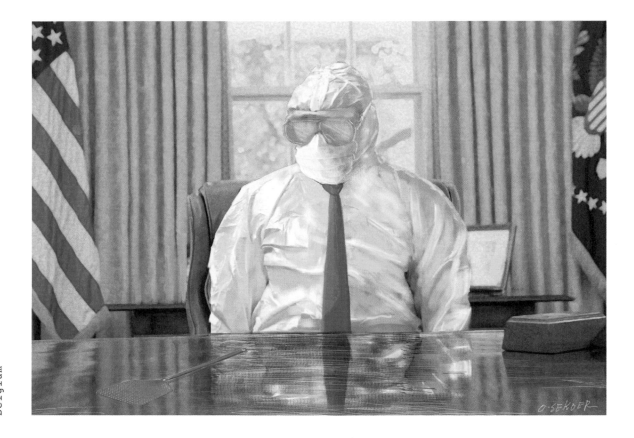

Luc Descheemaeker . Quarantine
Belgium

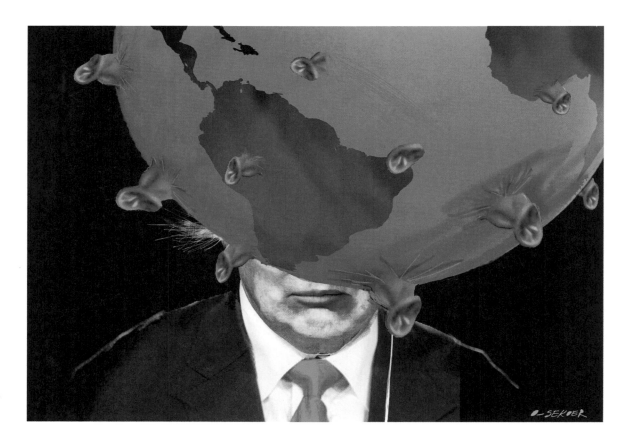

Luc Descheemaeker . It Is What It Is
Belgium

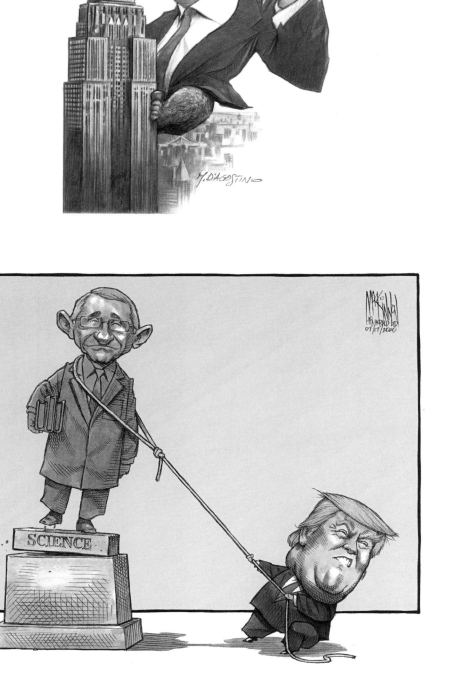

Marco D'Agostino . TrumpKong
Italy

Bruce MacKinnon
Canada

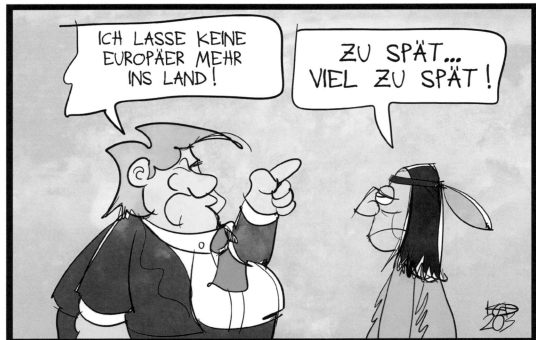

Kostas Koufogiorgos . Einreiseverbot USA
Germany

Not gonna let any more Europeans in!

Too late … much too late!

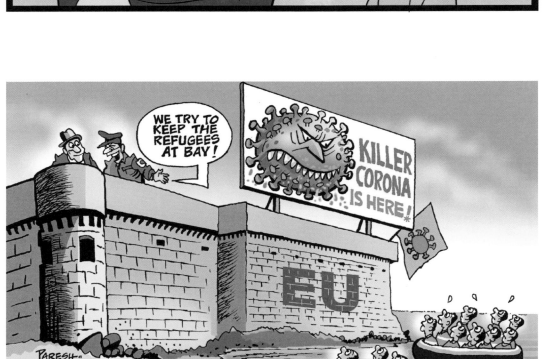

Paresh Nath . EU and Refugees
India

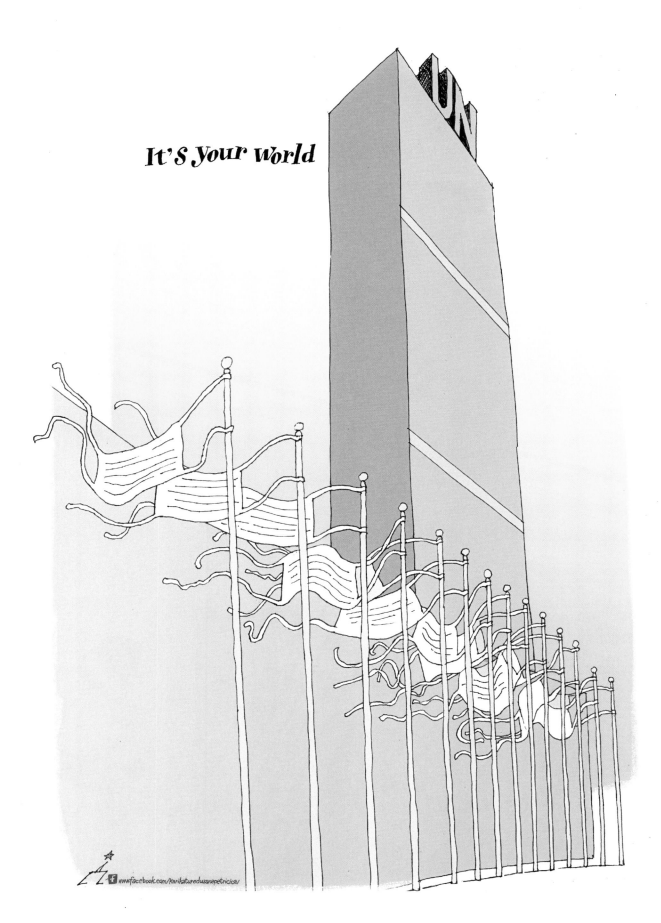

It's your world

Dušan Petričić . It's your world
Serbia

www.facebook.com/Karikaturedusanapetricica/

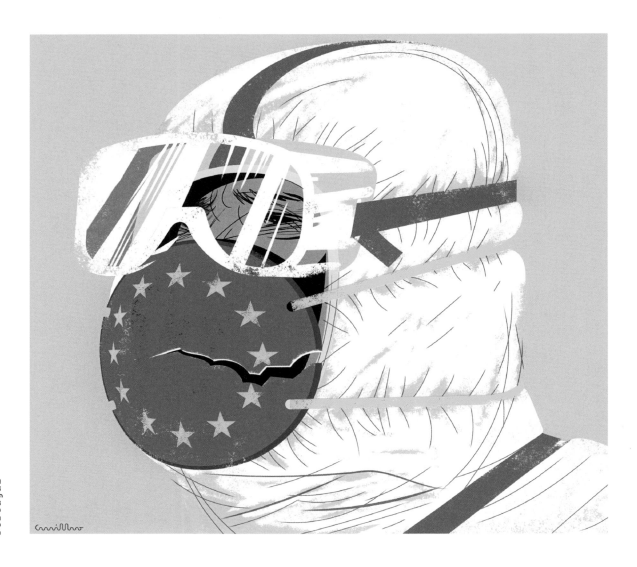

André Carrilho . North and South
Portugal

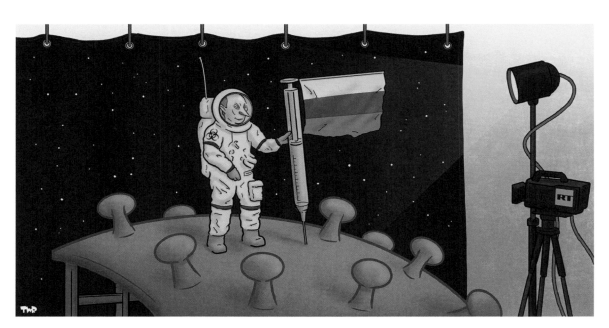

Tjeerd Royaards . Hoax
Netherlands

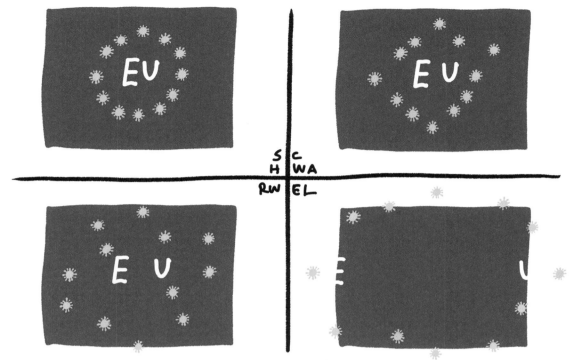

SOCIAL DISTANCING À LA EUROPA

Schwarwel . Corona Ungarn Notstandsgesetz
Germany

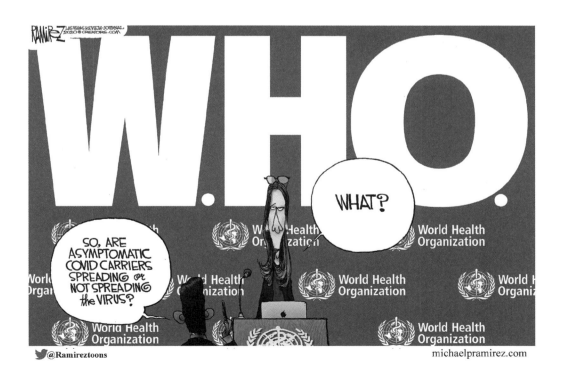

Michael Ramirez . Michael Ramirez Editorial Cartoons: W.H.O.
USA

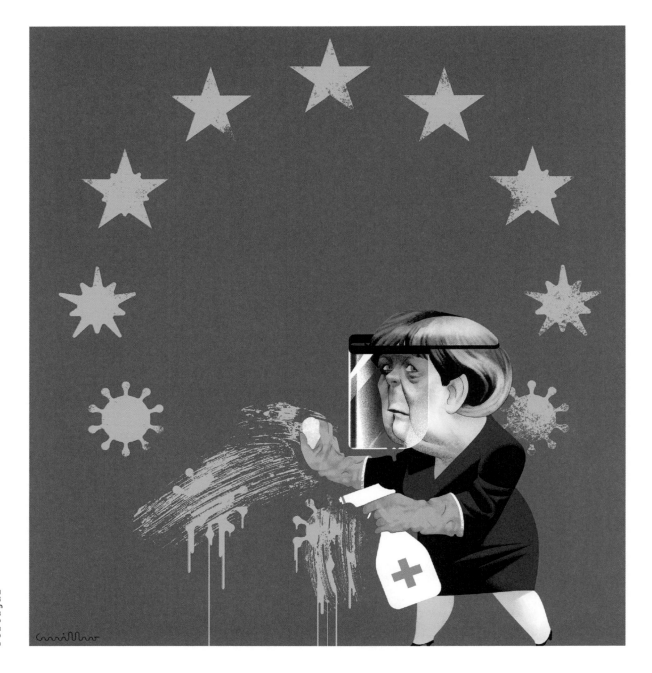

André Carrilho . A Divided EU
Portugal

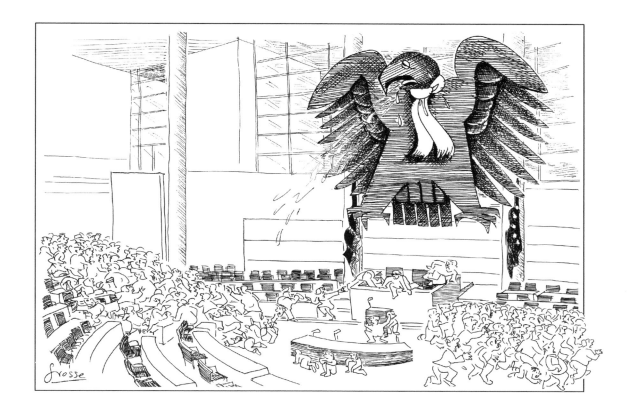

Dietmar Grosse . Bundesadler Pandemie
Germany

269

… And now
full throt-
tle!

EU economy

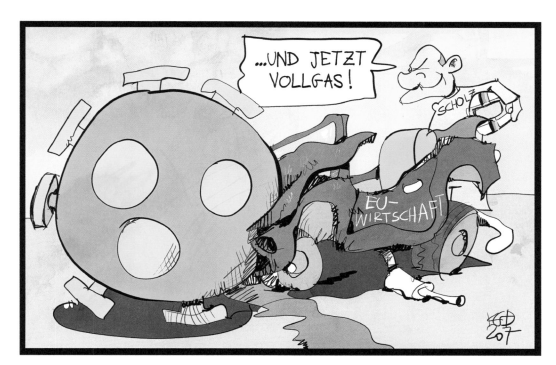

Kostas Koufogiorgos . " … und jetzt Vollgas!"
- Scholz kümmert sich um die europäischen Finanzen
Germany

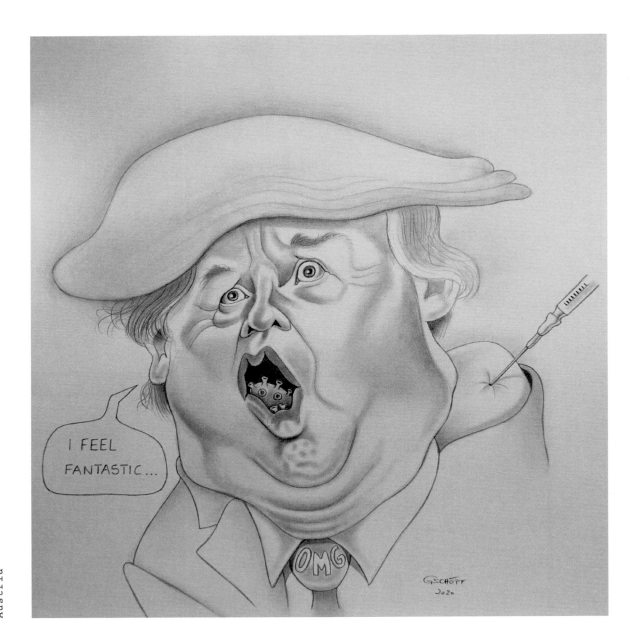

Christian Gschöpf . Donald Trumps Corona-Therapie
Austria

André Carrilho . Summer Special
Portugal

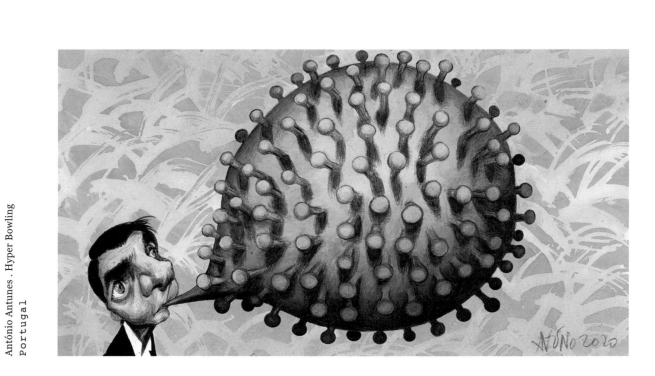

Muhamed Djerlek Max . Ahchoo
Serbia

António Antunes . Hyper Bowling
Portugal

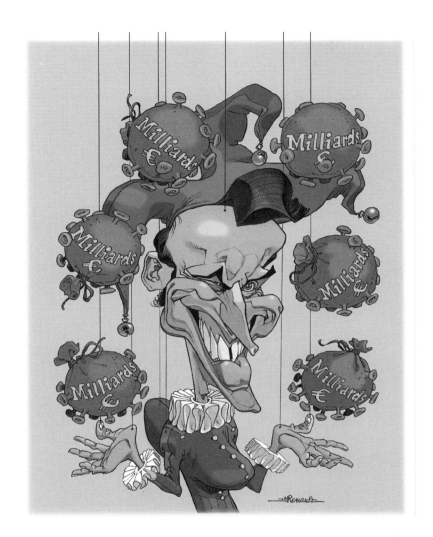

273

Jean-Michel Renault . Ali baba Macron a prononcé la formule magique :
« coronavirus ouvre toi ! » et distribue sans retenue les milliards.
France

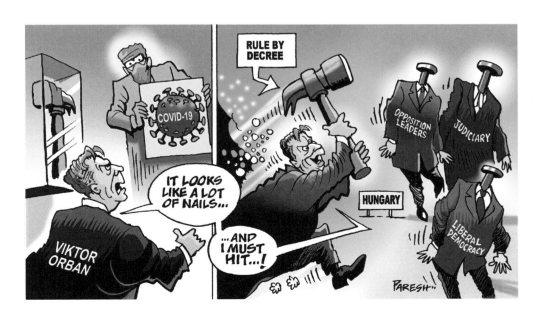

Paresh Nath . Hungary authoritarian way
India

274

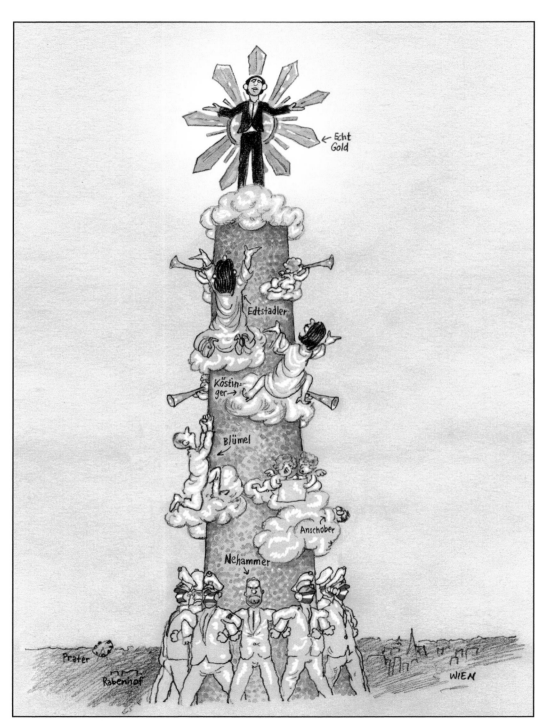

ERSTER ENTWURF FÜR EINE CORONASÄULE

Gerhard Haderer · Erster Entwurf für eine Coronasäule
Austria

Solid gold

First draft
of a coro-
na-column

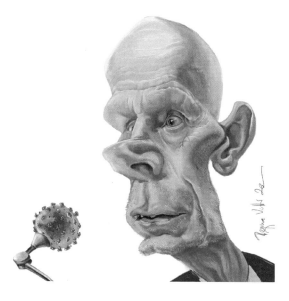

275

Regina Vetter . Daniel Koch
(das Schweizer Gesicht während der Pandemie)
Switzerland

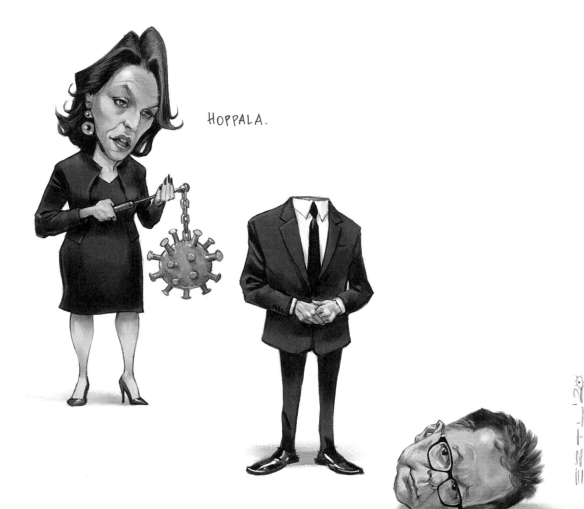

Oops.

HOPPALA.

Bernd Ertl . Die Corona Keule
Austria

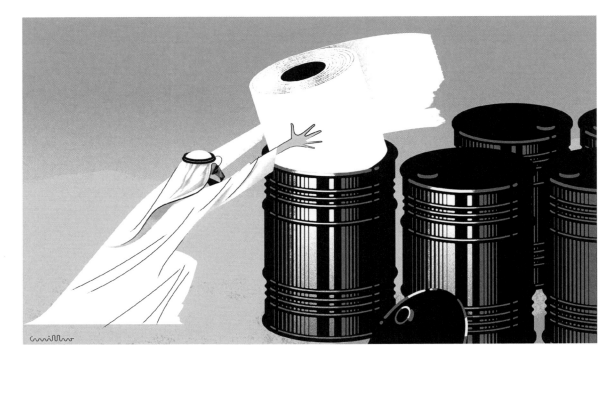

André Carrilho . New World (Dis)Order
Portugal

Zoran Petrovic
Germany

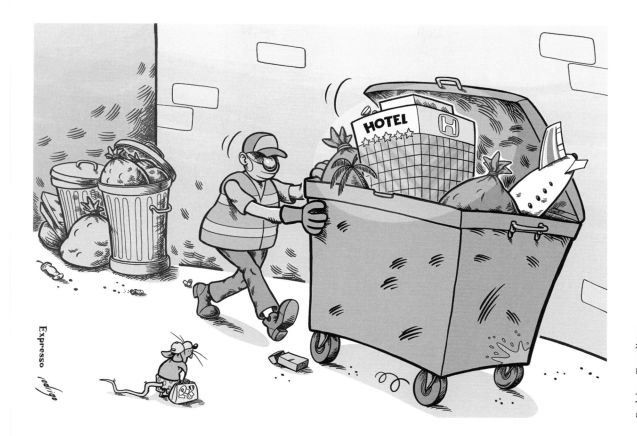

Rodrigo . Travelitter
China

Spiro Radulovic . Blockade
Serbia

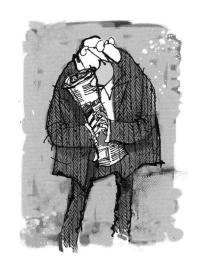

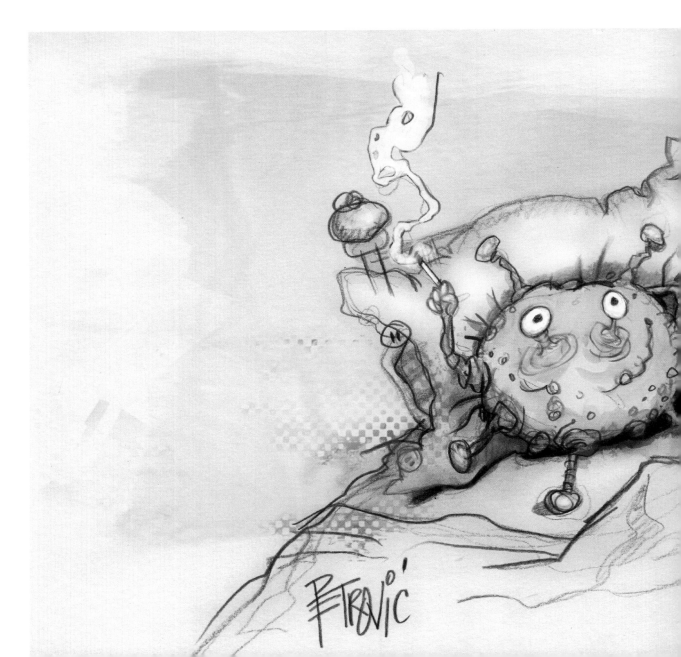

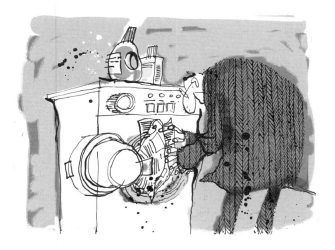

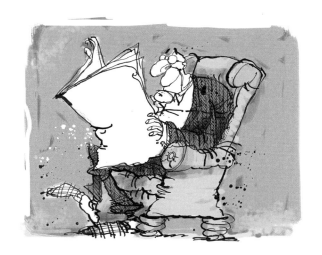

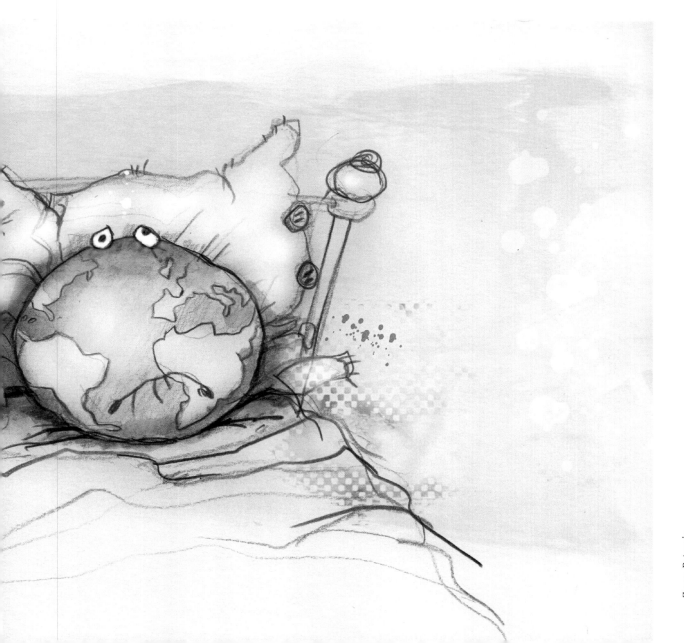

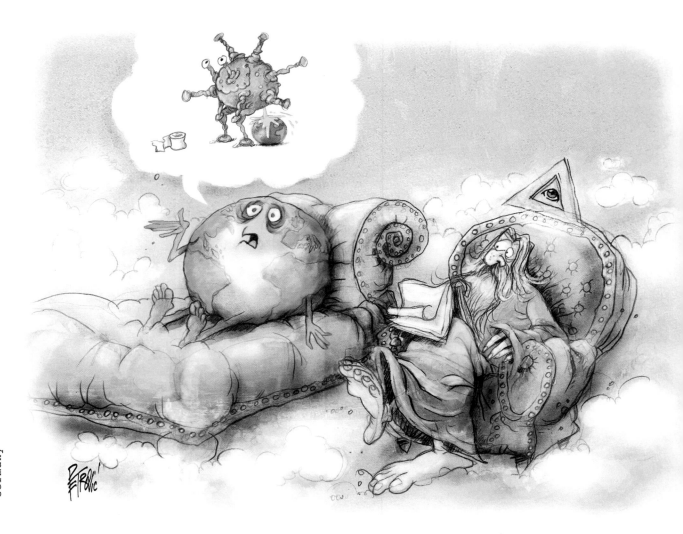

Zoran Petrovic
Germany

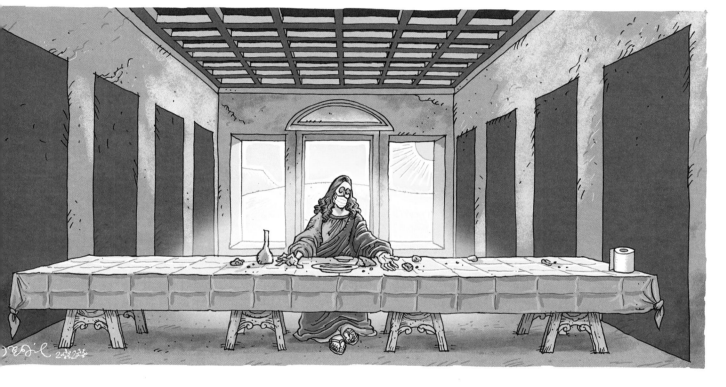

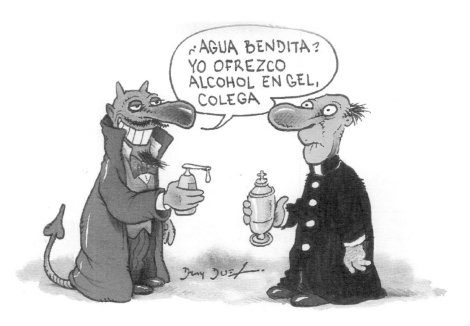

Holy water?
I'm offer-
ing alcohol
gel, bro'.

Dany Duel . Agua Bendita
Argentina

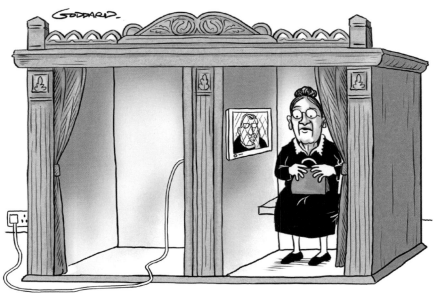

Clive Goddard . The Future of Confessional
United Kingdom

The Future of Confessional

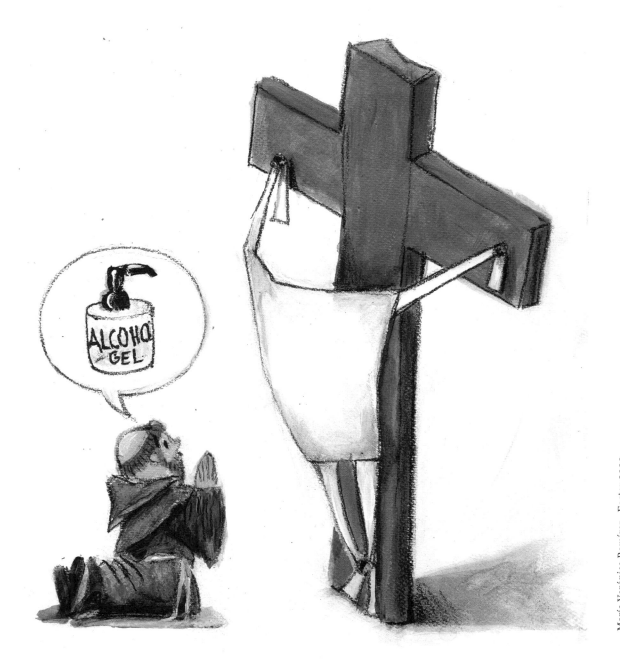

María Verónica Ramírez . Easter 2020

Argentina

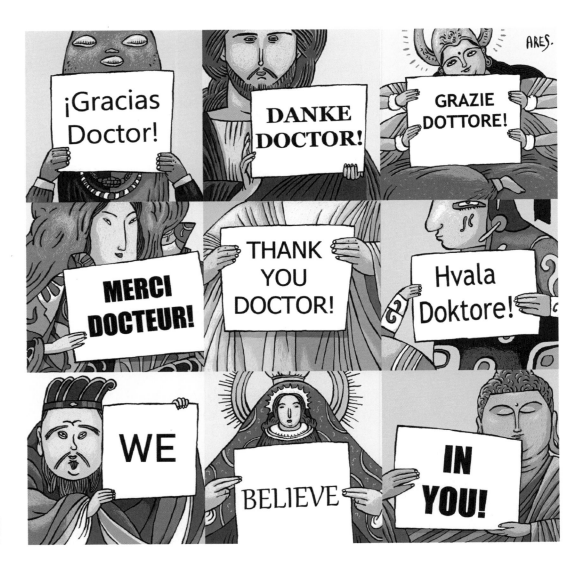

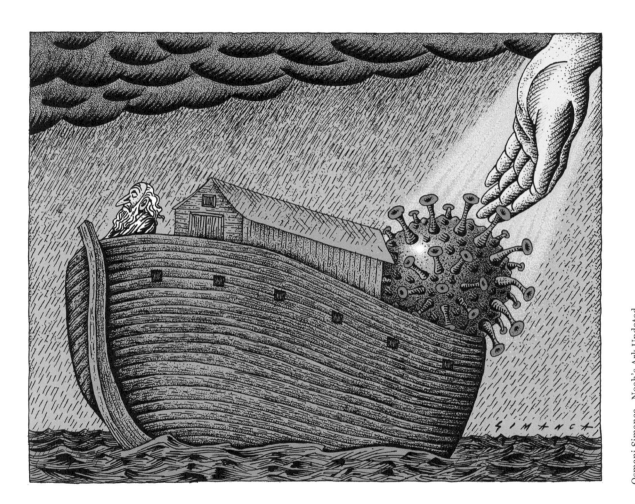

Osmani Simanca . Noah's Ark Updated

Brazil

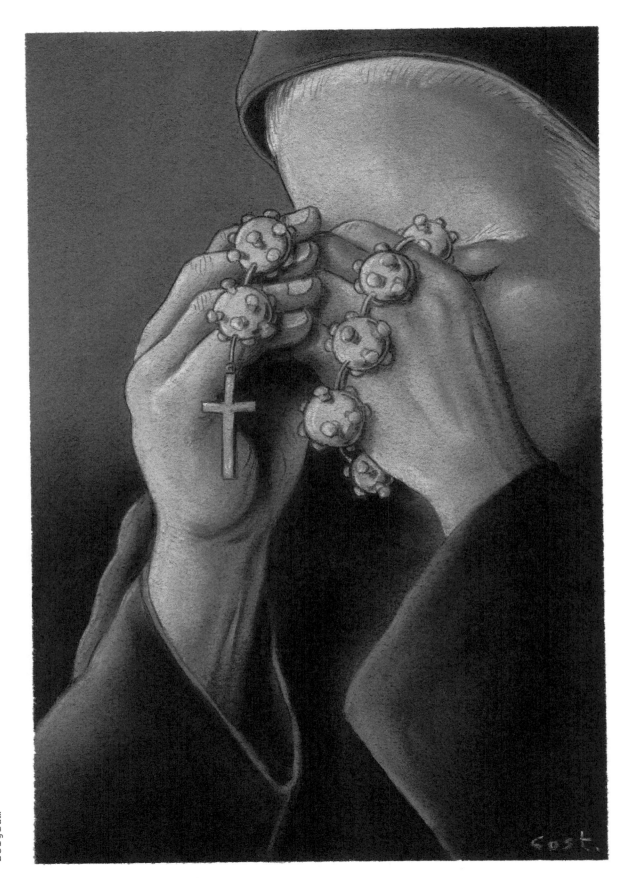

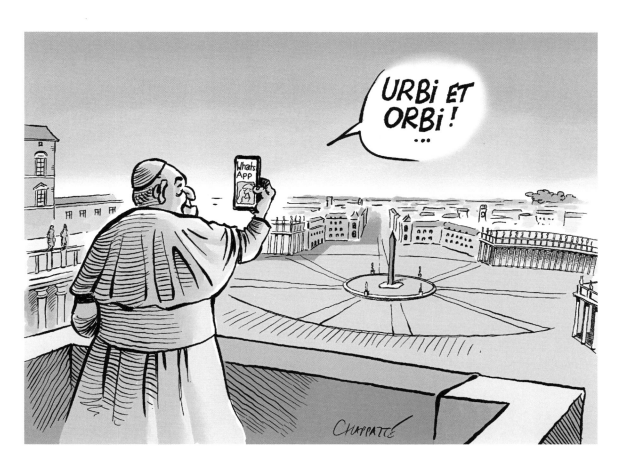

Chappatte . Easter Mass (first published by NZZ am Sonntag, Zürich)
Switzerland

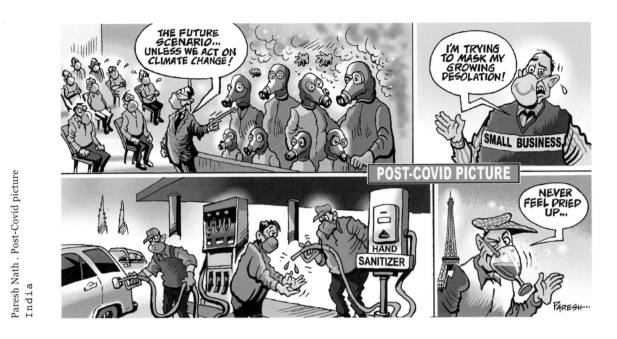

Paresh Nath . Post-Covid picture
India

Manuel Arriaga . We All Against The Virus
Spain

Special edi-
tion street
and freedom

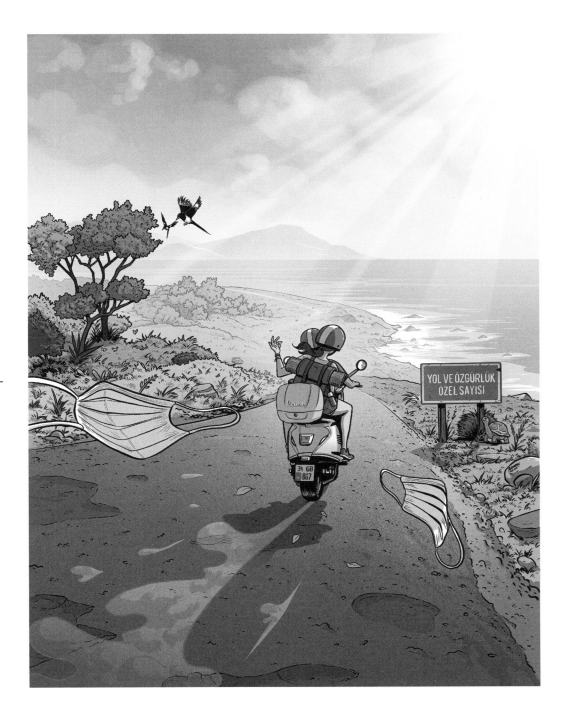

Berat Pekmezci . On the Road
United Kingdom

Phil Umbdenstock . Bientôt, le traçage des personnes infectées par le Covid-19
France

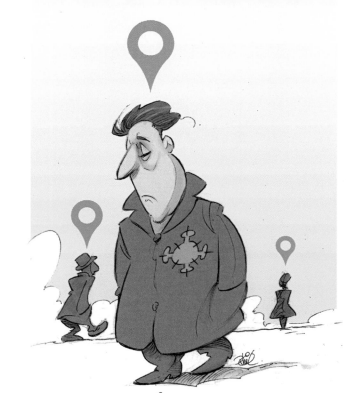

**BIENTÔT, LE TRAÇAGE
DES PERSONNES INFECTÉES PAR LE COVID-19**

COMING
SOON:
COVID-19
TRACKING
AND TRACING

Jitet Kustana . At Coronas Tomb
Indonesia

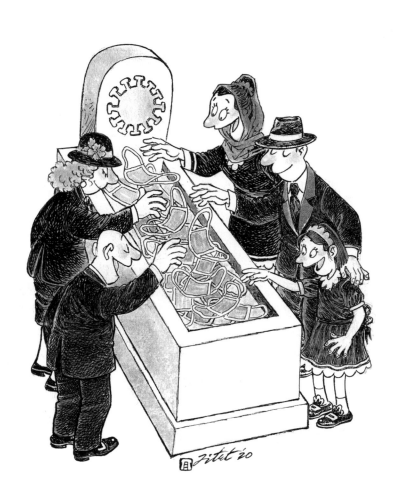

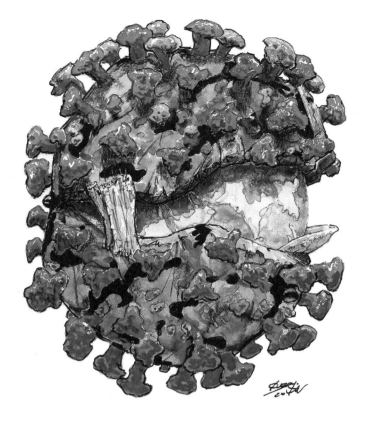

Alem Curin . Modern Military Camouflage
Croatia

Granddad
is going
on about
the toilet
paper war
again.

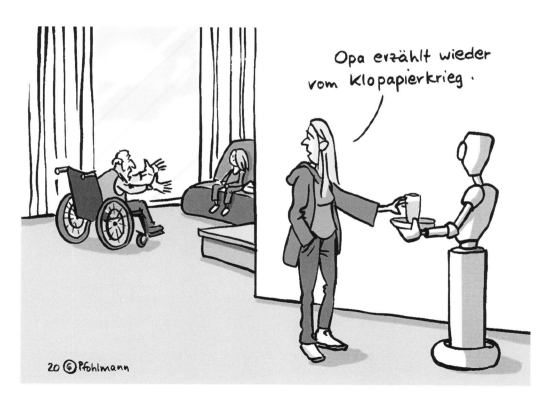

Opa erzählt wieder vom Klopapierkrieg.

20 © Pfohlmann

Christiane Pfohlmann . Klopapierkrieg
Germany

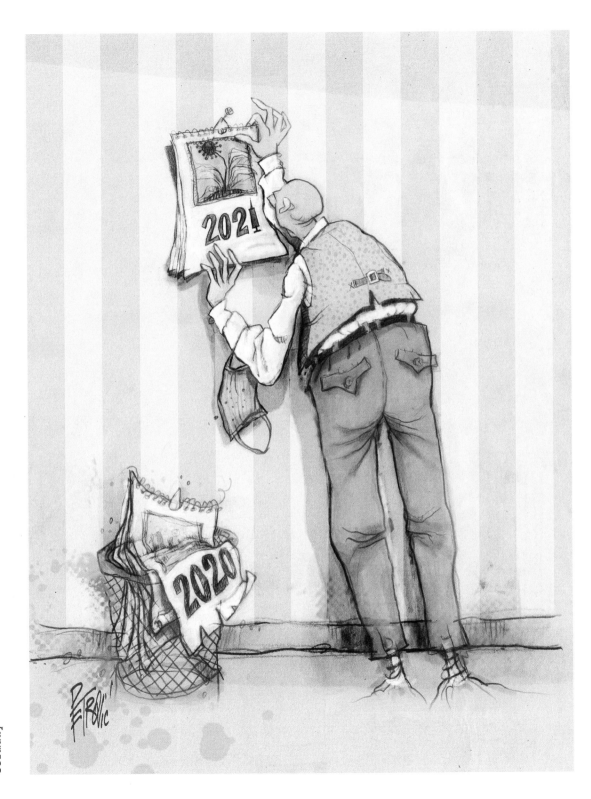

Zoran Petrovic
Germany

ACKNOWLEDGMENTS

Benevento Publishing and
Team Rottensteiner Red Bull would like to thank

Zoran Petrovic for proposing this project.

For supporting international artist contacts:

Bernd Ertl, Austria

Nol-Arnauid van der Donck
'Humor & Vigne' Président Internationale
Cartoon Biennale Jonzac, France

Marlene Pohle, Cartoonist.
Germany/Argentina, Vize president of FECO
(Federation of Cartoonists Organizations)

Culture & Multimedia International Association;
en.cmiassn.org, Beijing; China

Barbette Havriliak
Babette Media Services, New York, USA

Everything
will be fine.

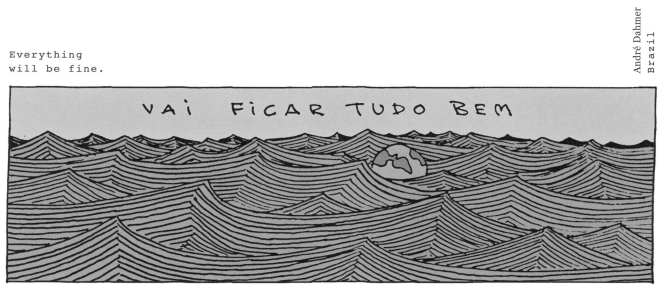

André Dahmer
Brazil

REGISTER

ALGERIA

Amine Labter . aminelabter@hotmail.com

ARGENTINA

Cristobal Reinoso . cristdibujos@gmail.com
Dany Duel . danyduel@hotmail.com
María Verónica Ramírez . maria.mvr@gmail.com
Marlene Pohle . marlenepohle2@gmail.com

AUSTRIA

Bernd Ertl . be@ausgezeichnet.com
Christian Gschöpf . gschoepf.at
Christian Stellner . stellner.at
Gerhard Haderer
Marian Kamensky
© Marian Kamensky / toonpool.com
Tex Rubinowitz

AUSTRALIA

John Ditchburn . inkcinct.com.au
© INKCINCT Cartoons

BELGIUM

Cost. . cost-art@skynet.be
Jacques Sondron . facebook.com/SONDRON
Lectrr . © dieKLEINERT.de/Lectrr
Luc Descheemaeker
luc.descheemaeker55@gmail.com
Luc Vernimmen . lucvernimmen.be
Stefaan Provijn . stefaanprovijn.be

BRAZIL

André Dahmer . andredahmer.com.br
Dalcio Machado . facebook.com/dalciomachado
Evandro Alves . alvescomics.carbonmade.com
Fabiane Langona . fabianelangona.com
Kleber . klebersales18@gmail.com
Osmani Simanca . politicalcartoons.com,
© Osmani Simanca, Courtesy Caglecartoons.com
Renato Peters . Instagram: renatopeters
Santiago . macanudosantiago@gmail.com
Zé Dassilva . Instagram: ze_dassilva

BULGARIA

Tchavdar Nikolov . politicalcartoons.com,
© Tchavdar Nokolov, Courtesy Caglecartoons.com

CANADA

Boris . jacques.goldstyn@gmail.com
Bruce MacKinnon . twitter.com/CH_cartoon
Dale Cummings . politicalcartoons.com,
© Dale Cummings, Courtesy Caglecartoons.com
Dave Whamond . politicalcartoons.com,
© Dave Whamond, Courtesy Caglecartoons.com
Theo Moudakis . tmou@rogers.com
Yayo . yayodiego.weebly.com

CHILE

Alen Lauzán . Instagram: alen_lauzan

CHINA

Gao Zhongli . 422712793@qq.com
Rodrigo . © Rodrigo / toonpool.com

COLOMBIA

Elena Ospina . Instagram: elenaospina
Nani Mosquera . Instagram: naniopina

COSTA RICA

Arcadio Esquivel
© Cartoonarcadio / toonpool.com

CROATIA

Alem Curin . alem.curin1@st.t-com.hr
Nikola Listeš . nikola.listes@gmail.com

CUBA

Ares . areshumour.com
Michel Moro Gómez . morocontacto@gmail.com

CZECH REPUBLIC

Marie Ploténá . marie.plotena@gmail.com

DENMARK

Niels Bo Bojesen . politicalcartoons.com,
© Niels Bo Bojesen, Courtesy Caglecartoons.com

ECUADOR

Bonil . Instagram: bonilcartoons

EGYPT

Doaa Eladl . doaa-eladl@hotmail.com

FRANCE

Bertrand Bouton
Biz (Pierre Bizalion) . bizhumour.over-blog.com
Cambon . mcambon2@wanadoo.fr
Jean-Michel Renault . patapan@orange.fr
Phil Umbdenstock . phil.umbdenstock@wanadoo.fr
Pichon. . pichon.amand@yahoo.fr
Pierre Ballouhey . ballouhey.canalblog.com
Plantu . plantu@lemonde.fr, © Plantu
Plop & KanKr . plopetkankr.com
Stephane Peray . politicalcartoons.com,
© Stephane Peray, Courtesy Caglecartoons.com

GERMANY

Bernd Zeller . zellerzeitung.de
Christian Berger . © Christian Berger/dpa
Picture Alliance/picturedesk.com
Christian Möller .
© CloudScience/toonpool.com
Christiane Pfohlmann . © Christiane Pfohl-
mann/toonpool.com
Dietmar Grosse
© dieKLEINERT.de/Dietmar Grosse
Hans Koppelredder . koppelredder@gmx.de
Karsten Weyershausen . © Karsten Weyershaus-
en/dpa Picture Alliance/picturedesk.com
Kostas Koufogiorgos . © Kostas Koufogior-
gos/dpa Picture Alliance/picturedesk.com
Lo Graf von Blickensdorf . © Lo Graf von
Blickensdorf/toonpool.com
Markus Grolik . Instagram: markusgrolik
Martin Erl . © Erl/toonpool.com
Marcus Gottfried
© Marcus Gottfried/toonpool.com
Mirco Tomicek . © Mirco Tomicek/toonpool.com
Oliver Wallbaum . © Rovey/toonpool.com

Paolo Calleri . © Paolo Calleri/toonpool.com
Petra Kaster . petrakaster.de
Ralf Böhme . © Rabe/toonpool.com
Schwarwel . © Schwarwel/toonpool.com
Sylvio Droigk . © Sylvio Droigk/dpa Picture
Alliance/picturedesk.com
Zoran Petrovic . mail.zoranp@gmail.com

GREECE

Michael Kountouris . politicalcartoons.com,
© Michael Kountouris, Courtesy Caglecartoons.com

HUNGARY

Géza Halász . © zu/toonpool.com

INDIA

Dattatreya Chiluveru . dattuchil4@gmail.com
Paresh Nath . pareshnath2003@gmail.com
Renu Sanyog Butolia . butoliarenu@gmail.com

INDONESIA

Jitet Kustana . kustanajitet@gmail.com

IRAN

Mahnaz Yazdani . MahnazYazdani.com
Rasoul Hajizade . r_hajizade@Yahoo.com

IRELAND

Jon Berkeley . Instagram: jonberkeley

ISRAEL

Grigori Katz . grigorikatz@yahoo.com
Ilya Katz . ilyaka1972@yahoo.com
Matan Kohn . © Matan Kohn/toonpool.com

ITALY

Andrea Pecchia . andreapecchia.com
Agim Sulaj . art.agimsulaj@gmail.com
Marco De Angelis . marcodeangelisart.com
Marco D'Agostino
Facebook: Marco D'Agostino Cartoons
Marilena Nardi . marilenanardi.it

REGISTER

JAPAN

No-rio Yamanoi . yamano@seagreen.ocn.ne.jp

JORDAN

Osama Hajjaj . politicalcartoons.com,
© Hajjaj, Courtesy Caglecartoons.com

LATVIA

Gatis Šļūka . gatissluka.com

MEXICO

Angel Boligán . boligan@hotmail.com
Arturo Rosas . art_rosas@hotmail.com
Dario Castillejos . politicalcartoons.com,
© Dario Castillejos, Courtesy Caglecartoons.com

MOROCCO

Ghamir Ali . caricmorrow@gmail.com

NETHERLANDS

Arend van Dam . politicalcartoons.com,
© Arend van Dam, Courtesy Caglecartoons.com
Bas van der Schot . politicalcartoons.com,
© Schot, Courtesy Caglecartoons.com
Tjeerd Royaards
© Tjeerd Royaards / toonpool.com

NORWAY

Egil . egnyhus@online.no

PERU

Karry Carrión . karrycartoons.blogspot.com
Pepe Sanmartin . facebook.com/pepesmgrafico,
Pepe Sanmartin © CARPAdeTINTA, Peru 2020

PHILIPPINES

Manny Francisco . politicalcartoons.com,
© Manny Francisco, Courtesy Caglecartoons.com

POLAND

Marcin Bondarowicz . bondarowicz.net

PORTUGAL

André Carrilho . andrecarrilho.com
António Antunes
antonio.antunes@artefinal.mail.pt
Cristina Sampaio . cristinasampaio.com

ROMANIA

Aurel Stefan Alexandrescu
alexcartoonist@hotmail.com
Costel Patrascan
costel_patrascan@yahoo.co.uk
Liviu Stanil . stanilaliviu1@gmail.com
Nicolae Lengher
facebook.com/lengher.nicolae.31

RUSSIA

Andrei Popov . Instagram: popov.a.a
Marina Bondarenko . marinabondart@gmail.com
Viacheslav Shilov . facebook.com/vfshilov

SERBIA

Doru Bosiok . doru.bosiok@gmail.com
Dušan Petričić . petricic46@gmail.com
Goran Celicanin . celicanin@yahoo.com
Jaksa Vlahovic . jaksavlahovic.net
Jugoslav Vlahovic . jugovlah@yahoo.com
Muhamed Djerlek Max . satirikart@gmail.com
Spiro Radulovic . spirorad@gmail.com
Toso Borkovic . toshow53@gmail.com
Vladimir Stankovski . v.stankovski@yahoo.com

SLOVAKIA

Martin Sutovec . politicalcartoons.com,
© Martin Sutovec (alias Shooty)
Courtesy Caglecartoons.com

SOUTH AFRICA

Carlos Amato . carlosamato.work

SPAIN

Juancarlos Contreras
facebook.com/juancarlerias
Manuel Arriaga
facebook.com/manuel.arriaga.169
Miguel villalba Sánchez 'Elchicotriste'
Instagram: elchicotristeofficial
Turcios . turciosdibuja@gmail.com

SWEDEN

Helena Lindholm . helenaillustration.com
Max Gustafson . maxgustafson.com

SWITZERLAND

Chappatte . chappatte.com, © Chappatte
Christof Stückelberger . stueckelberger.ch
Debuhme . Instagram: debuhme, © Vigousse
Regina Vetter . regina-vetter.ch,
© 2020 Regina Vetter
Mynt . schlafendehundewecken.ch
© SCHLAFENDEHUNDEWECKEN

TUNISIA

Dlog . facebook.com/labullededlog,
© NadiaDhab

TURKEY

Ercan Akyol . ercanakyol01@gmail.com
Hicabi Demirci . hicabidemirci@gmail.com
Hilal Özcan . Instagram: oozcanhilal
Muammer Olcay . Instagram: molcaycartoon

UNITED KINGDOM

Berat Pekmezci . Instagram: pekmezci
Chicane . chicanepictures.com
Clive Goddard . clivegoddard.com
Patrick Blower . telegraph.co.uk,
© Blower/Telegraph Media Group Ltd
Rebecca Hendin . rebeccahendin.com

UKRAINE

Vadim Siminoga
© Vadim Siminoga/toonpool.com
Vladimir Kazanevsky . kazanevsky@gmail.com

USA

Ali Solomon . cartoonbank.com,
© Ali Solomon/The New Yorker Collection/
The Cartoon Bank
Andy Marlette . imagn.com,
© Andy Marlette - USA TODAY NETWORK
Bill Bramhall . tribunecontentagency.com,
© 2020 Bill Bramhall. All rights reserved.
Distributed by Tribune Content Agency
Bob Englehart . politicalcartoons.com,
© Bob Englehart, Courtesy Caglecartoons.com
Chris Lyons . chrislyonsillustration.com
Daryl Cagle . politicalcartoons.com,
© Daryl Cagle, Courtesy Caglecartoons.com
J.D. Crowe . © JD Crowe, Courtesy
Politicalcartoons.com
Joe Dator . cartoonbank.com, © Joe Dator/
The New Yorker Collection/The Cartoon Bank
Jason Raish . jasonraish.com,
© Jason Raish/Central Illustration Agency
Mirko Ilic . studio@mirkoilic.com,
© Mirko Ilíć
Michael Ramirez . creators.com,
© By permission of Michael Ramirez and
Creators Syndicate
Peter C. Vey . cartoonbank.com,
© Peter C. Vey/The New Yorker Collection/
The Cartoon Bank
Peter Kuper . politicalcartoons.com,
© Peter Kuper, Courtesy Caglecartoons.com
Randall Enos . politicalcartoons.com,
© Randall Enos, Courtesy Caglecartoons.com
Rick McKee . politicalcartoons.com,
© Rick Mckee, Courtesy Caglecartoons.com
Sean Delonas . politicalcartoons.com,
© Sean Delonas, Courtesy Caglecartoons.com
Seth Fleishman . cartoonbank.com,
© Seth Fleishman/The New Yorker Collection/
The Cartoon Bank
Victoria Roberts . cartoonbank.com,
© Victoria Roberts/The New Yorker Collec-
tion/The Cartoon Bank

VENEZUELA

Maria Centeno . mariacent@gmail.com

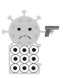